VISIONS OF LIGHT AND AIR

EXHIBITION TOUR

Musée du Québec, Québec
14 June to 4 September 1995

Americas Society Art Gallery, New York
27 September to 17 December 1995

The Dixon Gallery and Gardens, Memphis
18 February to 14 April 1996

The Frick Art Museum, Pittsburgh
12 June to 11 August 1996

Art Gallery of Hamilton, Hamilton, Ontario
12 September to 8 December 1996

The Americas Society gratefully acknowledges the generosity of the American Friends of Canada in underwriting the publication of this catalogue.

The American Friends of Canada seeks to foster "friendship through the arts" between the United States and Canada. Since its inception in 1972, the American Friends of Canada has encouraged and assisted donors in the United States wishing to support a broad range of cultural institutions throughout Canada. Funding has also been provided for traveling exhibitions, fellowships and acquisitions. It is the hope of the American Friends of Canada that others will be inspired to promote "friendship through the arts."

VISIONS OF LIGHT AND AIR

Canadian Impressionism, 1885–1920

CURATED BY CAROL LOWREY

Americas Society Art Gallery

NEW YORK, 1995

THE AMERICAS SOCIETY is a national institution devoted to informing people in the United States about the societies and cultures of its Western Hemisphere neighbors. Its goal is to foster a broader understanding of the contemporary political, economic, and social issues confronting Latin America, the Caribbean, and Canada, and to increase public awareness and appreciation of the rich cultural heritage of our neighbors. To this end, the Society offers a variety of programs that are organized into two divisions: Western Hemisphere Affairs and Cultural Affairs. As a not-for-profit institution, the Americas Society is financed by membership dues and contributions from corporations, foundations, individuals, and public agencies, including the National Endowment for the Arts, New York Council for the Humanities, and the New York State Council on the Arts.

LENDERS TO THE EXHIBITION

Art Gallery of Hamilton

Art Gallery of Ontario, Toronto

The Beaverbrook Art Gallery, Fredericton, N. B

The Brooklyn Museum

Eaton's of Canada Limited, Toronto

Government of Ontario Art Collection, Toronto

Hart House Permanent Collection, University of Toronto

MacKenzie Art Gallery, University of Regina Collection

Manoogian Collection, Taylor, Michigan

The Robert McLaughlin Gallery

Milne Family Collection

The Montreal Museum of Fine Arts Collection

Le Musée d'art de Joliette

Musée d'Orsay, Paris

Musée du Québec

National Gallery of Canada, Ottawa

Power Corporation of Canada/Power Corporation du Canada

Public Archives of Nova Scotia, Halifax

Kenneth W. Scott, Toronto

Winnipeg Art Gallery

Private Collections

© Copyright 1995 Americas Society
Library of Congress Card Catalogue Number 95-78255
ISBN: 1-879128-12-8

Published by the Americas Society
680 Park Avenue, New York, NY 10021

Distributed by the University of Washington Press
P.O. Box 50096
Seattle, Washington 98145

Editors: Robert Stacey and Elizabeth Ferrer
Publication Coordinators: Regina Smith and Erika Benincasa
Translators: Alphonse Saumier and Monique Nadeau
Design and typography: Russell Hassell
Printing: The Studley Press, Dalton, Massachusetts

PHOTOGRAPHY CREDITS

Contents

ACKNOWLEDGMENTS

THE AMERICAS SOCIETY takes deep pride in presenting the exhibition and publication *Visions of Light and Air: Canadian Impressionism, 1885–1920*. It is our hope that, with this project, a large audience in the United States and Canada will not only have the distinct pleasure of viewing this magnificent selection of paintings, but also the opportunity to learn about the important cultural links between Canada, Europe and the United States at the turn of the century.

Recent scholarly studies of Impressionism have shown that this artistic style had a far-reaching impact, well beyond France's borders. Many late–nineteenth-century Canadian painters travelled to and studied in France, where they were creatively invigorated by the Impressionist mode as it was then being practiced. Upon returning to Canada, these artists gave new life to Impressionism, finding it to be an ideal idiom for the depiction of their own landscapes, cities, and home life.

This project is of special significance to the Americas Society because of our hemispheric mission to foster a broader understanding and appreciation of the rich cultural heritage of our neighbors in Latin America, the Caribbean, and Canada. In addition, the Americas Society Art Gallery has long sought to present exhibitions on artistic traditions that are little known in the United States. *Visions of Light and Air* is the first exhibition on Canadian Impressionism ever to take place in the United States.

This major undertaking was made possible through the generous support of individuals and institutions from the United States, Canada, and France. Our great thanks are extended to the American Friends of Canada for underwriting this handsome and significant scholarly volume. Gaetana Enders, former president and current Chair of the American Friends of Canada, and a member of the Board of Directors of that organization as well as of the Americas Society, is to be singled out for her perseverance and enthusiasm in realizing this exhibition and its catalogue. Judy Ney, who is now the President of the American Friends of Canada, has been most diligent in carrying on the work of her predecessor.

The Americas Society also acknowledges the support of the Power Corporation of Canada/Power Corporation du Canada. The Canadian Consulate General in New York and The Richard and Priscilla Schmeelk Foundation also contributed to the presentation of the exhibition.

This exhibition was curated by Carol Lowrey, Curator of The National Arts Club Permanent Collection, New York, and a doctoral candidate in the Department of Art History at the Graduate School, City University of New York. The dedication and countless hours that Ms. Lowrey invested in this project are reflected in both the exhibition and catalogue. We are also grateful to the scholars who contributed fine essays to the catalogue: Dr. William H. Gerdts, Professor of Art History, Graduate School, City University of New York, and a leading scholar of American Impressionism; Robert Stacey, Associate Curator, Historical and Contemporary Art, Art Gallery of Hamilton; and Laurier Lacroix, Professor of Art History and Museology, Department of Art History, Université du Québec, Montréal.

We are pleased that this exhibition will be shown at four institutions besides the Americas Society. This will greatly increase the audience for this exhibition, both in the United States and Canada. At the exhibition venues, we thank the following staff members for their interest and cooperation: at the Art Gallery of Hamilton, Ted Pietrzak, Director; at The Dixon Gallery and Gardens, Memphis, Katherine C. Lawrence, Acting Director and John E. Buchanan, Jr., former Director; at The Frick Art and Historical Center, Pittsburgh, DeCourcy E. McIntosh, Executive Director; and at the Musée du Québec, John R. Porter, Directeur général, Didier Prioul, Conservateur en chef and Pierre L'Allier, Conservateur de l'art moderne.

The Americas Society is extremely grateful to the many individuals and institutions who assisted in all aspects of the exhibition. Staff members at museums and art galleries, as well as at corporate and private collections in Canada, the United States and France were most helpful in facilitating loans and providing documentation on works of art in their collections. I join Carol Lowrey, the exhibition curator, in extending our thanks to Ted Pietrzak, Robert Stacey, and Joan Weir, Art Gallery of Hamilton; Glenn Lowry, former Director,

Dennis Reid, Curator of Canadian Historical Art and Sherry Phillips, Assistant Conservator, Loans and Documentation, Art Gallery of Ontario; Ian G. Lumsden, Director, and Tom Smart, Curator, The Beaverbrook Art Gallery; Robert T. Buck, Director, Barbara Dayer Gallati, Associate Curator of Painting and Sculpture, Teresa A. Carbone, Associate Curator of Research, and Guillermo Ovalle, Assistant Registrar, The Brooklyn Museum; Marlene Josiak, Eaton's of Canada Limited; Fern Bayer, Chief Curator and Irma Ditchburn, Assistant to the Curator, Government of Ontario Art Collection; Judith Schwartz, Director/Curator, Justina M. Barnicke Gallery, Hart House, University of Toronto; Andrew Oko, Director, and Bruce Anderson, Registrar, MacKenzie Art Gallery; Cheryl Robledo for the Manoogian Collection; Joan Murray, Director and Linda Jansma, Registrar, The Robert McLaughlin Gallery; France Gascon, Director, and Christine La Salle, Registrar, Le Musée d'art de Joliette; Pierre Théberge, Director, Yves Lacasse, Curator of Canadian Art, and Louise Lalonde, Loans and Acquisitions Officer, The Montreal Museum of Fine Arts; Henri Loyrette, Conservateur en Chef, and Caroline Matthieu, Conservateur en Chef, Musée d'Orsay; John R. Porter, Directeur général; Didier Prioul, Conservateur en Chef; Pierre L'Allier, Conservateur de l'art moderne; and Lise Nadeau, Archiviste des Collections, Musée du Québec; Shirley L. Thomson, Director, and Charles C. Hill, Curator of Canadian Art, National Gallery of Canada; Serge Joyal, Art Counsel, and Paul Marechal, Assistant to Mr. Joyal, Power Corporation of Canada; Garry D. Shutlak, Archivist and Head of the Map/Architecture Division and of the Photographs/Documentary Art Division, Public Archives of Nova Scotia; Scott Robson, Nova Scotia Museum, Halifax; Michel Cheff, Director, Gary Essar, former Associate Curator of Historical Art, and Margot Rousset, Assistant Registrar, Winnipeg Art Gallery. Judy Dietz, Registrar, Art Gallery of Nova Scotia; D.G.B. Fair, Registrar/Curator of Canadian Historical Art, London Regional Art and Historical Museums; O. Aldon James Jr., President, and Arnold Davis and Roger Rosen, Co-chairmen, Curatorial Committee, The National Arts Club, New York; Herbert Mitterboeck; David C. Henry; and Anna Marie Larsen, Curator, Woodstock Art Gallery, Woodstock, Ontario, were also most helpful to the project.

Many friends, colleagues and collectors provided valuable assistance and encouragement, including: Curtis Barlow, Cultural Counsellor, Canadian Embassy, Washington, D.C.; Yves Beauregard; Bill and Wynn Bensen; Margaret Brown; Jim Burant; Margaret C. Conrads; Ross Fox; Ann Meredith Garneau, Consul, Cultural and Academic Affairs, Canadian Consulate General, New York; Marike Gauthier; John W. Grace; Stephen Jarislowsky; Lawrence Jeppson; Neil J. Kernaghan; Alan Klinkhoff; J. Blair MacAulay; David Mitchell; John O'Brian; Larry Ostrom; Lisa N. Peters; A.K. Prakash; Miles Price; Mr. and Mrs. Fred Schaeffer; Donn Schroder; David Silcox and Elizabeth Wylie, David Milne Catalogue Raisonné Project; Ira Spanierman; Michael Torosian; and William Turner.

We would like to extend a special note of thanks to Anne Grace of Ottawa for her invaluable services as a research assistant, and to the staffs of the libraries of the Art Gallery of Hamilton; the Art Gallery of Ontario; the Canadian Consulate General, New York; the Inter-Library Loan Department, Graduate School, City University of New York; The Montreal Museum of Fine Arts; the National Gallery of Canada; and the National Library of Canada.

For the exhibition catalogue, we are extremely grateful to editors Robert Stacey and Elizabeth Ferrer; to translators Alphonse Saumier and Monique Nadeau; and to Russell Hassell, a graphic designer of enormous talent. Maggie Keith provided additional editorial assistance.

At the Americas Society, the exhibition was organized by Elizabeth Ferrer, Head of Visual Arts and Curator of the Art Gallery; Regina A. Smith, Visual Arts and Education Programs Administrator; Joseph R. Wolin, Gallery Manager and Associate Curator of the Art Gallery; Cecilia C. Lizárraga, Exhibition Coordinator; and the Visual Arts departmental assistants, Erika Benincasa, Susan Garner, and Abigail Sider. They are to be commended for their diligence, good humor, and hard work. Fatima Bercht and Louis Grachos, formerly of the Department of Visual Arts, are to be thanked for their efforts in this project's planning phase. Special thanks go to Elizabeth A. Beim, Director of Cultural Affairs, and Linda Strong Friedman, Assistant to the Director of Cultural Affairs, who also provided valuable assistance. Finally, the members of the Visual Arts Advisory Board also offered guidance and support, which is deeply appreciated.

EVERETT ELLIS BRIGGS
President, Americas Society

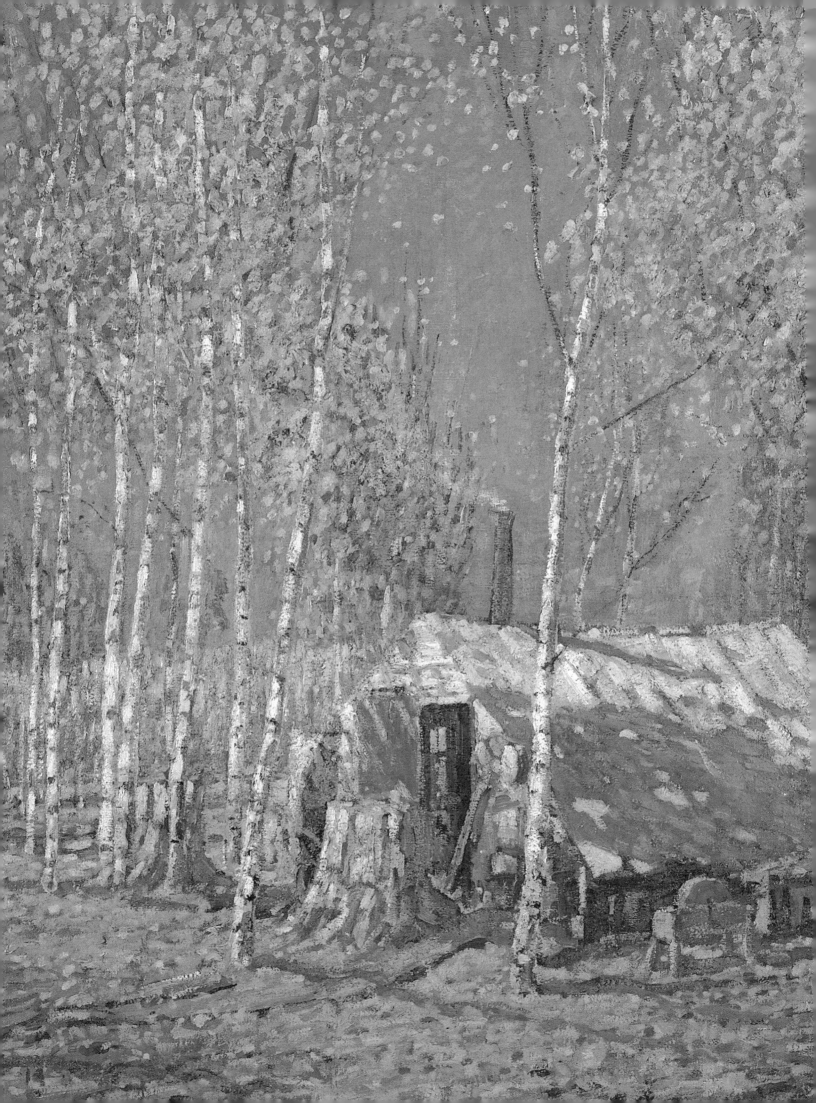

FOREWORD

WILLIAM H. GERDTS

I AM DELIGHTED to have been asked to introduce this exceptional exhibition and catalogue on Canadian Impressionism, a subject of increasing general enthusiasm and scholarly concern in Canada, but mostly unfamiliar to audiences in the United States. This is not surprising; with few exceptions, we here below the 49th Parallel are appallingly uninformed concerning the sometimes spectacular achievements of Canadian culture generally. In the case of Impressionism, however, this is especially surprising, since there was so much interaction between the Canadian contingent and that of the U.S. Indeed, in 1887 one of the seven original foreign "colonists" in the all-important Impressionist art center established in Giverny, France, was William Blair Bruce, from Hamilton, Ontario. Bruce was not only Canada's first Impressionist; it is my strong belief that he absorbed the strategies of Impressionism more fully than any of his colleagues and was instrumental in their assimilation by some of the others, such as Theodore Robinson.

Later, and an ocean and a continent away, William Henry Clapp from Montreal was a guiding force in the avant-garde Society of Six in the California Bay Area in the 1920s; he was probably also the most orthodox Impressionist in the region. Nor should we forget that Maurice Prendergast was born in St. John's, Newfoundland, while Ernest Lawson first saw light in Halifax, Nova Scotia. Both became Impressionist members of The Eight in New York City at the beginning of the twentieth century. Although Prendergast's association with the island colony (which became a Canadian province in 1949) did not continue, Lawson spent his youth in Kingston, Ontario, and subsequently lived in Toronto, where his work continued to be exhibited, and he visited and painted in Newfoundland and back in Nova Scotia. Finally, some of David Milne's finest Impressionist and Post-Impressionist pictures were painted in Manhattan and the Bronx in the first half of the 1910s—marvellous, unique urban imagery.

The very introduction of Milne into this discussion raises the question of the definition of Impressionism,

Arthur Lismer, *The Guide's Home, Algonquin,* detail, 1914.

not only an aesthetic but increasingly an ideological concept presently in flux. Generally speaking, we think of Impressionist pictures formally as concerned with transience, with changing qualities of light, color, and atmosphere presented often in a high key, and with a vigorous painterliness which underscores the perception of change and movement. In recent years, thanks especially to the writings of Robert Herbert on French Impressionism, increasing attention has been given to the subject matter of Impresssionism, with an emphasis upon themes realistically drawn from modern life, often situated in an urban setting. American scholars, too, such as David Park Curry, Ilene Susan Fort and Bram Dijkstra, have similarly investigated American Impressionism, as have Kenneth McConkey and Anna Gruetzner in Great Britain. The problem here is that while Impressionist paintings deal with real life situations, not all of them are necessarily "modern." The agrarian activities of the French peasants pictorialized by Bruce and Robinson in Giverny defined the nature of rural French peasant life, but they are not "modern" in the sense of Manet's *Bar at the Folies-Bergère* or Edgar Degas's and Mary Cassatt's theatre imagery.

While the initial reception of Impressionism in France in the 1870s was not uniformly favorable, the movement was well established by 1886, the year of the eighth and final Parisian exhibition of the work of that changing group of associated painters. The irony here is that it was that same year that not only firmly established the movement in North America with the great Impressionist show organized by Paul Durand-Ruel and shown at the American Art Association in New York City in April, but also established Americans as their premier patrons, and began to make a rich man out of at least one of their number, Claude Monet. Despite some inevitable critical opposition, Impressionism triumphed quite quickly in the United States—far more so, for instance, than in England and Germany. Indeed, one historian has even questioned the very existence of German Impressionism, beyond the series of pictures painted at the beginning of this century in Munich by Fritz Von Uhde, depicting his daughters in the family garden. In Great Britain, dis-

cussions of British Impressionism revolve around the rural imagery created by followers of Jules Bastien-Lepage, the leader of the Naturalist movement, an aesthetic that in the United States would be seen as antithetical to Impressionism; no discussion of American Impressionism, for instance, would encompass the peasant imagery of the expatriate Charles Sprague Pearce, for instance, which clearly derives from Bastien.

The popularity of French Impressionism, once it had triumphed, never abated. This was not necessarily true of the movement elsewhere. While Americans remained devotees of French examples, and while the aesthetic became a "popular" approach to art, dominating rural art colonies throughout the twentieth century, in terms of serious scholarly, critical, and commercial concern, interest in native Impressionism declined precipitously during the 1920s, was first resurrected by a few collectors during the 1960s, and gained scholarly recognition only in the following decade. Recognition of a Canadian "branch" of the movement is of relatively recent origin, in this case, beginning with Joan Murray's exhibition *Impressionism in Canada, 1895–1935*, organized by the Art Gallery of Ontario in Toronto in 1973. Until the last several decades, critical reaction against the native Impressionists in the United States, and I expect elsewhere, left no ground for approval. Either the domestic artists misunderstood the premises of French Impressionists and were unsuccessful, or they understood them only too well, and were slavish imitators.

What was undeniable, of course, was that the movement *was* indubitably of French origin; the political antipathy between Germany and France, in fact, can account at least in part for the initial reluctance to the exhibition and collection of French Impressionist works in Germany, as well as the limited subscription to this very French movement by German artists. Nevertheless, we have seen in recent years, not only the inception or resurrection of interest in distinctly national forms of Impressionism outside of France—in the U. S., England, and Canada, but also throughout the Western world, including Scotland, Scandinavia, Poland, Russia, and even Slovenia, as well as Japan.

In addition, there recently have been a number of international surveys of Impressionist art, offering comparisons not only of French Impressionism with other national expressions, but among those expressions themselves. In 1990, the Wallraf-Richartz-Museum

in Cologne, Germany, and the Kunsthaus in Zurich, Switzerland, presented *Landschaft im Licht; 1860–1910*, a survey of Impressionist painting in Europe and North America and, at the same time, Norma Broude, as editor, published her *World Impressionism: The International Movement, 1860–1920*. The following year, the Matsuzakaya Art Museum in Japan mounted a show entitled *World Impressionism and Pleinairism*. Unfortunately, neither exhibition included the work of the Canadians, though Dennis Reid provided a brilliant synopsis of the Canadian phase of the movement in Broude's masterful survey.

These international surveys offer the possibility of a kind of "comparative shopping," in order to discern similarities and differences among specific artists and national schools, as well as the general degree of commitment to the aesthetic, both formally and thematically. That is, depending on the criteria used to define the movement in the first place, how Impressionist *was* Canadian (or Slovenian) Impressionism? And, if different, what accounts for those distinctions? Of course, the subscription to traditional aesthetic practices, the newness of cultural maturation, industrial progress, the concentration of wealth, the degree (or lack) of democratization of society, and even the nature of the religious and moral establishment: any and all of these may play their part. But an additional factor I have found in determining the nature of national Impressionist expressions—and this is necessarily a generalization—has been the specific preferences among the major French Impressionists. That is, after 1886, Americans—collectors, critics, exhibitors, historians—invariably gave the palm to Claude Monet, and this in part determined the nature of American Impressionism. The British, and not only Walter Sickert, rather favored Degas, and they produced a very different interpretation of the movement, while the Germans took more to Manet. The Belgians endorsed Seurat and, despite Emil Claus and the *Vie et Lumière* movement, the late nineteenth-century modern art of that nation was swept up much more into Post-Impressionist Divisionism than into Impressionism proper. Canadian Impressionism may yield such an exemplar also.

The question of whether Impressionism exhibits distinct national characteristics seems unavoidable. In the United States, for instance, there are formal differences between the native artists and the French, grounded, I believe, in the significance of the academic training that the Americans had engaged in just prior

to their investigation of what was then an avant-garde approach; they were often simply not willing to summarily shuck off those accomplishments they had worked so hard to acquire. No American went abroad to learn to be an Impressionist; they went to study in Paris, Munich, Antwerp or London, to become competent, professional (and inevitably, to some degree, academic) artists. Thematically, Americans painted many of the same subjects as their French predecessors—parks and flower gardens and seaside resorts. There are themes the French painted which the Americans avoided, for instance, such as prostitutes and the concert halls frequented by the lower classes (although New York had fully as many of these establishments as Paris). But a number of writers—wrongly, in my opinion—have insisted that, unlike the French, American Impressionists avoided the modern city and the urban worker. Yet Childe Hassam, for instance, painted as many New York City views as Manet, or Monet, or Pissarro (or perhaps all of them together!) did of Paris, and he was hardly the only American artist to do so. Likewise, Hassam's oeuvre is replete with working men (especially the ubiquitous cab driver who is often the focus of his picture) and women (the flower-seller, who *always* is). It's true that the first generation of foreign colonists in Giverny devoted their attention to the local peasantry, unlike Monet, who lived there permanently, but then peasant subject matter dominates Pissarro's oeuvre at very much the same time.

Is there a distinctly Canadian Impressionism? That depends. First of all, even the formal strategies of the movement are vastly different when handled by Clarence Gagnon or Maurice Cullen or James Wilson Morrice, to name only the more famous, and, like John Henry Twachtman in the United States, none of these subscribed to the most "orthodox" usage of color and brushwork that we associate with Monet and Renoir, for instance. Others do, of course, at least to a greater degree: painters such as Marc-Aurèle Suzor-Coté, William Clapp, and that wonderful woman Impressionist (one of only a few in Canada, it seems), Helen McNicoll. Thematically, one finds peasant farms and flowering fields by Bruce, sunny rural landscapes by Gagnon and Clapp, pretty women and children in sunlight by McNicoll, Suzor-Coté, and Laura Muntz, beach scenes by Morrice and Gagnon, Old-World Paris by Morrice, and urban modernism by Milne, and Suzor-Coté, and occasionally by members of the Group of Seven, such as J.E.H. MacDonald and

Lawren Harris. These are all standard Impressionist subjects that could be duplicated in France or the United States (though possibly not all in Slovenia!).

Then what characteristics, in fact, can be especially ascribed to Impressionism in Canada? I think, in fact, that the answer lies precisely there. That is, the Canadians, perhaps not when painting in France or elsewhere abroad, including the United States, but when in their native land, were far more involved with the rugged and the wild, indeed, often with wilderness itself. While painters such as C.W. Jefferys and L.L. FitzGerald explored and even glorified the unending prairie land of central-western Canada in a series of major canvases, very few of their Southern neighbors—Harvey Dunn and Charles Greener in South Dakota, and John Noble and Birger Sandzén of Nebraska come to mind—emulated them in applying Impressionist strategies in depicting the Great Plains. The characteristics of winter—lowering days, heavy snow, and ice—are of course more a fact of life in Canada than in more southern climes, and winter scenes, though ubiquitous in Canadian Impressionism, are hardly unknown in the United States. But the Canadians recognize the realities of winter in their pictures, whether landscapes or cityscapes. Life moves with difficulty in Morrice's winter, and ships are icebound in Cullen's pictures. And Cullen, Gagnon, and especially Suzor-Coté present us with the wilderness itself in Impressionist terms, a theme which the painters from the U.S. rejected as part of the baggage of the old Hudson River School. Suzor-Coté evokes, in fact, for his most prevalent images—the light-reflecting stream winding through an empty landscape of purple-toned snow—no French exemplar at all, but rather the then-tremendously popular Norwegian Impressionist, Fritz Thaulow.

The Scandinavian connection is key here, I think, to the distinctiveness of Canadian Impressionism, not only for Suzor-Coté's pictures but also those of the Group of Seven, many of whom—Harris, Lismer, MacDonald, and Jackson especially—also painted wilderness scenes, for a while at least in an Impressionist manner, and for whom contact with Scandinavian art at the Albright Art Gallery in Buffalo in 1913 was significant. Not that any of these works—not even Harris's pictures especially inspired by those of the Swedish painter Gustaf Fjaestad—could be confused with Scandinavian Impressionism. Rather, they are Impressionist paintings that are also very Canadian.

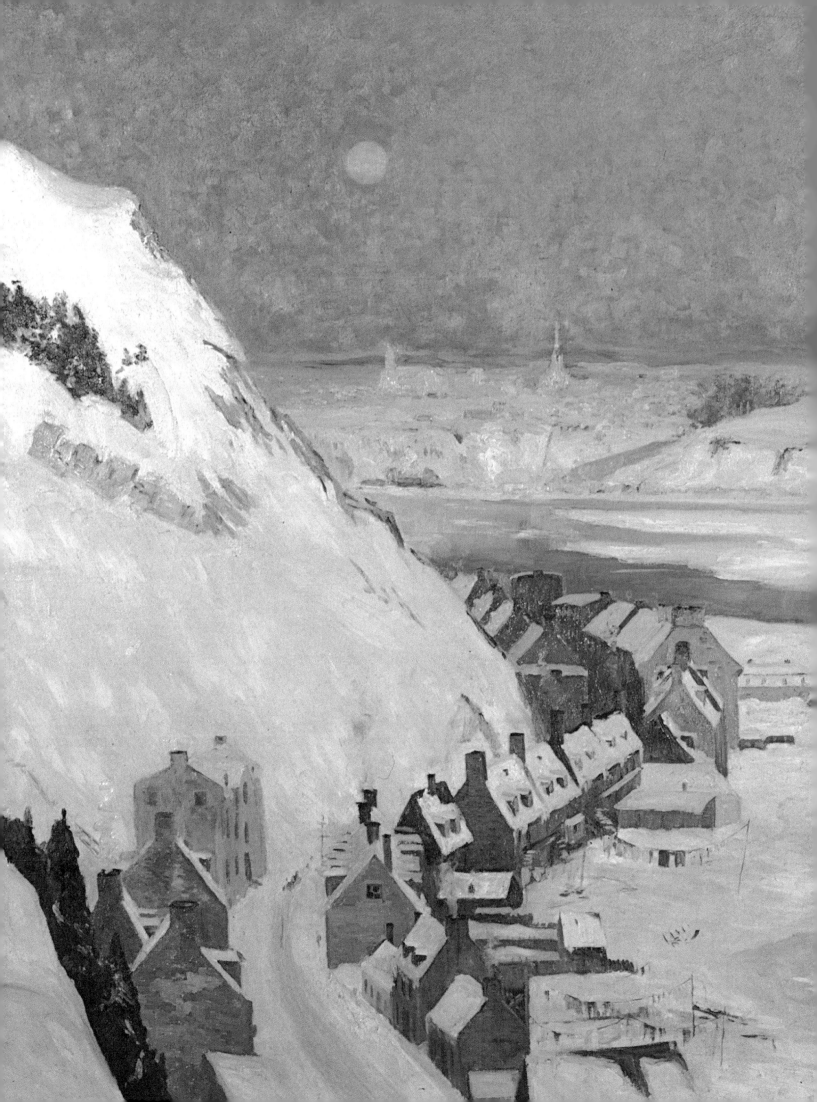

INTO LINE WITH THE PROGRESS OF ART[1]

The Impressionist Tradition in Canadian Painting, 1885–1920

CAROL LOWREY

IN AN ARTICLE APPEARING in the June 1901 issue of *Canadian Magazine,* the critic Margaret Laing Fairburn provided readers with a summation of Canada's artistic development during the previous decade. As well as discussing advancements pertaining to collecting, art education and exhibitions, Fairburn also noted that "Somewhere during the last ten years the movement, known as 'impressionism,' first showed itself here."[2] She went on, stating that

> Though adversely criticized and spoken of as a 'craze' or 'fad,' it was something of far more importance. While we read of these wild vagaries abroad our home painters kept on in the good old way...with no distracting or startling note. Then came one and another of these canvases from abroad, or from those who had been—vague, hazy and unreal, they appeared to some, while to others they seemed visions of light and air, of sunshine and out-of-doors. Those violet shadows and crude greens were certainly peculiar, the streaks and blobs of raw colour difficult to understand. It was all very bewildering and the wise shook their heads. But by and by the most knowing were aware that in these canvases there was no attempt to paint things as they are, but as they appear, and that, in spite of its exaggerations and eccentricities, the *plein-air* work held a truth and had come to stay.[3]

Fairburn's commentary underscores Impressionism's role in the development of a modernist tradition in Canadian painting. With its emphasis on an intimate and highly subjective interpretation of Nature, on conveying the tran-

Maurice Galbraith Cullen
Cape Diamond, detail, 1909

sitory effects of light and atmosphere with a heightened chromaticism and loose brushwork, and on the portrayal of contemporary life, Impressionism constituted the first stage of modernism in Canada, serving as a vital link between nineteenth-century academicism and the work of the nationalist landscape painters known as the Group of Seven.[4]

Visions of Light and Air: Canadian Impressionism, 1885–1920 demonstrates the various degrees to which Canadian painters adopted Impressionist strategies at the turn of the century. As recent scholarship has revealed, Impressionist painting was not restricted to France, the country of its origin; rather, the New Painting was international in scope, attracting the attention of artists from around the globe.[5] In Canada, the Impressionist tradition was not so much a movement *per se,* but a group of diverse painters responding to the aesthetic each in his or her own distinctive way. Orthodox Impressionism, which involved the dissolution of form and which is usually associated with the work of Claude Monet, was as rare in Canada as it was in the United States; formal responses varied from artist to artist and, in many instances, were tempered by the artist's commitment to academic ideals, as well as by his or her subject matter.

The project presents a variety of interpretations of the Impressionist aesthetic, ranging from the cool winterscapes of Maurice Cullen and the brilliant figure paintings of Helen McNicoll, to the bold, vigorously painted canvases of Tom Thomson, David Milne and Emily Carr, whose work encompassed aspects of both Impressionism and Post-Impressionism. The exhibition also includes examples of work by academic figure painters such as George Agnew Reid, whose Impressionist experiments were influenced by a continuing allegiance to traditional precepts of form and structure.

Visions of Light and Air also reveals the thematic parameters of the Canadian Impressionist tradition. A number of works in the exhibition were painted abroad, primarily in France, where most Canadians made their initial forays into Impressionist light and color. A few of these artists, such as William Blair Bruce, James Wilson Morrice and Helen Galloway

McNicoll remained true cosmopolites, chosing to remain in Europe while retaining intermittent contact with the Canadian art world through visits and exhibition activity.

However, as William Colgate has pointed out, the "liberating influence" of Impressionism "turned the thoughts of the Canadian painter to the pictorial possibilities of his own land."[6] Accordingly, repatriated artists such as Cullen, Marc-Aurèle Suzor-Coté and A.Y. Jackson applied Impressionist techniques to native subjects, creating a fresh, vivid conception of the Canadian landscape and establishing the modernist basis that would give rise to the Group of Seven. Although depicting the contemporary scene was not new to Canadian art, the period also saw a greater degree of involvement with themes relating to modern life, evident, for example, in the streetscapes and industrial images of Lawren Harris and J.E.H. MacDonald, and in the figural work of a number of accomplished women painters, such as Frances M. Jones Bannerman, Henrietta Mabel May, and the aforementioned McNicoll. Canadian artists turned to Impressionism as a means of conveying the essence of their own time and place and, in so doing, they produced some of the most important and engaging images in the history of Canadian art.

Although such artists as Robert Pilot and Frederick Hutchinson carried the Canadian Impressionist tradition well into the 1930s and 1940s, *Visions of Light and Air* focuses on the period 1885–1920, when the aesthetic had its greatest impact on Canadian painters. The cut-off date coincides with the official formation of the Group of Seven, whose preoccupation with the development of a "national" school of landscape painting, based on the depiction of the rugged north country, instigated a new, programmatic direction in Canadian art.

Intended as an overview of the subject, *Visions of Light and Air* will, it is hoped, prompt more detailed studies of particular issues, and of artists whose careers are in need of further documentation. The exhibition will also serve to introduce this body of work to an American audience, while re-acquainting Canadians with the accomplishments of this talented and disparate group of painters.

FIG. 1 William Brymner (1855–1925), *A Wreath of Flowers*, 1884, oil on canvas, 48¼ × 51¼ in. (122.5 × 142.7 cm.), National Gallery of Canada, Ottawa.

Canadians Abroad: The French Connection

The years between Confederation and the beginning of the first world war (1867–1914) constitute the most cosmopolitan period in Canadian art, a time when many native artists began to look to Paris for aesthetic inspiration and cultural validation. As noted by Robert Gagen, the French art seen at the 1876 Philadelphia Centennial Exhibition "opened the eyes of many to the fact that they were behind the times, and was the cause of so many ambitious young men both in the U.S. and Canada, taking advantage of the admirable system of education in the schools of Paris."[7] Spurred on by a desire to enter the international mainstream, Canadian painters gravitated to Paris to supplement their training at the prestigious École des Beaux-Arts or at one of the private art schools, particularly the Académie Julian, whose lack of language requirements and rigorous entrance examinations contributed to its popularity among anglophone art students.[8]

Canadians first became aware of the artistic innovations associated with contemporary French painting during the mid-1880s, when critics began to comment on the stylistic changes appearing in the work of William Brymner (FIG. 1), Robert Harris, James Kerr-Lawson and other Canadians trained in France. While abroad, these artists had adopted a more advanced style inspired by Jules Bastien-Lepage, the popular French *pleinairist* who lightened his palette and loosened his brushwork in response to Impressionism but retained a naturalistic rendering of the figure, usually in conjunction with sentimental peasant themes. While some commentators readily accepted the change from mid-century realism to *plein-air* naturalism, others were more hesitant about the foreign-begotten style, including the Scottish-born painter and teacher William Cruikshank, who deemed the work "clever, but too Frenchy."[9] Critical response aside, what was important was the fact that these "academic progressives" established the precedent for foreign study and for the assimilation of modern styles that would be taken up by a younger generation who would, in turn, bring Impressionism back to Canada.[10]

In Parisian art schools, Canadians dealt with what was essentially an academic curriculum based on the study of the figure. Classes, conducted by the likes of Jules-Joseph Lefebvre, Benjamin Constant and Jean-Léon Gérôme, emphasized traditional precepts of solid draftsmanship, meticulous detail, a realistic depiction of the figure and, depending on the instructor, high finish.[11] The tenets of Impressionism—heightened color, fluid brushwork, and an emphasis on the momentary—were expressed primarily through landscape painting and were thus absorbed through experiences outside the classroom.

In Paris, Canadians could view French Impressionist and Post-Impressionst work first-hand, at commercial galleries and at the annual salons, including the more avant-garde Salon d'Automne and the Salon des Indépendants. With the exception of an exhibition of French Impressionist painting held at Montreal's W. Scott & Sons in 1892, Canadians had few opportunities to view examples of the New Painting in Montreal and Toronto, collectors preferring the muted canvases of the Barbizon and Hague Schools instead.[12] Although Impressionism and other vanguard movements received first-rate coverage in

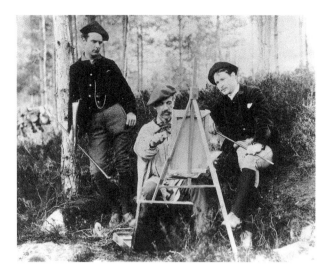

FIG. 2 William Blair Bruce (at right) and Theodore Robinson (seated), Giverny, France, 1887 [?]. Courtesy of Mrs. R.H. Dickson, Burlington, Ont. Joan Murray Papers, William Blair Bruce Archives, The Robert McLaughlin Gallery, Oshawa, Ontario.

the short-lived Montreal art magazine, *Arcadia* (1892–93), Canada's periodical press paid scant attention to the movement during the 1880s and early 1890s, and when it did, the style itself was often misunderstood by critics.[13]

In addition to studying Impressionist pictures on their own, Canadians in Paris made sketching trips to the French countryside, eventually abandoning Bastien's naturalism in favor of an aesthetic of light and color. Since Parisian art schools provided a common meeting ground for artists of varied nationalities, Canadians found themselves experimenting with Impressionist strategies along with American, British, German, Italian, and Scandinavian painters, as well as with their fellow countrymen. In fact, Canadians learned just as much, if not more, from looking at each other's work, and that of their international counterparts, as they did from French Impressionist paintings. William Blair Bruce and the American, Theodore Robinson, for example (FIG. 2), turned to Impressionism while working together in Giverny during the late 1880s, while James Wilson Morrice went on sketching trips with the American painters Robert Henri (FIG. 3), William Glackens and Robert Henry Logan, and with the Australian Impressionist Charles Conder. Both John Sloan Gordon and A.Y. Jackson were involved with the art colony at Etaples,

where they fraternized with a number of American Impressionists from the Midwest, including Myron Barlow and Roy Brown. Impressionist precepts were also disseminated through contacts with other Canadians: Maurice Cullen and Bruce were in regular touch in Paris and at Grèz-sur-Loing during 1892–94, while Morrice is known to have introduced fellow Montrealer Clarence Gagnon and the Newfoundland-born Maurice Prendergast to his practice of sketching on small-scale wooden panels during visits to Normandy beach resorts (a method Morrice borrowed from Henri).

Certainly, not all Canadians arrived at Impressionism *via* the French connection: a few, such as Helen McNicoll, studied in England, assimilating Impressionist precepts through contact with British artists. Although a later generation of Canadians adopted Impressionist methodologies independent of France, they did so at a time when the aesthetic was already fairly well-established in Canada, giving them the opportunity to see Impressionist work in Montreal and Toronto, at the annual exhibitions of the Royal Canadian Academy, the Art Association of Montreal, and at the Canadian Art Club. By the early 1900s, Impressionist precepts were also being disseminated in art schools and outdoor painting classes in Montreal, Toronto, Hamilton, Halifax, and Winnipeg. For many second- and third-generation Canadian Impressionists, travel and/or study in the United States, particularly New York and Boston, also provided valuable exposure to American Impressionism and to other international manifestations of the aesthetic, including that of Scandinavia.[14] However, of those Canadians who adopted Impressionism before 1910, the majority did so in France.

While Frances Jones Bannerman, whose work is discussed later in this essay, was producing Impressionist-inspired paintings as early as 1882, William Blair Bruce was really the first Canadian to employ the high-keyed colorism and broken brushwork associated with Impressionism. A figure and landscape painter, Bruce had worked outdoors in Grèz and Barbizon during the early 1880s, emulating the academic naturalism of Bastien-Lepage, an approach that proved successful when his *Temps Passé* (1884; Owens Art Gallery,

Mount Allison University, Sackville, N.B.) was favorably reviewed at the 1884 Salon.

In the summer of 1887, Bruce was among the group of North American painters who established an art colony in Giverny, a small agricultural village located on the Seine about forty miles northwest of Paris.[15] Although Bruce and his cohorts claimed they were drawn to Giverny because its rural setting was conducive to painting outdoors, the presence of Claude Monet, who settled there in 1881, probably contributed to their decision as well.

Writing to his family back in Hamilton, Ontario, Bruce deemed Giverny "far ahead of Barbizon in every respect," and remarked: "I get up at four or five these summer mornings and…proceed to paint in the open air."[16] After exploring Giverny's misty atmospheric effects in several transitional oils, such as *Rain in Giverny* (private collection), Bruce converted to the brilliant hues and fluid brushwork of Impressionism, probably before any of his American colleagues. In works such as *Landscape with Poppies*

(PLATE 3), which features a view of Les Bruyères, the crest of hills that rises up directly behind the village, Bruce captures the effects of dappled sunlight with verve and spontaneity.[17] The landscape concerns that preoccupied the first-generation American Givernois are also revealed in Bruce's *The Rainbow* (PLATE 4) and in *Giverny France* (PLATE 2). Painted from Les Bruyères, *Giverny, France* features a panoramic view of the Seine Valley with the town of Vernon in the distance, a motif that was explored in serial form by Robinson a few years later. Bruce continued to paint Impressionist works into the 1890s, often in conjunction with the figure. He eventually turned to a more subdued coloration, producing a series of evocative marines in which he explored the play of sunshine and moonlight on water.

Following his marriage in 1888 to the wealthy Swedish sculptor Caroline Benedicks, Bruce divided his time between Paris and Grèz-sur-Loing and travelled extensively before settling in Visby, on Sweden's Gotland Island, in 1899. This, coupled with the fact that he rarely exhibited in Canada, meant that he had little impact on the development of Impressionism back home. However, he did have contact with a number of Canadians who came to Paris to study, including Maurice Cullen, who arrived in the French capital in the fall of 1888, continuing his training at the Académies Colarossi and Julian and at the École des Beaux-Arts.

Cullen seems to have adopted Impressionism relatively quickly: by 1891, the *Courrier du Canada* noted, in reference to two paintings he exhibited at the American Student Association, "M. Cullen penche plutôt vers l'école impressioniste."[18] Extant works from this period include several broadly painted marines produced between 1890 and 1892, two of which Cullen presented as gifts to Bruce (Brucebo Foundation, Gotland), whom he met in Paris in 1892. As Joan Murray has pointed out, the luminous blues, pinks and mauves appearing in Bruce's marines and moonlit nocturnes were taken up by Cullen later in his career, as is evident in such works as *Cape Diamond* (PLATE 25).[19]

From there, Cullen quickly moved toward a greater concern with light and color, as revealed in

FIG. 3 James Wilson Morrice (1865–1924), *Portrait Sketch of Robert Henri*, 1896, oil on canvas, 23 3/4 × 18 in. (60.3 × 45.7 cm.), General Purchase Fund, London Regional Art Gallery, 60.A.44.

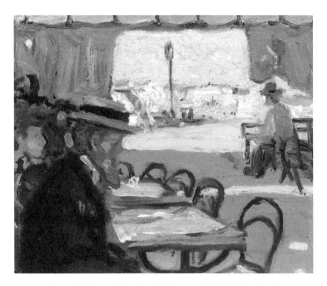

Biskra (PLATE 7), painted during a trip to Algeria in 1893. Employing a palette dominated by vivid blues and yellows, Cullen captures the dazzling light of the Mediterranean reflecting off water and sand. Although Cullen employs the bright colorism of Impressionism, his concern for the effects of intense sunlight reflected off solidly rendered forms is also related to the "glare aesthetic," which involved the study of outdoor light in conjunction with an emphasis on deep shadows and firm draftsmanship.[20]

Cullen's interest in conveying ephemeral light effects on water is fully realized in *Moret, Winter* (PLATE 8), notable for its carefully designed composition, spontaneous brushwork and luminous palette of pinks, blues and purples. Perhaps his finest French canvas, and one that comes closest to the French version of Impressionism, *Moret, Winter* anticipates the snowscapes Cullen would paint upon returning to Quebec, where he would emerge as the quintessential Canadian Impressionist.

Although a few Canadians, such as Bruce and Clarence Gagnon, achieved critical and commercial success in Paris, only one—the expatriate painter James Wilson Morrice—enjoyed a sustained international reputation. Having abandoned a prospective law career to become an artist, Morrice studied at the Académie Julian around 1889–90, where he met both Prendergast and Conder.[21] He also worked briefly under the Corot-inspired landscapist, Henri Harpignies. During these early years abroad, Morrice was active in Dieppe, Saint-Malo, Dinard, and other towns on the Channel coast, where he painted small, spontaneously rendered oils. In 1895 he met Henri, Glackens and Logan and, through Henri's example, began making sketches on small wooden panels which he often translated into large canvases in his studio.

Morrice returned to Montreal in November 1896, remaining in Canada until the early spring of 1897, during which time he worked outdoors with Cullen at Sainte-Anne-de-Beaupré. Having returned to France in the early spring of 1897, he resumed painting Parisian subjects, while making frequent trips to resort towns on the Brittany and Normandy coasts, painting scenes of holiday life, such as as *Beneath the Ramparts* (PLATE 14). In these, he employed the light palette and fluid technique of Impressionism while treating his forms as flat color-patterns in the manner of the Nabis.[22] The Nabis influence is also evident in his various versions of *Quai des Grands Augustins* (PLATES 15–16), although in the painting purchased by the French Government for the Luxembourg Museum (now the Musée d'Orsay, Paris) Morrice abandons the bright colors of *Beneath the Ramparts* in favor of a tonal Impressionism involving soft, muted colors and a thin paint application. The inspiration here is obviously that of James McNeill Whistler, whose work was in vogue among many North American artists in Paris at the turn of the century.

Of all the Canadians in France, it was Morrice who most consistently celebrated the pleasures of modern life, inspiring the comment that "One always feels that he does his paintings on a Sunday afternoon."[23] His canvases and sketches, rarely unpeopled, possess a festive air and a mood of optimism reflecting his own love of life. Independently wealthy, with a sophisticated cosmopolitan outlook and a somewhat eccentric personality as well, Morrice immersed himself in café society, fraternizing with an international coterie of artists and literati that included Somerset Maugham, Arnold Bennett, Stéphane

Mallarmé, Paul Verlaine and Henri Matisse. Morrice's *Circus, Montmartre* (PLATE 18) underscores his penchant for depicting the joyous side of contemporary urban life. In terms of style, subject matter and compositional design, the painting suggests the impact of Morrice's friend, the British Impressionist Walter Sickert. His European haunts also included Madrid, which he visited in 1903, as well as Venice, one of his favorite paintings spots. Indeed, Venetian scenery, ranging from canals, lagoons and cafés (FIG. 4) to the Doge's Palace, Saint Mark's and the *Church of San Pietro di Castello* (PLATE 17), served as a major thematic interest for Morrice, to the extent that he became the foremost Canadian interpreter of Venetian light and life.

As the selection of paintings in this exhibition indicates, Morrice synthesized a range of contemporary sources, evolving a distinctive and highly personal interpretation of Impressionism that inspired one critic to note that he did "not rebel against tradition yet is in agreement with his period.... He is independent without being revolutionary, and he belongs to no narrow sect or coterie."[24] Morrice was the only Canadian included in Charles Borgmeyer's article, "The Master Impressionists," the author claiming that while not a

> master Impressionist, he is a legitimate successor of theirs. Not that he decomposes his tones, or uses the 'comma' of Claude Monet.... He is too personal for that. He is one of the few who know where to stop and still hold to the essentials.... Corot's saying, 'Art is made up of sacrifices; it is done with nothing and everything is there,' applies to the work of Morrice.[25]

After around 1909, Morrice's art took on a more structured approach and a heightened colorism stemming from his friendship with Matisse and the influence of Fauvism. Although Morrice made occasional trips back to Quebec until 1914 and contributed paintings to major exhibitions in Montreal and Toronto, he remained somewhat aloof from the Canadian art scene, due in part to a lack of support from Montreal critics, as well as disappointing sales. In contrast to the majority of his Canadian contemporaries, he remained committed to the expatriate lifestyle and to absorbing foreign influences, firm in his belief that "it is always France that produces anything sympathetic in art."[26]

Other Canadians who adopted Impressionism in France during the 1890s included Montrealers Henri Beau and Raoul Barré, as well as the multi-talented Ernest Percyval Tudor-Hart. Tudor-Hart attended Julian's and the École des Beaux-Arts (where his teacher, Gérôme, nicknamed him the "Young Canadian"), developing a bold, Impressionist palette during painting trips to Fontainbleau and Brittany.[27] By 1903 he was operating his own art school on the rue d'Assas in Paris, teaching color theory to a younger generation of artists that included Stanton MacDonald-Wright and Morgan Russell, the co-founders of American Synchromism.[28]

One of many Canadian women who felt the lure of Paris, Laura Muntz lived and worked in France from 1891 until 1898, during which time she painted sparkling portraits of women and children, drawing her thematic inspiration from the American Impressionist Mary Cassatt. John Sloan Gordon, from Hamilton, Ontario, made the most of his three-year sojourn in the French capital (1895–97) by absorbing the technical approach of French painters such as Henri Le Sidanier, Georges Seurat and Claude Monet. In addition to painting landscapes in Paris, Etaples and Martigues, Gordon, along with the New Orleans painter Trist Wood, launched a little magazine known as *Quartier Latin*, which "was sturdy enough to survive twenty-five issues."[29]

The Halifax-born painter Ernest Lawson had already studied with the American Impressionist, John Henry Twachtman, in New York and Cos Cob, Connecticut, before arriving in Paris in 1893. Lawson remained abroad until 1898, during which time he painted landscapes, including colorful views of Moret-sur-Loing, inspired, in subject if not style, by his meeting the French Impressionist Alfred Sisley.

Another Québécois who converted to Impressionism in France was Marc-Aurèle Suzor-Coté, who arrived in Paris in 1891. Over the ensuing years, he divided his time between Paris and Montreal, executing commissions for church decorations as well as

painting academic figure and historical subjects and Barbizon-inspired landscapes. His conversion to Impressionism took place during the summer of 1906 in Brittany, where he painted landscapes such as *Port-Blanc-en-Bretagne* (National Gallery of Canada, Ottawa). Although representative of a very conservative approach to Impressionist light and color, *Port-Blanc-en-Bretagne* nevertheless paved the way for the more innovative snowscapes Suzor-Coté would paint on his return to Canada a year later.

Clarence Gagnon and William H. Clapp, both former Brymner students, painted and sketched outdoors in the lower St. Lawrence region before arriving in Paris in 1904. A year later, Gagnon was painting brightly colored rural landscapes in the Seine Valley, in both Pont de l'Arche and Giverny.[30] Later, after coming into contact with Morrice, he turned his attention to beach scenes painted in resort towns along the Normandy coast. In works such as *Summer Breeze at Dinard* (PLATE 9), Gagnon explored transitory light effects and the movement of sunlight, water, and air, portraying his subject matter with fluent brushwork and translucent colors. His French canvases, especially works such as *Autumn, Pont de l'Arche* (1905; The Montreal Museum of Fine Arts), reveals the distinctive chromatic sensibility that would characterize his later renditions of picturesque villages of Quebec.

William H. Clapp studied for varying periods of time at the Académies Julian, Colarossi, and La Grande Chaumière, and shared a Montparnasse apartment with Montrealers Gagnon, Henri Hébert, and Edward Boyd. Two years later, he was painting Monet-inspired landscapes, primarily at Chèzy-sur-Marne. In 1907, Clapp visited Spain, painting sunfilled landscapes such as *A Road in Spain* (PLATE 6), which exemplifies the rich palette and lush painthandling that would inform Clapp's treatment of Canadian subjects, as well as his later work as a member of the Oakland, California-based Society of Six.

A.Y. Jackson, also a Brymner student, made trips to Paris in 1905 and 1907–09 and, by early 1910, was painting Impressionist-inspired landscapes in Sweetsburg, Quebec. Returning to France in 1911, accompanied by his friend and fellow painter, Albert

FIG. 5 Roy Brown (1879–1956), *Sapins et Peupliers aux Dunes*, oil on canvas, 32 × 39½ in. (81.28 × 100.33 cm.), The National Arts Club Permanent Collection, New York.

Robinson, Jackson painted in St. Malo, Paris, and throughout Brittany. He spent June to October of 1912 in Trépied, near Etaples. During an earlier visit to Étaples (May 1908–March 1909), a popular gathering place for Americans and Britons which offered "studios, models and hotels...a fishing fleet, sand dunes, and a bathing beach...," Jackson worked alongside such American painters as Max Bohm and Myron Barlow as well as Roy Brown, a fellow student at Julian's who was active in the colony from 1907 until 1912.[31]

Jackson's work from 1912 includes canvases painted in a loose, Impressionist manner, such as *Sand Dunes at Cucq* (1912; National Gallery of Canada, Ottawa). However, like Brown and a few other members of the Etaples colony (FIG. 5), he also developed a more decorative, Post-Impressionist style characterized by a brighter palette and textured surfaces, as revealed in *Assisi From the Plain* (PLATE 10), painted during a trip to Italy (October 1912–January 1913). Indeed, in a letter to Albert Laberge written from Assisi, Jackson declared he was "Still on the move, leaving the country a mess of palette scrapings behind me...the Futurists, Cubists and Post Impressionists are working feverishly and already the old Impressionist movement seems like ancient history in Paris."[32] *Assisi from the Plain* was

one of several Post-Impressionist works exhibited by Jackson and other artists at the 1913 Spring Exhibition at the Art Association of Montreal, prompting "shock" among local art audiences, including a reviewer for the *Montreal Witness*, who noted that "Immensity of canvas, screamingly discordant colors, and execrable drawing are the chief methods they have employed to jar the public eye."[33]

Although Emily Carr had studied at the California School of Design in San Francisco and at the Westminster School of Art in London, it was while attending Algernon Talmage's painting classes at St. Ives, Cornwall that she first began to paint outdoors. Certainly Talmage, who taught her that "there was sunshine in shadows," was instrumental in Carr's conversion to Impressionism; however, her style would begin to evolve beyond Impressionism when, in 1910, she received instruction in Paris from John Duncan Fergusson, a Scottish painter who "tempered the lessons of Matisse and Derain."[34] This was followed, in 1911, by outdoor painting classes in Crécy-en-Brie and St. Efflam conducted by Phelan Gibb, an English painter whose Fauvist tendencies contributed to Carr's continuing development as a colorist as well as her use of simplified forms and spontaneous paint-application. After working with Gibb, Carr moved on to Concarneau, where she attended watercolor classes conducted by the New Zealand-born painter Frances Hodgkins. Hodgkins's vigorous paint-handling, vivid palette and use of dark contour lines deeply influenced Carr's own Concarneau watercolors, which consisted of streetscapes bathed in summer sunlight as well as scenes of daily life.

Mabel May, a former Brymner student in Montreal, was among the final wave of Canadians to go to France. During 1912–1913 May visited galleries and museums in Paris, familiarizing herself with the work of French Impressionists such as Renoir, as well as that of Gauguin, Matisse, and van Gogh, and refining her skills in the depiction of light and atmosphere on a summer sketching trip to northern France, Belgium, and Holland. While Carr would apply her bold, vigorous style to the depiction of the Indian villages and forests of her native British Columbia, May returned to Montreal, where she established a notable reputation for her Impressionist streetscapes and outdoor figure subjects.

With the outbreak of war in 1914, the migration of Canadian artists to Paris came to a standstill. Although a few Canadians, primarily from Quebec, continued their training in the French capital in the post-war years, the aesthetic dialogue with France came to a close in 1920 with the official formation of the Group of Seven. However, for just over four decades, Paris had become the goal of those Canadian artists seeking advanced art education and opportunities for exhibition and patronage, stirred by a self-conscious knowledge that they were behind in '"art matters." There, through contact with modern French painting, as well as with artists from throughout Europe and North America, the majority of first- and second-generation Canadian Impressionists turned their attention to an aesthetic of light and air.

Impressionist Canada

With the exception of William Blair Bruce and James Wilson Morrice, most Canadian painters who worked in France returned home, usually to Montreal or Toronto, the two principal centers of artistic and cultural activity. Repatriated painters who adopted Impressionism abroad turned their attention towards the rendering of native scenery, celebrating not only its beauty but its unique local, or regional, character. As noted by C. Lintern Sibley, Canadian artists returning from France began to "discover their own country," translating into paint "the beauty of their own land, and the greatness, the memories, the dreams, and the sentiments of their own people."[35]

In the process of domesticating Impressionism, Canadian painters would certainly have been aware of the growing mood of nationalism that characterized Post-Confederation Canada, and the demand, on the part of critics and cultural commentators, for Canadian subject matter.[36] The preoccupation with conveying national and regional sentiment, in art as well as in literature, became a major concern of Canada's periodical press. Writers expounded on the issue in newspapers as well as in popular magazines of the day, especially in English-language publications

such as *Canadian Magazine* and *Saturday Night*. The development of a native iconography became especially vital when so many Canadians began to study and work abroad. Indeed, for anglophones in particular, foreign influence had become a source to be reckoned with, inspiring a wealth of commentary from the likes of cultural nationalists such as William Sherwood and J.A. Radford, as well as a critic for *Saturday Night* who, writing in July of 1889, questioned why so many Canadian painters felt the need to spend their summers in France.[37] This somewhat indignant commentator declared that it was

> a pity that more of our painters do not seem capable of utilizing some of the charming and powerful compositions which Canadian rural life affords.... There may be found men—all, square-shouldered, hard with toil and brown with the sun, who might pose for Hercules or Apollo.... These are subjects which would delight a master's eye and be worthy of a master's hand. American and Canadian painters in France wax enthusiastic over the picturesque peasant life of that country. If only they thought so, there are better pictures to be found in the country on this side of the water....[38]

For many Canadian Impressionists, interest in indigenous subject matter was also sparked by a heightened awareness of the special qualities of their own country—its topography, its people, its customs, and its climate. Many repatriated Canadians, having conducted their initial forays into Impressionism in France, also arrived home to discover the unique quality of Canadian light. Upon returning to Quebec from his second trip abroad in December of 1909, A.Y. Jackson declared that "After the soft atmosphere of France, the clear, crisp air and sharp shadows of my native country...were exciting."[39] Canada's distinctive light and atmosphere or, as Jackson put it, "good Canuck air," has also been discussed by the art historian Donald Buchanan, who identified a "touch of ruddiness in the atmosphere, especially on winter days."[40] Buchanan also noted that his European friends described their most memorable impression of Canada as being that "diffused

and pinkish light that is nearly always present in our snow-bound skies. One does not see it in the grayer atmospheres of northern or central Europe or in the clearer horizons of the Mediterranean."[41]

Although academic painters such as William Brymner in Montreal and George Reid in Toronto had been depicting Canadian scenery *en plein air* during the early 1890s, Maurice Cullen was really the first Canadian to interpret native landscape and light in an Impressionist manner. Following his return to Montreal from Paris in 1895, Cullen divided his time between Montreal and Sainte-Anne-de-Beaupré, a small village about twenty-two miles east of Quebec City on the north shore of the St. Lawrence. Working in and around Beaupré, Cullen used Impressionist strategies to develop a new conception of the Canadian winterscape, translating into paint his belief, stemming from earlier French pictures such as *Moret, Winter,* that "snow borrows the colours of the sky and sun. It is blue, it is mauve, it is grey, even black, but never entirely white."[42]

Cullen captures the effects of eastern Canada's "clear, crisp air" in many of his early Quebec canvases, one of the most revered of which is *Logging in Winter, Beaupré* (PLATE 24), which features a view of a *habitant,* or French-Canadian farmer, driving a team of oxen across snow-covered terrain. Although rendering the effects of chilly winter sunlight and frosty air are Cullen's primary aesthetic concerns, his incorporation of the figure in conjunction with the theme of labor, which appears in other Quebec canvases such as *The Ice Harvest* (PLATE 27), would serve to distinguish Quebec Impressionism from its Ontario counterpart.

While Cullen's Impressionist activity was focused, for the most part, on the depiction of the Quebec countryside, he also investigated themes related to modern urban and industrial life. Indeed, the years 1896 to 1914 were characterized by increased immigration and industrial growth, with Montreal, a major inland port located at the confluence of the St. Lawrence and Ottawa Rivers, emerging as the economic and cultural hub of Canada.

Cullen's Montreal subjects consist primarily of intimate views of well-known landmarks, such as *St.*

James Cathedral, Dominion Square, Montreal (PLATE 26), as well as ordinary streetscapes, among them *Old Houses, Montreal* (1909; The Montreal Museum of Fine Arts). *St. James Cathedral* demonstrates the range of Cullen's Impressionist style, for here he abandons the atmospheric clarity of *Logging in Winter* in favor of a tonal Impressionism based on a limited palette of pale mauve, pink and blue, while treating the horse-drawn *calèches* in the foreground as decorative, two-dimensional forms.

In *Montreal Harbour* (PLATE 28), Cullen pays tribute to the modern commercial growth of Canada's (then) principal city. Working within an expansive, horizontal format, he presents us with a panoramic view of the urban skyline with its complex profile of buildings, smokestacks, grain elevators, and church spires. Mount Royal, the city's most popular recreational area (whose park was designed by the American landscape architect Frederick Law Olmsted), can be seen in the distance. In this canvas, Cullen takes a highly evocative approach towards his subject matter, employing smooth brushwork and luminous colors to convey mood and poetic effect.

Cullen was also the foremost Impressionist interpreter of Quebec City, the provincial capital and the oldest settlement in North America, founded as a fur-trading post by Samuel de Champlain in 1608. Dramatically situated at a narrow point of the St. Lawrence River, with its Upper Town located on the massive, high cliff known as Cape Diamond (FIG. 6), Quebec's spectacular setting made it a natural subject for artists. It attracted the creative energies of early nineteenth-century British military painters as well as a later generation of professional Canadian artists, such as Joseph Legaré and Cornelius Krieghoff, the American painter Albert Bierstadt, and Canadian Impressionists including James Wilson Morrice and Clarence Gagnon (PLATE 31).[43] The majority of Cullen's Quebec pictures were painted in the winter months, including his large and impressive *Cape Diamond* (PLATE 25), which features a view of the steep cliffside that gave Quebec its nickname, "Gibraltar of the North," towering over the houses, shops and port nestled within the Lower Town (the site of the Champlain's first settlement or "*habitation*").[44]

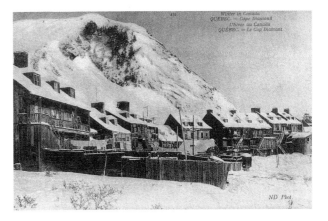

FIG. 6 Neurdein Brothers. *Winter in Canada. Québec-Cape Diamond*, 1907, postcard, Collection Yves Beauregard.

The 1892 exhibition of French Impressionist painting at William Scott's gallery notwithstanding, it was really Cullen who introduced Impressionism to Montreal art audiences. In December of 1896 he exhibited a group of his Canadian, European, and North African canvases in a rented storefront. The exhibition was duly noticed by local critics, prompting one writer to describe the artist as an "extreme impressionist" whose work would "give some a better idea of the Impressionist School than anything else seen here," while a commentator for the Montreal *Gazette* claimed that Cullen was "undoubtedly a pronounced Impressionist," his snow scenes being "unusually fine and very pleasing to the eye."[45]

In the ensuing years, Cullen's work would continue to be praised by local critics: a reviewer for the *Montreal Star*, writing in 1906, described him as "distinctively Canadian," one who "delights in a continued passage at arms with our curious atmospheric effects," and a year later, Margaret Fairburn claimed that "No Canadian painter has approached Mr. Cullen in his delineation of snow in sunshine."[46]

As the preeminent Canadian Impressionist, Cullen interpreted indigenous imagery in a fresh, exciting way, and in so doing exerted an important influence on his contemporaries, especially the future members of the Group of Seven. Arthur Lismer, for example, lauded Cullen's ability to combine "the impressionist mood with the Canadian spirit," while

A.Y. Jackson declared, "To us he was a hero. His paintings of Quebec City from Levis and along the river are among the most distinguished works produced in Canada."[47]

Unfortunately, despite the critical recognition acknowledging both his modernity and his ability to capture the spirit of place, Cullen found few patrons for his work; with the exception of Sir William Van Horne and a few other discerning individuals, Montrealers continued to focus their collecting activity on the more traditional Barbizon and Hague School painters and their Canadian followers.

Following Cullen's example, the expatriate painter James Wilson Morrice also portrayed Quebec subjects on his annual Christmas trips back to Montreal, working in and around Beaupré and Quebec City. As noted by Sylvia Antoniou, the crisply defined forms and bright coloration of Morrice's *Sainte-Anne-de-Beaupré* (PLATE 41) of 1897, were possibly inspired by *Logging in Winter, Beaupré,* which Morrice could have seen in Cullen's studio in December 1896.[48]

Morrice's later Canadian canvases, among them *Return from School* (PLATE 42), with its plunging perspective and animated brushwork, exemplify the tonal Impressionism he adopted during the early 1900s. Other Quebec scenes, such as the intimate *Canadian Square in Winter* (PLATE 43), which features the Del Vecchio house in Old Montreal portrayed behind a veil of gently falling snow, and *Pont de Glace sur la Rivière St-Charles (Ice Bridge Over the St. Charles River)* (PLATE 44), one of four pictures Morrice exhibited at the 1908 exhibition of the Sociétié nationale des Beaux-Arts in Paris, reveals his post-1905 practice of obtaining subtle color harmonies through a thin application of pigment, which was in turn rubbed down with a rag or cloth. Although Morrice's Canadian subjects convey aspects of modern life and regional scenery, his pursuit of indigenous subject matter was certainly not a forced issue; he simply painted what appealed to him, selecting his themes in accordance with his desire to explore color, line, and form, as well as light.[49]

The Impressionist iconography of Quebec was also enriched by second-generation Canadian Impressionists such as Clarence Gagnon, who returned to Canada from Paris in 1909, having established an international reputation as an etcher. After settling in Baie St. Paul, a picturesque village upriver from Quebec City in Charlevoix County, one of Québec's loveliest regions, Gagnon applied the lessons of Impressionism to his depictions of the local countryside. Works painted in the manner of *Winter, Village of Baie St. Paul* (PLATE 30) dominated the pictures featured in Gagnon's important one-man show held at Galerie A.-M. Reitlinger in Paris in 1913, his fresh chromaticism, fluent handling and subject matter conveying a sense of rural tranquility that Parisian audiences found particularly appealing. Gagnon's colorful snow scenes won praise from many Canadian critics, including a commentator for the *Montreal Daily Star*, who lauded their "mellowness and lusciousness of tone" and deemed them "characteristically national scenes."[50]

Returning to Montreal after study and travel in France and Spain, William H. Clapp transferred the vivid chromaticism of his European pictures to the depiction of rural Quebec, often in connection with themes of daily life and labor, such as picking fruit (PLATE 23). In *La Moisson* (PLATE 21), *Loading Lumber (Lumber Boats)* (PLATE 22), and other canvases, Clapp introduced Montrealers to his more innovative form of Impressionism and revealed his familiarity with the principles of optical mixture. Critical reaction to Clapp's Neo-Impressionist style was varied: one reviewer, for example, claimed that he was "still so strongly under the influence of the French impressionist school that he tries to out-Monet Monet," while a writer for the *Montreal Star* claimed his paintings "lacked depth."[51] Commenting on Clapp's contributions to the 1913 exhibition of the Canadian Art Club in Toronto, Hector Charlesworth described him as a "man of genuine talent with a real decorative sense," and in that same year, a commentator for the *Montreal Daily Witness* praised him as "one of the pioneers of a vivid impressionism," while noting the "sincerity and originality" of his work.[52]

Whether due to the mixed response to his style or the poor sales resulting from his 1914 solo exhibition at Montreal's Johnson Galleries, Clapp left Canada permanently in 1915, going first to Cuba, then to Oakland, California, where he became director of the

Oakland Museum and a member of the Society of Six, a group of Post-Impressionist landscape painters. While Clapp's American career has been thoroughly documented, his Canadian activity, which resulted in his most advanced work, deserves further scholarly documentation.

According to C. Lintern Sibley, Marc-Aurèle Suzor-Coté, who returned to Canada in 1907 after a lengthy sojourn in France, was in the "front rank" of the emerging "Canadian School."[53] Suzor-Coté settled in his native Arthabaska, a small town south of the St. Lawrence about halfway between Montreal and Quebec City, where he proceeded to paint landscapes and winterscapes, specializing in renditions of the nearby Nicolet River. Moving away from the rather conventional Impressionist style he used in France, he subsequently developed a more original aesthetic involving thick applications of paint, liberal use of the palette knife, and strong tonal contrasts (PLATES 46, 48) not unlike that of the Norwegian painter, Fritz Thaulow, as well as American Impressionists such as John Henry Twachtman and Edward Redfield. Suzor-Coté's ability to imbue his work with a subtle poetic abstraction is best exemplified in *Dégel d'avril* (PLATE 49), wherein his soft, iridescent colors and fluent paint handling convey the effects of shimmering winter sunlight on snow, while his abrupt cropping of the composition creates a strong sense of immediacy.

Numerous critics credited Suzor-Coté with contributing to the development of a distinctive Canadian iconography, including the frequently perceptive Hector Charlesworth, who remarked that his "work is so individual, so genuinely Canadian…as to delight all who aspire toward a national art."[54] In addition to his landscapes, Suzor-Coté also produced a number of boldly colored, Post-Impressionist renditions of *courier de bois*, as well as *Fire in the Port of Montreal* (PLATE 47), a rare excursion into urban imagery for an artist whose subject matter was derived largely from his immediate rural environment.

In 1908 Albert Robinson moved from his native Hamilton, Ontario to Montreal, where he proceeded to paint views of the local harbor, as well as park and street scenes, among them the loosely handled *Fletcher's*

FIG. 7 Albert H. Robinson (1881–1956), *Fletcher's Field*, circa 1910–12, oil on canvas, 12 ¼ × 14 ¼ in. (31.0 × 36.0 cm.), National Gallery of Canada, Ottawa, Gift of Leanora D. McCarney, Hull, Quebec, 1993.

Field (FIG. 7), wherein city dwellers partake of the pleasures of urban parkland—the landscape within the city. After the first world war, the summary execution of Robinson's early paintings gave way to a more structured aesthetic. In *Montreal Fruit Seller* (PLATE 45) he employs a subtle Impressionist palette while applying paint in a divisionist manner, emulating, to some extent, the example of his former teacher, John Sloan Gordon.

Although he remained in France for many years, Ernest Percyval Tudor-Hart painted Impressionist renditions of Quebec during visits home. In *Springtime, Canada* (PLATE 51), which features a female figure reading within a sunlit country setting, he combines the vivid realism and solid draftsmanship of Edouard Manet and his own teacher, Jean-Léon Gérôme, with a distinctive palette comprised of high-keyed greens, yellows, pinks and blues.

While Impressionism had gained a foothold in Quebec by the late 1890s, due largely to the accomplishments of Cullen, it did not really acquire any momentum in Ontario until well after 1900, and when it did, its lifespan was relatively brief. Impressionism in Ontario had its beginnings in the *plein-air* experiments of George Agnew Reid, exemplified in works from the early 1890s, such as *Idling* (PLATE 63).

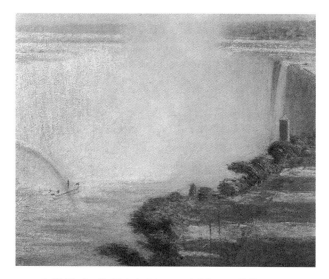

FIG. 8 Phillip Leslie Hale (1865–1931), *Niagara Falls,* 1902, oil on canvas, 35 × 41¼ in. (88.9 × 104.77 cm.), Courtesy of Spanierman Gallery, New York.

Other turn-of-the-century Toronto painters, among them Farquhar McGillivray Knowles and his wife, Elizabeth, George Reid's wife, Mary Heister, and Clara Hagerty, were also conducting similar investigations into Impressionist strategies. However, as Dennis Reid has pointed out, these artists viewed their "artistic modernity in a more broadly based Aestheticism."[55] The Impressionist tradition in Ontario did get a boost when John Sloan Gordon returned from Paris and settled in Hamilton, a mid-sized industrial city on the western end of Lake Ontario about fifty miles west of Toronto. Inspired by the example of Le Sidanier, Monet, Seurat and other French painters whose work he saw in Paris during 1896-97, Gordon evolved an advanced Neo-Impressionist technique which he used in his various depictions of regional scenery.

Gordon painted in and around Hamilton and in his home-town of Brantford, Ontario. He was also the only Canadian Impressionist to explore the aesthetic potential of nearby Niagara Falls (PLATE 32). A few of his American counterparts, notably John Henry Twachtman and Philip Leslie Hale (FIG. 8), were also drawn to Niagara; however, by the late nineteenth century the site had lost its appeal for most painters. While mid-century landscapists found Niagara a perfect subject for conveying a sense of awe and grandeur, Impressionist painters generally avoided this famous natural wonder, seeking the more intimate corners of nature instead.

Whereas Montrealers had the opportunity to view French Impressionist paintings at the gallery of William Scott and became increasingly familiar with the aesthetic when Cullen's work began to appear in local exhibitions during the late 1890s, Torontonians were not really exposed to Impressionism until 1908, when the Canadian Art Club held its inaugural exhibition. Founded in 1907 by the painters Edmund Morris and Curtis Williamson, the Canadian Art Club served as an alternative exhibition organization for Canada's more progressively-minded artists, who had become disenchanted with what they deemed to be the "provincialism" of the work shown at the annual exhibitions of the more established Ontario Society of Artists.[56] The Club's members, most of whom were foreign-trained, also sought to promote the work of expatriate painters such as James Wilson Morrice, who thus far had shown little interest in exhibiting in Toronto. Until the organization's demise in 1915, its exhibitions featured the work of Barbizon-inspired painters such as Morris, Williamson, and Horatio Walker, as well as that of Impressionists from Montreal, namely Cullen, Clapp, Gagnon and Suzor-Coté. The American-born, Ottawa-based Impressionist Franklin Brownell also exhibited many of his Caribbean subjects at the Club (PLATE 1), while Morrice's contributions consisted of European scenes and Canadian canvases such as *Return from School* (PLATE 42). The Canadian-born Ernest Lawson, who by this point had emerged as one of New York City's most prominent Impressionist painters, exhibited views of Manhattan (PLATE 12) and New England, as well as several colorful floral subjects similar to *Garden Landscape* (PLATE 11).

The Impressionist paintings shown at the Canadian Art Club would certainly have provided further impetus for J.E.H. MacDonald, Arthur Lismer, and Lawren Harris, all future members of the Group of Seven. MacDonald developed a familiarity with Impressionism through reproductions of paintings in art magazines, and presumably would have seen examples of French and British Impressionist painting

while living in London from 1903 until 1907. After leaving his post at the Grip Engraving firm in 1911 to paint full-time, he began sketching in High Park, a broad expanse of rolling landscape in Toronto's west end that even today offers a respite from the city's increasingly busy streets. MacDonald subsequently produced a number of major oils of High Park including *Edge of a Town: Winter Sunset, No. 2* (PLATE 39), capturing the patterns of late-afternoon sunlight and shadow on snow by means of a lucent palette and rhythmic brushwork. Although figures stroll through the park, enjoying the distant view of downtown Toronto, MacDonald's real concern is on rendering the topography of the park rather than on depicting its pleasures.

Considering MacDonald's overriding preoccupation with landscape subjects, *Tracks and Traffic* (PLATE 38) remains unique in his work, representing his sole excursion into industrial urban imagery. Painted in Toronto in 1912, *Tracks and Traffic* features a view of the Grand Trunk Railyards and Bathurst Street in winter. In addition to demonstrating MacDonald's skills in conveying the ephemeral nature of light, air, smoke and steam, this painting stands as a Canadian analogue to the urban/industrial images of French Impressionists, notably Monet's Gare Saint-Lazare series and, at the same time, underscores the modern commercial growth of Toronto during the early twentieth century.

While images of the floral environment figure prominently in the American Impressionist tradition, depictions of flower gardens are rare in Canadian Impressionism. MacDonald was one of only a few Canadians who painted outdoor floral subjects in conjunction with his domestic surroundings. Upon moving to Thornhill, a village north of Toronto, in 1913, MacDonald cultivated his own flower and vegetable garden, which he portrayed in works such as *Asters and Apples* (PLATE 40) and *The Tangled Garden* (1916, National Gallery of Canada, Ottawa). The bright colors and bold brushwork in *Asters and Apples* would form the aesthetic basis of his later wilderness landscapes.

Arthur Lismer, MacDonald's fellow employee at the Grip Engraving firm in Toronto, also explored

Impressionist precepts before turning to a more structured Post-Impressionist manner. Trained in his native Sheffield, England (1898–1905) and at the Académie des Beaux-Arts in Antwerp (1906–07), Lismer had the opportunity to view Impressionist painting on trips to London and Paris prior to emigrating to Canada in 1911. He subsequently sketched in and around Toronto with Tom Thomson, another Grip employee, and in 1913 he made his first painting trip to Georgian Bay in 1913. *The Guide's Home* (PLATE 37), his most eloquent Impressionist statement, was painted the following year in Algonquin Park, an area of dense woodland, lakes, and rivers in mid-northern Ontario. The view itself is intimate and unpretentious, featuring a sun-dappled shack belonging to two guides, surrounded by tall birch trees. Lismer depicts his subject matter with loose, flickering brushwork, creating lively surface effects as well as capturing the nuances of light and shadow on the landscape. The sense of movement and animation that pervades *The Guide's Home* is enhanced by the intricate play of complementary colors, cool blues and mauves being skillfully juxtaposed with contrasting tones of yellow and orange.

Although his interest in urban themes would eventually give way to landscape imagery, Lawren Harris painted a series of important Impressionist canvases depicting the rowhouses of "The Ward," a neighborhood of largely Jewish immigrant families in central Toronto, as well as views of industrial sections of the city. In contrast to the majority of his contemporaries, who acquired their knowledge of current art trends by going to France or the United States, Harris took a different route, studying in Berlin from 1904 until 1907. In addition to working under the realist painters Fritz von Wille, Adolf Schlabitz and Franz Skarbina, Harris familiarized himself with modern German and European art through visits to local galleries and museums, including the exhibitions of the Berlin Secession, where he saw work by German Impressionists such as Max Liebermann, and by French Post-Impressionists, including Gauguin, Cézanne and van Gogh.

Harris's urban and industrial images reflect the impact of Skarbina and Liebermann, both of whom

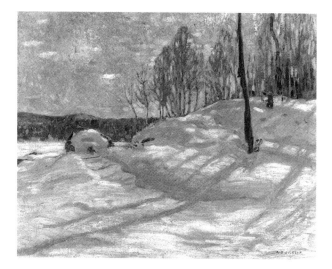

FIG. 9 Alexander Young (A.Y.) Jackson (1869–1952), *Near Canoe Lake,* 1914, oil on canvas, 25 3/8 × 32 in. (64.5 × 81.7 cm.), Art Gallery of Hamilton, Gift of J.M. Cunningham, Esq.

depicted working-class Berlin.[57] In *The Eaton Manufacturing Building from the Ward* (PLATE 33), Harris portrays the Number 4 clothing factory belonging to the Timothy Eaton Company, one of Canada's leading retail firms, with flagship stores in major Canadian cities as well as a flourishing catalogue business.[58] The "modern" Eaton building, approximately twelve stories high, looms both physically and psychologically over a number of older, low-lying cottages belonging to immigrant workers (many of them employees of Eatons). While the upper half of the Eaton structure is veiled in an atmospheric envelope of golden late-afternoon sunlight, the fore- and middleground areas are covered in shadow, prompting Harris's use of muted grays and browns as well as various earth-tones.

In *The Eaton Manufacturing Building from the Ward* and in *The Gas Works* (see FIG. 7, p. 66), Harris combines elements of Impressionism and Realism. However, in his "house portraits," he took a more decorative approach, often employing the emphatic brushwork of van Gogh or, as in *Hurdy-Gurdy* (PLATE 34), a more delicate, Impressionist-inspired technique. *Hurdy-Gurdy,* a portrayal of rowhouses bathed in a soft, autumnal light, stands out among Harris's Toronto streetscapes for its gentle lyricism. Here, Harris conveys the myriad fluctuations of light and atmosphere by means of fine, pointillist brushwork and a sumptu-

ous palette dominated by warm golds and russets, with contrasting shades of mauve and blue.

Harris's interest in two-dimensional pattern, first seen in his urban subjects, would culminate in his wilderness snowscapes, painted in Ontario's Georgian Bay and Algoma districts. In *Winter Sunrise* (PLATE 35), he employs broad, divisionist brushstrokes and a vivid chromaticism to transform an ordinary grove of snow-covered spruce trees into a rich tapestry of color, line, and form. Influenced by European Post-Impressionism, as well as by the exhibition of Scandinavian painting he saw at Buffalo's Albright Art Gallery in January of 1913, where he was captivated by the stylized snowscapes of Gustaf Fjaestad, *Winter Sunrise* exemplifies the nature-based imagery that would characterize the work of the Group of Seven. Although the painters affiliated with Canada's "official" landscape school would embrace a bold, Post-Impressionist aesthetic, they arrived at their signature styles by way of Impressionism. As Harris later wrote to the author Paul Duval, "Impressionism affected all of us. It took us out of doors in the early years and for most of our lives as painters we remained there."[59]

In contrast to his artist friends at Grip, Tom Thomson did not study in Europe; rather, his exposure to Impressionism came from reproductions in art periodicals and, most importantly, from his contact with Harris, Lismer, MacDonald and especially A.Y. Jackson, who moved to Toronto from Montreal in the fall of 1913. Indeed, both artists shared space in the new Studio Building on Severn Street and it was there that Jackson passed on his knowledge of vanguard European painting to Thomson who, in turn, informed Jackson about the pictorial potential of northern Ontario (FIG. 9).

In *The Pointers* (PLATE 50), his most fully Impressionist rendering of the densely wooded Ontario north country, Thomson depicts the scene with divisionist brushwork, applying his brightly colored pigments in directional, stitch-like strokes interwoven across the canvas to create a rich tapestry effect. While Thomson would certainly have seen Lismer's *The Guide's Home,* his technique could also have been inspired by the divisionism of the Swiss Symbolist painter Giovanni

Segantini, whose paintings, reproduced in the January 1903 issue of *Jugend*, inspired a number of North American painters, among them Marsden Hartley. In *The Pointers*, Thomson incorporates his penchant for the wilderness landscape with a secondary theme related to Ontario's logging industry, the title of the painting referring to the sharp-prowed boats, called "pointers," which were used to transport horses and equipment to isolated logging camps before the winter freeze-up.

While the majority of Canadian Impressionists were active in Quebec and Ontario, small pockets of regional activity emerged in western Canada, extending from Manitoba to British Columbia. Charles William Jefferys, a Toronto-based painter and illustrator, played a key role in dispelling the broadly held notion that the vast, open spaces of the Canadian Prairies were unpaintable. Jefferys made several trips to Western Canada between 1907 and 1924, becoming, in effect, the first Canadian artist to depict the gently rolling plains and distinctive flora of the Prairies in an Impressionist manner. As he stated to one contemporary, in order to capture the special light of the region, the "painter-trekker" should "fill his paint-box with…the brightest colors…pinks, blues, grass-greens and yellows soon run out, whilst purples and browns and all the deeper tones are rarely touched."[60] Jefferys effectively conveys the dazzling luminosity and the expansive topography of the sun-drenched farmlands near Portage-La-Prairie, northwest of Winnipeg, in *Wheat Stacks on the Prairie* (PLATE 36), one of his first excursions into western imagery and a Canadian counterpart to the monumental grainstacks which figured so prominently in the iconography of Claude Monet.

The application of Impressionist tenets to the depiction of Western Canada is also revealed in the work of the Winnipeg-born painter Lionel LeMoine FitzGerald, whose exposure to Impressionism came largely through reproductions in art magazines. However, FitzGerald's knowledge of Impressionist precepts were also nurtured through contact with various Glasgow School painters who had settled in Winnipeg during the 1910s. Indeed, around 1912, FitzGerald shared a studio with the Scottish-born *pleinairist* Donald MacQuarrie, and he would certainly have been familiar with the Impressionist-inspired work of George Telfer Bear, another Glasgow painter who was affiliated with the Winnipeg School of Art.[61]

FitzGerald's *Summer Afternoon—The Prairie* (PLATE 29) is a sweeping vista of lush hay-fields dominated by an expansive sky populated with wisp-like cloud formations. Painted in the pointillist style employed by FitzGerald during 1920–21, this canvas underscores the role of agricultural production in western Canada's economy as much as it conveys the light and breadth of the Prairie landscape. It also testifies to FitzGerald's intense love of Manitoba's farmlands, deriving from childhood summers spent at his grandparents' farm outside the village of Snowflake.

Upon returning to Vancouver in 1912, after a three-year sojourn in France, Emily Carr directed her creative energies towards the depiction of coastal Indian villages, often in a state of decay or deserted, which featured abandoned wooden houses and massive, elaborately carved cedar totem poles. In *Yan, Queen Charlotte Islands* (PLATE 20), Carr combines animated brushwork and vibrant, high-keyed coloration to depict the verdant topography of the Queen Charlotte Islands and provides us, as well, with a highly distinctive pictorial record of the habitat of Canada's Northwest Coast Indians.

In domesticating Impressionism, the majority of Canadian painters focused their attention on the portrayal of native scenery, with Montreal, and later Toronto, emerging as the dominant centers of activity. Although a few painters occasionally explored urban and industrial subjects, landscape was viewed as the most effective means of conveying Canadian identity. Quebec Impressionists were drawn to the rugged countryside, as well as to the small towns and villages along the St. Lawrence, and it was this group that most frequently conjoined their landscape concerns with aspects of daily life. In Ontario, where the Impressionist tradition was much more short-lived, the principal landscape painters—those who would go on to form the Group of Seven—captured the spirit of place by turning to the uninhabited wilderness in the northern portions of the province. All of these painters, including their counterparts working elsewhere in Canada,

created new visions of the Canadian scene, employing the innovative techniques of Impressionism to produce works of art that expressed national and regional sentiment as much as they reflected the artist's own subjective response to Nature.

Figures and Portraits

While indigenous scenery remained the primary thematic concern of most Canadian Impressionists, a number of artists specialized in figure painting and, to a lesser extent, portraiture. Many combined their interest in the figure with the depiction of landscape, concentrating on themes related to outdoor recreational activity. The urban working-class subjects associated with French Impressionism—the laundresses, milliners, and dancers of Degas, for example—were avoided in favor of more genteel depictions of the female figure.

George Agnew Reid was one of the first Toronto artists to experiment with Impressionist strategies during the early 1890s. However, his involvement with the aesthetic was minimal, overshadowed by his activity as an academic figure painter and muralist. During summers at Onteora, New York, however, Reid worked *en plein air*, painting colorful, loosely rendered landscapes. In canvases such as *City and Country* (1893; Government of Ontario Art Collection) and *Idling* (PLATE 63), he explores his dual interest in the landscape and the figure. Painted around 1892, *Idling* is typical of Reid's modified Impressionism, demonstrating his concern for rendering the effects of flickering sunlight while adhering to a traditional approach in his portrayal of the figures.[62]

Frederick Challener (1869–1959), a student of Reid's who emerged as Canada's foremost muralist at the turn of the century, painted Impressionist-inspired landscapes in and around Toronto, in the Catskill Mountains, and in Conestogo, Ontario, a popular summer gathering place for Charles Macdonald Manly and other Toronto-based painters during the early 1900s.[63] However, Challener's outdoor work was really a secondary, seasonal activity, for he was first and foremost an academic figure painter. In *A Sewing Lesson* (FIG. 10), he depicts a female figure

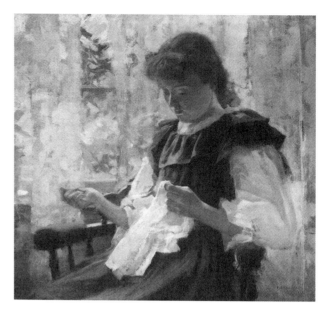

FIG. 10 Frederick S. Challener (1869–1959), *A Sewing Lesson*, 1896, oil on canvas, 22 ¼ × 24 in. (56.3 × 60.9 cm.), National Gallery of Canada, Ottawa.

seated next to a window, adorned with transparent muslin curtains, which looks out on to a verdant summer landscape. Although Challener adheres to traditional precepts of figure construction in rendering the sitter, his interest in conveying sunlight and shadow is revealed in his summary handling of the adjacent landscape, depicted with high-keyed greens and yellows. At the same time, he effectively captures the more subdued illumination filtering through the sheer curtains onto the figure, creating vivid contrasts of light and dark. Not surprisingly, Challener's ability to render light was duly noted by E.F.B. Johnston, who claimed he possessed "the keenest sense of light and brilliancy of color of any of the Canadian painters."[64]

The figure-in-a-landscape motif remained a vital part of the aesthetic repertoire of the expatriate painter William Blair Bruce, evident in *Summer Days, France* (PLATE 5). This magnificent, salon-scale canvas features Bruce's wife, the Swedish sculptor Caroline Benedicks, and his sister Bell, in a sunlit outdoor setting. The work was probably painted at Grèz-sur-Loing, which the threesome visited during the summer of 1889. Bruce renders the figures in a solid, academic manner; however, the Impressionist inclinations revealed in his earlier Giverny landscapes are continued here in the vibrant, spontaneous handling

of the landscape and foliage, depicted in shimmering greens and yellows. By portraying his wife in the act of sketching, Bruce also pays homage to her skills as an artist.

Like his friend Maurice Cullen, Henri Beau converted to Impressionism at a relatively early date, concentrating on the figure, usually shown out-of-doors. In *Woman with a Parasol* (PLATE 54), from 1897, Beau investigates a typical Impressionist theme, that of the female figure holding an umbrella. Like Cullen's *Biskra*, however, Beau's canvas also has much in common with the glare aesthetic, evident in the intense light-dark contrasts and in the attempt to convey the effects of bright sunlight reflecting off the planar surfaces of architecture. The differences between the glare aesthetic and Impressionism are underscored by comparing *Woman with a Parasol* with the much larger *Youth and Sunlight* (PLATE 65), by Marc-Aurèle Suzor-Coté, a more traditional investigation of the parasol motif wherein color and sunlight are conveyed by means of a luminous, high-keyed palette. Beau's transition from glare painting to a full-fledged Impressionist style is exemplified in slightly later works, such as *The Picnic* (PLATE 55). Probably painted in the vicinity of Montreal, *The Picnic* reveals Beau's practice of using small dabs of pigment to create a richly textured paint surface in the manner of Monet and Pissarro.

Other exponents of the figure included Raoul Barré, a Paris-trained painter who made a name for himself as an illustrator and animator. Barré left his native Montreal in 1910 and moved to New York, where he opened one of the first studios devoted to the production of animated films. However, he continued to paint in his spare time, working in Long Island, in the northeastern United States and, towards the end of his career, in Quebec. His *Au bord de la mer* (PLATE 53) was painted in Gloucester, the bustling seaport and Impressionist art colony on the Cape Ann peninsula, about forty miles north of Boston. In this work, two young women wearing flowing summer dresses relax in a sun-drenched coastal setting. Barré depicts the scene with the heightened colorism and broken brushwork associated with Impressionism. What is unique about the painting, however, is Barré's empha-

sis on the jagged rock formations in the foreground. That he chose to emphasize this particular aspect of the topography suggests a distinctive Canadian sensibility stemming from his familiarity with the rugged northern landscape.[65]

Some of the best Impressionist figure work in Canada came from the brushes of a number of accomplished women painters who pursued the subject on a more consistent basis than their male counterparts. The late nineteenth and early twentieth centuries saw the emergence of the professional woman artist in Canada, many of them enjoying notable reputations at home and abroad.[66] Spurred on by increased educational opportunities, the suffrage movement, and other advances in women's rights, many Canadian women sought formal training in the country's art schools, such as the Art Association of Montreal, the Ontario College of Art in Toronto, and the Victoria School of Art and Design in Halifax. From there, many continued their educations abroad, attending art schools and/or outdoor painting classes in France, England, and the United States. The new spirit of confidence and independence experienced by Canadian women artists at the turn of the century is revealed to us in George Reid's Impressionist-inspired portrait of his student, Henrietta Moodie Vickers (PLATE 64), a "Canadian Girl" whose artistic aspirations and lust for adventure took her from "Toronto the good" to such then exotic locales as Paris and Tangier.[67]

Like their American counterparts (most of whom were male), women Impressionists in Canada favored genteel subjects, depicting women and children in interiors or in outdoor settings, often in conjunction with the floral environment and/or leisure activity. Inspired by the examples of Mary Cassatt and Berthe Morisot, many explored maternal themes, combining female empathy with the formal concerns of Impressionism.

As a number of North American art historians have recently emphasized, the new female imagery signalled a retreat from an increasingly urbanized and industrialized society.[68] However, in some instances, personal backgrounds also played a role in the choice of theme. Frances Bannerman and Helen McNicoll, for example, came from established, well-to-do families in

MISS McNICOLL AND A CORNER OF HER STUDIO.

A high honor has been conferred upon a Montreal artist of note, Miss Helen McNicoll, who has been elected a member of the Royal Society of British Artists. Above is shown a view of her London studio.

FIG. 11 "Miss McNicoll and a Corner of Her Studio," *Montreal Daily Star*, 2 April 1913, p. 2. National Library of Canada, Ottawa.

eastern Canada. Bannerman was the youngest daughter of Alfred Gilpen Jones, a lieutenant-governor of Nova Scotia, while McNicoll's father, David, was an executive with the Canadian Pacific Railway in Montreal. Both women depicted the world they knew—comfortable, upper-middle-class environments populated by family and friends engaged in domestic, recreational, or cultural pursuits. Such is the case with Bannerman's *The Conservatory* (PLATE 53), a portrayal of the artist's friend Nelly Morrow, seated in the aboretum of the Jones's mansion (now Halifax's Waegwoltic Club). The sitter is engaged in the act of reading, possibly a novel by an English writer such as Dickens, Kipling, or Thackeray, all of whom found large audiences in Canada and the United States.[69] Indeed, reading was an activity that was considered both a moral and social necessity for members of the leisure class. Not surprisingly, images of women reading books and newspapers proliferated throughout the late nineteenth century, explored by the likes of James McNeill Whistler, Mary Cassatt and many others who took the depiction of women beyond the traditional domestic sphere and into the realm of culture, education, and politics.

Taking her aesthetic cue from Edouard Manet's

In the Conservatory (1879; Nationalgalerie, Staatliche Museen Preussischer Kulturbesitz, Berlin), which she could have seen during her trip to Paris in 1881, Bannerman closely crops the composition to create a sense of spontaneity and intimacy. At the same time, Bannerman combines elements of academicism and Impressionism, portraying the figure and architecture with firm brushwork, while rendering the flowering plants and the outdoor landscape with a more fluid technique. The effects of light flowing in through the conservatory windows are conveyed not only through her spontaneous handling of the flowers and plants, but through her bright palette, wherein cool greens, blues, and greys intermingle with touches of white, pink, yellow, and mauve.

Bannerman was the first Canadian painter to experiment with the stylistic and thematic precepts associated with the New Painting, evident not only from *The Conservatory* but in several outdoor subjects painted around the same time, among them *Autumn Sunbeams* (1882; Art Gallery of Nova Scotia, Halifax), in which she effectively captures the play of sunlight on both the figure and landscape. Despite the progressive nature of Bannerman's work, her paintings had little impact on her Canadian con-

temporaries; following her marriage in 1886, she moved permanently to England, where she pursued a successful career an artist, illustrator, and poet.

Helen McNicoll's career also involved activity in both Canada and England; however, unlike Bannerman, McNicoll played a more prominent role in the Canadian Impressionist tradition through her regular participation in exhibitions in Montreal. McNicoll, who became deaf at an early age, initially studied with William Brymner at the Art Association of Montreal. She then went on to seek further instruction at the Slade School in London, following which she attended outdoor painting classes conducted by the British Impressionist Algernon Talmage, at St. Ives, Cornwall.[70]

McNicoll painted pastoral landscapes in Quebec, England, and France. However, she was best-known for her colorful depictions of women and children, portraying modern life while applying herself, as noted by one contemporary reviewer, "to new problems of light, line and beauty."[71] Such is the case with *Under the Shadow of the Tent* (PLATE 61), featuring two women, one reading, the other sketching, in a sunlit beach setting. As Paul Duval has pointed out, McNicoll's style and subject preferences, exemplified in works such as *Under the Shadow of the Tent*, are similar to those of her close friend, the British Impressionist Dorothea Sharp.[72] McNicoll and Sharp would certainly have been inspired by each other's Impressionist efforts; at the same time, both women would have been aware of, and possibly influenced by, the work of Joaquín Sorolla, the Spanish Impressionist whose sparkling beach scenes, painted along the Mediterranean Coast, were extremely popular throughout Europe and North America. In all likelihood, McNicoll and Sharp would have seen the exhibition of Sorolla's paintings (280 in total) held at London's Grafton Galleries in 1907.

McNicoll's concern with rendering the effects of bright sunlight is also evident in her numerous depictions of women and children participating in everyday domestic tasks, such as picking flowers or gathering fruit (PLATES 57, 58), while her indoor intimism is revealed in *The Chintz Sofa* (PLATE 59). Painted in the artist's London studio (FIG. 11), McNicoll's subject

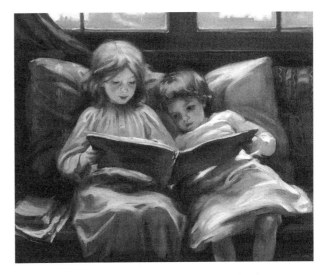

FIG. 12 Laura Muntz Lyall (1860–1930), *Interesting Story*, 1898, oil on canvas, 32 × 39½ in. (81.3 × 100.3 cm.), Art Gallery of Ontario, Toronto, Gift of the Government of the Province of Ontario, 1972.

(possibly Sharp herself) reads a book in comfortable domestic surroundings.[73] In its vivid coloration, simplification of form, and emphasis on decorative patterning, *The Chintz Sofa*, as well as *In the Shadow of the Tree* (PLATE 60), indicates McNicoll's increasing awareness of aesthetic strategies associated with Post-Impressionism. Unfortunately, McNicoll's career was cut short by her premature death at age thirty-six. In a lengthy obituary notice published in the *Montreal Gazette*, an anonymous writer perceptively summed up the essence of McNicoll's Impressionism, noting the individuality of her style, her knowledge of drawing and composition, her "direct and vigorous technique," and, above all else, her "skill in depicting sunlight and shadow.... Strong sunlight especially appealed to her and each year she exhibited work which showed that she was attaining her ends without extravagant color and freakish treatment."[74]

A more sentimental interpretation of children (FIG. 12) was taken by Laura Muntz Lyall (1860–1930), who grew up on a farm in Ontario's Muskoka district.[75] Lyall painted her first Impressionist canvases in Paris during the late 1890s, employing a bright palette and spontaneous brushwork. Her paintings were especially admired by Newton MacTavish, an influential editor, collector and critic, and her stature at the turn

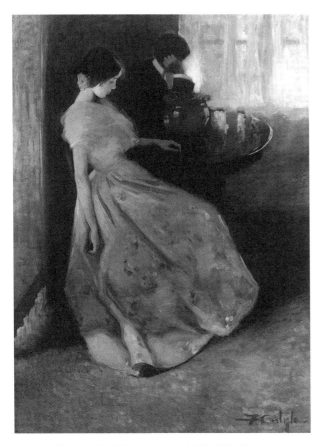

FIG. 13 Florence Carlyle (1864–1923), *The Tiff*, oil on canvas, 72 ¼ × 53 in. (183.8 × 134.6 cm.), Art Gallery of Ontario, Toronto, Gift of the Government of the Province of Ontario, 1972.

FIG. 14 Florence Carlyle (1864–1923), *The Garden at Englewood*, circa 1913, oil on canvas, 30 × 24 in. (76.2 × 60.9 cm.), Woodstock Art Gallery, Woodstock, Ontario.

of the century was such that she was the only woman invited to exhibit with the male-dominated Canadian Art Club.

Other Canadian exponents of Impressionist figure painting included Florence Carlyle (1865–1923), whose academic Impressionism is revealed in such major works as *The Tiff* (FIG. 13). Carlyle also experimented with the theme of the woman among flowers in her later *The Garden at Englewood* (FIG. 14), abandoning the restrained palette, naturalistic rendering and stylish interior setting of *The Tiff* in favor of a brilliant summer palette and a decorative interpretation of the figure and landscape.

A Brymner student who was exposed to French Impressionism during a 1913 trip to Europe, Mabel May returned to her native Montreal where she developed a reputation for her streetscapes and por-

traits. She also painted joyous scenes of leisure activity, such as *The Regatta* (PLATE 56), rendered with the soft, pliant brushwork and light tonalities associated with Impressionism. May's Impressionist activity lasted approximately a decade; after the mid-1920s, as she came under the influence of the Group of Seven, she turned almost exclusively to landscapes, painted with a greater emphasis on structure and form than in her earlier figural work. Indeed, the impact of the Group during the 1920s was such that the figure painting tradition in Canada gave way to the overwhelming emphasis on depicting native scenery. Accordingly, the work of Canadian Impressionist figure painters is made all the more unique, for in celebrating modern life in relation to the figure, they provided a more intimate and lyrical dimension to turn-of-the-century Canadian painting.

NOTES

1 M[argaret] L[aing] Fairburn, "A Decade of Canadian Art," *Canadian Magazine* 17 (June 1901): 160.

2 Fairburn, 160.

3 Fairburn, 160.

4 A group of Toronto-based painters (Frank Carmichael, Lawren Harris, A.Y. Jackson, Frank Johnston, Arthur Lismer, J.E.H. MacDonald, F.H. Varley) who exhibited together for the first time in May 1920. Inspired by the example of Tom Thomson, who painted wilderness landscapes in Ontario's Algonquin Park, the Group sought to interpret the unique character of the Canadian landscape (especially the Ontario northland), employing a style informed by the aesthetics of European Post-Impressionism and contemporary Scandinavian painting. Their artistic philosophy, centered around the development of a national landscape school, dominated Canadian art throughout the 1920s. For further reading, see the Selected Bibliography, including publications by C. Hill, P. Mellen, R. Nasgaard, D. Reid, and M. Tooby.

5 See, for example, Norma S. Broude, ed., *World Impressionism* (New York: Harry N. Abrams, 1990) and Ingo F. Walther, ed., *Impressionist Art, 1860–1920: Volume II: Impressionism in Europe and North America* (Cologne: Benedikt Taschen Verlag, 1993).

6 William Colgate, *Canadian Art: Its Origin and Development* (Toronto: Ryerson Press, 1943), p. 77.

7 Robert Gagen, "Ontario Art Chronicle" [circa 1919–21], p. 19, typescript, E.P. Taylor Reference Library, Art Gallery of Ontario, Toronto.

8 For information pertaining to Canadians in France, see the publications by S. Allaire, L. Lacroix, J. Ostiguy and D. Wistow in my Selected Bibliography. Canadians are also included in "A Roster of Gérôme's American Pupils, 1864–1903," pp. 101–108, in H. Barbara Weinberg's *The American Pupils of Jean-Léon Gérôme* (Fort Worth: Amon Carter Museum, 1984), and in Catherine Fehrer's "The Julian Academy: List of Students and Professors, 1869–1939," which appears as an appendix (n.p.) in *The Julian Academy, Paris, 1868–1939* (New York: Shepherd Gallery, 1989). For Canadian artists and art students in Giverny prior to 1900, see Carol Lowrey, "Hotel Baudy Guest Register," pp. 222–27 in William H. Gerdts, *Monet's Giverny: An Impressionist Colony* (New York: Abbeville Press, 1993). For general information pertaining to art colonies frequented by Canadians, see David Sellin, *Americans in Brittany and Normandy, 1860–1910* (Phoenix: Phoenix Art Museum, 1982) and Michel Jacobs, *The Good and Simple Life: Artist Colonies in Europe and America* (Oxford: Phaidon, 1985).

9 [William Cruikshank], "A Look at the Pictures," *Toronto Telegram*, 18 May 1885, p. 1. See also, his "Native Artists' Work. A Glimpse at the Exhibition," *Toronto Telegram*, 23 May 1885, p. 1. In "A Look at the Pictures," Cruikshank deemed *A Wreath of Flowers*, which was painted at Runswick, England, to be "overdone by about twelve inches of superfluous foreground …the vogue in Paris right now," and went on, stating that it was a "sincere, good picture; its faults are only those of a school not indigenous to this country." I would like to thank my colleague, Robert Stacey, for bringing these reviews to my attention. Researchers should also see W.A. Sherwood, "The Influences of the French School Upon Recent Art," *Canadian Magazine* 1 (October 1893): 638–41.

10 For use of this term see, for example, Gabriel P. Weisberg, "Jules Breton, Jules Bastien-Lepage, and Camille Pissarro in the Context of Nineteenth-Century Peasant Painting and the Salon," *Arts* 56 (February 1982): 115–19, and, by the same author, *Beyond Impressionism: The Naturalist Impulse* (New York: Harry N. Abrams, 1992). Although William Brymner worked primarily in an academic-realist style throughout the course of his career, he remained open to artistic innovation, urging his students at the Art Association of Montreal to follow their own artistic inclinations. In March 1896, Brymner gave a public lecture on Impressionism in which he acknowledged that "There are other kinds of beauty besides that of a pretty face or a form....The beauty of the arrangement of spots of colour and the light and shade or even of lines are not often thought of." See "Re Impressionism. What It Is and in What It Differs From Other Schools, By Mr. W. Brymner, R.C.A.," *The Gazette* (Montreal), 12 March 1896, p. 2.

11 For information on Parisian art teachers, see H. Barbara Weinberg, *The Lure of Paris: Nineteenth-Century American Painters and Their French Teachers* (New York: Abbeville Press, 1991). In preparing this section of my essay, I also referred to William H. Gerdts's *Artistic Transitions: From the Academy to Impressionism in American Art* (Jacksonville, Fla.: Cummer Gallery of Art, 1986) as well as my own study "The French Influence on Canadian Art, 1880–1915: Critical Commentary," term paper, Ph.D. Program in Art History, C.U.N.Y. Graduate School, New York, 1984, which deals with issues pertaining to critical response and nationalism.

12 See Marta H. Hurdalek, *The Hague School: Collecting in Canada at the Turn of the Century* (Toronto: Art Gallery of Ontario, 1983).

13 See Carol D. Lowrey, "Arcadia and Canadian Art," *Vanguard* 15 (April–May 1986): 19–22.

14 See Robert Stacey, "A Contact in Context: The Influence of Scandinavian Landscape Painting on Canadian Artists Before and After 1913," *Northward Journal* 18/19 (1980): 36–55, and Roald Nasgaard, *The Mystic North: Symbolist Landscape Painting in Northern Europe and North America, 1890–1940* (Toronto: Art Gallery of Ontario, 1984).

15 For a discussion of the founding of the Giverny colony and Bruce's influence on Theodore Robinson, see Gerdts, *Monet's Giverny*, pp. 21–32, 52.

16 William Blair Bruce to his mother [Janet Bruce], 24 June 1887, in Joan Murray, ed., *Letters Home: 1859–1906: The Letters of William Blair Bruce* (Moonbeam, Ont.: Penumbra Press, 1982), pp. 123–24.

17 *Landscape with Poppies* bears comparison with Monet's *Poppy Field near Giverny* (1885; Museum of Fine Arts, Boston), which Bruce could have seen in Paris. With the exception of Theodore Robinson, Lilla Cabot Perry and, for a time, John Leslie Breck, Monet avoided the colonists, often despairing of their presence in the village. There is no indication that Bruce had any contact with the French master. See Gerdts, *Monet's Giverny*, pp. 35–40.

18 M. O'r, "Nos Artistes à Paris," *Courrier du Canada*, No. 181 (22 January 1891): 1, which translates as "Mr. Cullen inclines somewhat towards the impressionist school...."

19 Murray, *Letters Home*, p. 29.

20 For a discussion of the glare phenomenon, see Gerdts, *American Impressionism* (New York: Abbeville Press, 1984), pp. 17–21.

21 In Catherine Fehrer's "The Julian Academy," Morrice's dates of enrollment are listed as 1888–90. However, both Lucie Dorais and Nicole Cloutier state that he entered Julian's in the autumn of 1891. See Dorais, *J.W. Morrice*, Canadian Artists Series; 8 (Ottawa: National Gallery of Canada, 1985), p. 8, and Cloutier *et al.*, *James Wilson Morrice, 1865–1924* (Montreal: The Montreal Museum of Fine Arts, 1985), p. 45.

22 See John O'Brian, "Morrice—O'Conor, Gauguin, Bonnard et Vuillard," *Revue de l'Université de Moncton* 15 (avril–décembre 1982): 9–34.

23 Marius and Ary Leblond, quoted in Donald W. Buchanan, "A Canadian in St. Malo," *Queen's Quarterly* 43 (Autumn 1936): 300. For a discussion of the relationship between Morrice's personality and his art, see O'Brian, "Morrice's Pleasures (1900–1914)," pp. 89–97 in Cloutier *et al.*, *James Wilson Morrice, 1865–1924*.

24 Muriel Ciolkowska, "A Canadian Painter: James Wilson Morrice," *International Studio* 50 (September 1913): 182.

25 Charles Louis Borgmeyer, "The Master Impressionists," *Fine Arts Journal* 28 (June 1913): 347.

26 J.W. Morrice to Edmund Morris, [1911?], Edmund Morris Letterbooks, Archives, E.P. Taylor Reference Library, Art Gallery of Ontario, Toronto.

27 See Alasdair Alpin MacGregor, *Percyval Tudor-Hart, 1873–1954: Portrait of an Artist* (London: P.R. Macmillan, 1961), p. 59.

28 For Tudor-Hart's influence on Russell and Macdonald-Wright, see Gail Levin, *Synchromism and American Color Abstraction, 1910–1925* (New York: Whitney Museum of American Art, 1978), p. 14.

29 John Sloan Gordon, "My First Library," typescript, n.d., pp. 7–8.

30 In a letter to G.S. Harold, Regina, Saskatchewan, 20 November 1935 (private collection), Gagnon stated that he had sketched in Giverny in 1905. His letter also includes reference to Monet, who "loved flowers, when he was not painting he was in his gardens weeding & planting."

31 Jackson, *A Painter's Country: The Autobiography of A.Y. Jackson*, memorial ed. (Toronto: Clarke, Irwin & Co., 1976), p. 11.

32 A.Y. Jackson, Assisi, to Albert Laberge, Montreal, 6 December 1912, T.R. Lee Papers, E.P. Taylor Reference Library, Art Gallery of Ontario, Toronto.

33 See "Post Impressionists Shock Local Art Lovers at the Spring Exhibition," *Montreal Daily Witness*, 26 March 1913, p. 5. See also: "Spring Exhibition at Art Gallery, *Gazette* (Montreal), 26 March 1913, p. 13, and "Post-Impressionism Creates Much Discussion Locally," *Montreal Daily Star*, 7 April 1913, p. 10.

34 Ian M. Thom, *Emily Carr in France* (Vancouver: Vancouver Art Gallery, 1991), p.15.

35 C. Lintern Sibley, "A. Suzor-Coté, Painter," in *The Year Book of Canadian Art, 1913* (Toronto: J.M. Dent and Sons, 1913), p. 152.

36 The importance of fostering of nationalist sentiment in art and politics was initially expressed by the members of the Canada First movement, founded in Ottawa in 1868. Unfortunately, considerations of space prevent a thorough discussion of the very complex issues surrounding Canadian nationalism and culture. Readers wishing to explore the subject on an introductory basis should consult Ramsay Cook, *The Maple Leaf Forever: Essays on Nationalism and Politics in Canada* (Toronto: Macmillan, 1971); Northrop Frye, *The Bush Garden* (Toronto: House of Anansi Press, 1976); Peter Russell, ed., *Nationalism in Canada* (Toronto: McGraw-Hill, 1966); John Lennox, ed., *Se Connaître: Politics and Culture in Canada* (Toronto: York University Dept. of Communications and Robarts Centre for Canadian Studies, 1985), among other studies. The nationalist movement in Quebec, which sought to preserve the unique aspects of French-Canada—its language, culture and religion—arose during the 1920s. See Susan Mann Trofimenkoff, *The Dream of Nation: A Social and Intellectual History of Quebec* (Toronto: Gage Publishing, 1983).

37 See, for example, W.A. Sherwood's "Hindrances to Art in America," *Lake Magazine* 1 (September 1892): [95]–96, "The Influence of the French School Upon Recent Art," *Canadian Magazine* 1 (October 1893): 638–41, and "A National Spirit in Art," *Canadian Magazine* 3 (October 1894): 498–501; and J.A. Radford's "Art at the World's Fair," *Canadian Magazine* 2 (December 1893): [128]–30, and "Canadian Art Schools, Artists and Art,' *Canadian Magazine* 2 (December 1893): [462]–66. Other commentators, however, embraced cosmopolitanism, among them the painter Harriet Ford, who claimed that Canadian artists were "not in a position to stand by ourselves…it is a satisfaction to notice the infiltration of ideas and methods from abroad." Ford also discussed Walter's Pater's notion that art should be a matter of "pure perception" without responsibilities to subject matter. See Harriet Ford, "The Royal Canadian Academy of Art," *Canadian Magazine* 3 (May 1894): 45–50.

38 Van, "Art and Artists," *Saturday Night* 2 (13 July 1889): 7.

39 A.Y. Jackson, *A Painter's Country*, p. 16.

40 Donald W. Buchanan, "The Gentle and the Austere: A Comparison in Landscape Painting," *University of Toronto Quarterly* 11 (October 1941): 73.

41 Buchanan, "The Gentle and the Austere," p. 73.

42 Maurice Cullen, quoted in Jean Chauvin, *Ateliers: études sur vingt-deux peintres et sculpteurs canadiens* (Montreal: L. Carrier, 1928), p. 112.

43 See the excellent study by John R. Porter and Didier Prioul, *Québec plein la vue* (Québec: Musée du Québec, 1994).

44 Cullen's *L'Anse-des-Mères* (1904; Musée du Québec) features the same view, but in the summertime. A number of turn-of-the-century American artists painted Impressionist views of Quebec, including Birge Harrison and Everett Longley Warner.

45 "The City in Brief: A New Artist's Work," *The Gazette* (Montreal), 24 January 1896, p. 3, and "City and District: Mr. M. Cullen's Pictures," *The Gazette* (Montreal), 2 December 1896, p. 3.

46 See Margaret Laing Fairburn, "A Milestone in Canadian Art," *Canadian Courier* 1 (13 April 1907): 12, and "Exhibition of Canadian Art," *Montreal Daily Star*, 24 March 1906, p. 12.

47 Arthur Lismer, quoted in Peter Mellen, "Around a Retrospective: Maurice Cullen and the Group of Seven," *Vie des Arts*, No. 61 (hiver 1970–71): 29; Jackson, *A Painter's Country*, p. 19.

48 Sylvia Antoniou, *Maurice Cullen, 1866–1934* (Kingston, Ont.: Agnes Etherington Art Centre, Queen's University, 1982), p. 12.

49 In "The Gentle and the Austere," p. 73, Buchanan noted that in his Quebec paintings, Morrice "was not telling you, like a lesson, that this was a nationalist landscape and northern air and skies; instead, he was simply depicting on canvas, with great sensitivity, his own conception of those snow-covered scenes which he had used to sketch, out-of-doors, on his numerous visits home."

50 "Thirty-Second Annual Exhibition of The Royal Canadian Academy of Arts opens," *Montreal Daily Star*, 25 November 1910, p. 8. For further information on Gagnon's connection with Baie-Saint-Paul and Charlevoix County, see Victoria A. Baker, *Images de Charlevoix 1784–1950 = Scenes of Charlevoix 1784–1950* (Montreal: The Montreal Museum of Fine Arts, 1981). Baker's study also includes information pertaining to American painters who visited Charlevoix during the 1930s, among them Karl Anderson and William Glackens, as well as numerous members of New York's Salmagundi Club.

51 "Thirty-Second Annual Exhibition…," p. 8, and "Art Association Shows Notable Features," *Montreal Daily Star*, 25 March 1913, p. 1.

52 Hector Charlesworth, "The Canadian Art Club, 1913," *Saturday Night* 26 (24 May 1913): 6, and "Post Impressionists Shock Local Art Lovers," p. 5.

53 Sibley, "A. Suzor-Coté, Painter," p. 152.

54 Charlesworth, "The Canadian Art Club, 1913," p. 6.

55 Dennis Reid, "Impressionism in Canada," in Norma Broude, ed., *World Impressionism*, p. 111.

56 For information on the Canadian Art Club, see Robert J. Lamb, *The Canadian Art Club, 1907–1915* (Edmonton: Edmonton Art Gallery, 1988), and Geoffrey Simmins, "Reinterpreting the Canadian Art Club: A Documentary Approach," term paper, Graduate Department of Art History, University of Toronto, 1983, photocopy in the E.P. Taylor Reference Library, Art Gallery of Ontario.

57 For Harris's early training, see Peter Larisey, *Light for a Cold Land: Lawren Harris's Work and Life—An Interpretation* (Toronto: Dundurn Press, 1993).

58 For recent discussions of this painting, see Rosemary Donegan, *Industrial Images = Images industrielles* (Hamilton, Ont.: Art

Gallery of Hamilton, 1987), pp. 44–48, and Glen Norcliffe, "In a Hard Land: The Geographical Context of Canadian Industrial Landscape Painting," pp. 73–75, in *A Few Acres of Snow: Literary and Artistic Images of Canada,* ed. by Paul Simpson-Housley and Glen Norcliffe (Toronto: Dundurn Press, 1992). Harris's canvas was exhibited at the 1912 exhibition of the Ontario Society of Artists in Toronto at the same time that the employees of Eaton's No. 4 factory were on strike.

59 Lawren Harris to Paul Duval, quoted in Paul Duval, *Canadian Impressionism* (Toronto: McClelland & Stewart, 1990), p. 110.

60 C.W. Jefferys, quoted in J. Edgcumbe Staley, "Jefferys: Painter of the Prairies," *Maclean's Magazine* 26 (July 1913): 84.

61 I would like to thank Gary Essar, former Associate Curator at the Winnipeg Art Gallery, for bringing G. Telfer Bear's work to my attention. Alec J. Musgrove, the first principal of the Winnipeg School of Art, was a former member of the Glasgow School of Art and was presumably responsible for bringing Bear and McQuarrie to Winnipeg.

62 For a discussion pertaining to the date of *Idling,* see Reid, "Impressionism in Canada," p. 111. As Reid points out, the work was originally about a third wider than its present size.

63 See Gerald Noonan, "Conestogo's Picturesque Past as a Summer Art Colony," *Waterloo Historical Society Annual* 70 (1982): 25–30.

64 E.F.B. Johnston, "Painting and Sculpture in Canada," in *Canada and Its Provinces*, vol. 12 (Toronto: Glasgow, Brook, 1914), p. 623.

65 This point is also discussed in Duval, *Canadian Impressionism,* p. 88.

66 For aspects of my discussion on women Impressionists in Canada, I am indebted to the scholarship of Karen Antaki, Dorothy Farr, Julia Gualtieri, Natalie Luckyi, Anne Mandely Page and Maria Tippett (see Selected Bibliography).

67 Vickers, who studied under Reid in Toronto from 1895 until 1897, remains an elusive figure in the history of Canadian art. A photograph of the studio Reid occupied between 1895 and 1899 (George Reid Scrapbook, E.P. Taylor Reference Library, Art Gallery of Ontario, Toronto, p. 187) includes the Vickers portrait in the corner, identified in the caption as "Miss Hettie Vickers as a 'Canadian Girl'." For further information, see Robert Stacey's catalogue entry on the Vickers portrait in Fern Bayer, *The Ontario Collection* (Markham, Ont.: Fitzhenry & Whiteside for the Ontario Heritage Foundation, 1984), pp. 101, 103. Vicker's letters home from Tangiers are now in the National Library of Canada, Ottawa.

68 See, for example, Julia Gualitieri, *The Woman as Artist and Subject in Canadian Painting (1890–1930): Florence Carlyle, Laura Muntz Lyall, Helen McNicoll,* M.A. thesis, Queen's University, Kingston, Ont., 1989 (Ann Arbor, Mich.: University Microfilms International, 1989; Canadian Theses on Microfiche, no. 60737, Ottawa: National Library of Canada, 1991), and H. Barbara Weinberg, Doreen Bolger and David Park Curry, *American Impressionism and Realism: The Painting of Modern Life, 1885–1915* (New York: Metropolitan Museum of Art, 1994).

69 For images of reading in turn-of-the-century American painting, see Ronald G. Pisano, *Idle Hours: Americans at Leisure, 1865–1914* (Boston: Little, Brown and Company, 1988), pp. 22–31.

70 Talmage, along with Julius Olsson, operated the Cornish School of Landscape, Figure and Sea Painting at St. Ives. Although Talmage inspired McNicoll's love of working *en plein air,* his own Impressionist style was rather subdued, lacking the full-blown colorism of McNicoll's. For recent commentary on Talmage, see Kenneth McConkey, *Impressionism in Britain* (London: Yale University Press in association with Barbican Art Gallery, 1995), pp. 63, 202.

71 "A Loss to Canadian Art," *Saturday Night* 28 (10 July 1915): 3.

72 Duval, *Canadian Impressionism,* pp. 9–[10], 96.

73 I would like to thank the owners of *The Chintz Sofa* for providing me with additional documentation relative to this painting.

74 "Death Cuts Short Promising Career," *The Gazette* (Montreal), 28 June 1915, p. 5.

75 For Muntz, see Newton MacTavish, "Laura Muntz And Her Art," *Canadian Magazine* 37 (September 1911): 419–26, and Gualtieri, *The Woman as Artist and Subject in Canadian Painting.*

In conjunction with the appearance of the exhibition in Quebec City (14 June–4 September 1995), a French translation of this essay has been published separately by the Musée du Quebec.

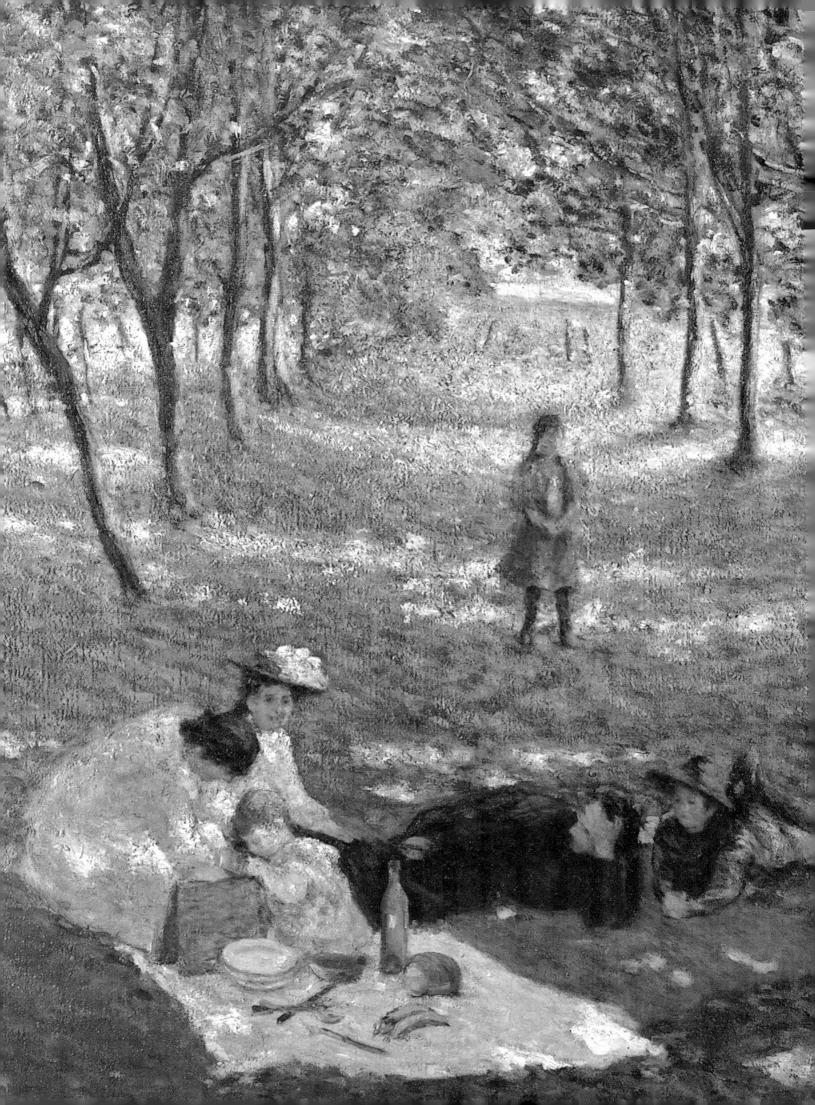

THE SURPRISE OF TODAY IS THE COMMONPLACE OF TOMORROW

How Impressionism Was Received in Canada

LAURIER LACROIX

IMPRESSIONISM FIRST BEGAN to make headway in Canada in the early 1890s. At that time, a struggle began between its supporters and its opponents which ended, over twenty years later, with its acceptance. The initial resistance to Impressionism by artists, critics, and collectors reveals how existing concepts of art and beauty were altered by the "New Painting," as well as how the New Painting was perceived by art-lovers.

Although recognized by a few collectors and artists as a pictorial renewal, Impressionism was denounced by many critics. It emerged at a time when the Canadian press called for the establishment of a national art, based on subjects inspired by Canadian life, and any formal or stylistic elements influenced by other national schools would be disregarded. Indeed, the French School was perceived as having a nefarious influence on the development of a typically "Canadian" art. This point of view, promoted by the painter William A. Sherwood, for example, emerged after the establishment of the Royal Canadian Academy in 1880. In Sherwood's words:

> The contention that all Art is universal, the subtle arguments of the latter-day connoisseur and foreign trained painter, are most effectual in checking or eliminating national life from our Art and affixing upon the pictures in our Art Galleries the stamp of foreign thought and theme.[1]

The Canadian government was attacked by the press for its laxness in supporting the development of art by training artists and building accessible public collections that would be the foundation of this national art.[2]

The delayed and restrained welcome meted to Impressionism is evidence of the principle that any artistic production, developed in a specific cultural context

Henri Beau
The Picnic, detail, circa 1905

and creative environment, cannot be transferred unless certain adaptations and modifications are applied by the accepting culture prior to its appropriation and self-identification. Expecting Canadian artists to adopt concepts and practices promoted by French Impressionists, without transforming them, would have been unreasonable, when it is well known that the appearance and development of Impressionism in France was itself modified by the artistic, intellectual, urban and even geographic milieus.

A study of how Impressionism was received raises certain problems relating to the evolution of the movement's interpretation. Accounts of French Impressionism reveal notable dissimilarities in the definition and appreciation of this complex movement, diversified as it is by hardly comparable variations in artistic sensitivities.[3] More recently, an evaluation of Impressionism's influence in many other countries has led to a review of the spread and transformation of this movement throughout the world.[4]

One of the major problems that interfered with the dissemination of the movement involved the difficulties in making these works more widely available.[5] Reproduction was a favored means by which a broad public could come into contact with art from other countries,[6] but paintings by Impressionists lost their meaning when reproduced with the printing technology then available. Copying, another traditional method of dissemination, was unthinkable for these paintings, which were perceived too often as spontaneously created and structureless, and which, in any case, were still seeking acceptance. For this reason, few Canadians had the experience of seeing Impressionist paintings directly—the only real way of grasping what was important in the work of the artists who employed the style. Although very imperfect, literary descriptions remained the main instrument in making known these paintings and the effects they produced, although the field-day satirists had with these compositions did not help to make them better understood.

In the thinking of much of Canada before 1915, the word "Impressionism" was synonymous with "modern" painting, which had to be resisted in order to insure quality and high standards in art.[7] And yet a few young artists did embrace this style and the new feeling of vitality and spontaneity with which it was associated, in order to express their sense of oneness with their environment.

In Canada, Impressionism was regarded as an example of art-for-art's-sake, a way of eliminating subject matter and, hence, the moral or didactic character judged essential for a work of art. Not only did many critics deny that such paintings manifested style and technique, both of which were shaped by the artist's interest in working directly from nature, but they also denounced the questioning of tradition and the intrusion of modern subjects. The term "Impressionism" was usually applied to a manner of painting that was spontaneous, involving loose brushwork and a light palette. Critics cast doubt on the longevity of such innovations, deeming them eccentric and perverse. With Impressionism, the creative process, as known at the time, and the reaction of the viewer to a work of art, begged for a new definition.

For example, commenting on a painting by William Henry Clapp, the Montreal art dealer William R. Watson discerned a creative process that began with an initial observation based on nature but ended in a blurred and incomprehensible painting:

> How did Mr. Clapp conceive this scene [*Afternoon*]? Certainly not as he put it on the canvas. He saw the men clear in the brilliant sunlight and sparkling water, the light streaming in their faces and casting dark shadows; he saw smooth masses of color in striking contrast to each other, an opposition of light and shade, and a distinct aerial and linear perspective. So much for the vision conveyed to the mind; we then commence work with the new fangled (and, I hope, ephemeral) technique of thirty-one-palette-knife-dots to the square inch; and the clear conception of the brain is transmuted into something almost incomprehensible. Truth is confounded into doubt, and light into darkness. Mr. Clapp is wonderfully clever; so much so, indeed that we find ourselves admiring his dexterity and labor instead of the picture as a picture.[8]

The introduction of Impressionism to Canada took place over the course of a few important stages. After 1890, a few Montreal collectors were acquiring Impressionist paintings, some of which were put on public display. Their selection by these collectors, whose social standing was undeniable, encouraged a careful examination of these paintings.

The exhibition of French works became more and more prevalent before the first world war. Paintings in an Impressionist style celebrating the Canadian wilderness were first seen in an exhibition in 1897. The warm reception accorded to them encouraged younger artists to adopt this manner of seeing and painting.[9] Slowly, the taste of the viewer was being transformed and, far from being automatically rejected, these works were gradually accepted by the public. One Montreal critic favorably observed that

> The main note of the exhibition is a riotous energy of the polychromatic. The dazzling color note of the ultra modern French school is alarmingly struck this year in many of the cleverest canvases and by comparison the rainbow becomes as bleached as a simple chord in C Major when juxtaposed to Claude de Bussy's [sic] complex harmonies.[10]

So-called Post-Impressionist works were first shown in Canada in 1913, at the spring show of the Art Association of Montreal,[11] thus providing Impressionism with a certain legitimacy and extending the borders of what was considered acceptable. It seems that it took just as much time in Canada as in France for certain Impressionist teachings to become, only some twenty years later, generally accepted practices.

French Impressionism in Canadian Collections

Janet Brooke's research indicates that the first Impressionist-inspired painting to enter a Canadian collection was Jean-François Raffaëlli's *Le terrain vague (Figures et âne)*, purchased in 1889 by Sir George A. Drummond.[12] This work was followed by traditional Impressionist paintings by artists such as Cassatt, Degas, Manet, Monet, Pissarro, Renoir, and Sisley.[13] It was mostly in the early 1890s that paintings by the forerunners of the movement, Eugène Boudin and especially Jean-Baptiste Corot,[14] were collected by Drummond, Angus, Hosmer, Learmont, and other magnates prominent in Montreal's financial circle. In 1891 Drummond also purchased the important *Portrait of Henri Michel-Lévy (The Artist in His Studio)*, painted by Edgar Degas in 1878.[15] At the time, it was one of the most important Impressionist canvases in Canada, together with the five Claude Monet paintings in the Drummond and Van Horne collections.[16] A few works by Camille Pissarro, Pierre-Auguste Renoir, Alfred Sisley;[17] *Head of a Woman (The Seamstress)* (circa 1881), a pastel-on-canvas by Édouard Manet;[18] and a canvas by Mary Cassatt, *Mother and Child (The Child's Caress)* (circa 1891),[19] completed this nucleus of modern French paintings collected by Montreal art-lovers. The limited number of acquisitions inspired A.Y. Jackson's disparaging remarks about Montreal collectors, the majority of whom continued to prefer Dutch painters—but not, ironically, van Gogh and Mondrian, he noted—and their Barbizon contemporaries, over the modern painting that was coming out of France.[20]

It would seem that Toronto collectors were not inclined to acquire Impressionist works during this period.[21] Yet it was at the Canadian Art Club,[22] founded in Toronto in 1907 (and in existence until 1915), that works in the Impressionist vein by artists such as W.H. Clapp (FIG. 1), Maurice Cullen, Clarence Gagnon, Ernest Lawson and Marc-Aurèle Suzor-Coté were most regularly shown. Works by these same artists, previously exhibited at the Art Association of Montreal and the Royal Canadian Academy, were lost among the hundreds of canvases on display, which made it difficult for the public to appreciate them.

A number of Impressionist paintings drawn from Montreal collections were shown at several of the annual loan exhibitions of paintings held on the premises of the Art Association of Montreal (now The Montreal Museum of Fine Arts), located at first on Phillip Square and, after 1912, in its new Sherbrooke

FIG. 1 William H. Clapp (1879–1954), *Birdnesting*, circa 1909, oil on canvas, 36½ × 28¾ in. (92.1 × 73.0 cm), The Oakland Museum of California. Gift of Mr. and Mrs. Donn Schroder.

Street building. Thus, in 1895 visitors had the opportunity to view two paintings by Renoir and three others by Cassatt, Monet, and Pissarro.[23] In 1897, 1914, and 1918 other Impressionist paintings from local collections were also exhibited there.[24]

The William Scott Gallery of Montreal appears to have been the only commercial gallery to have shown, on an irregular basis, works by members of the Impressionist school. In 1892 Scott presented a selection of canvases by Monet, Sisley, Pissarro, and Renoir.[25] In February 1906 the Art Association of Montreal held an exhibition of works loaned by Durand-Ruel,[26] and three years later mounted an important exhibition of French modern art, with more than 300 paintings, including works by Monet, Renoir, Besnard, and Le Sidaner.[27] It is not easy to estimate the interest and impact these paintings had on artists and the public. Sir William Van Horne stated, in reference to this exhibition:

I was interested to see how it had affected some of the painters exhibiting at the Royal Academy show. There were signs of touching up—evidently the brilliant coloring of the Frenchmen had made the Canadian pictures appear dull and sombre, and the artists had tried to liven them up.[28]

The Royal Canadian Academy's annual exhibition and, more importantly, the 1909 spring exhibition of the Art Association of Montreal were turning points as to the quality and number of works in the Impressionist style produced by Canadian artists. Paintings by Cullen, Clapp, and Gagnon shown there were praised by local journalists, as were canvases by Morrice, Suzor-Coté, and Helen McNicoll. "There is not a square inch in the canvas that is not luminous,"[29] wrote the *Montreal Daily Witness*'s art commentator referring to Morrice's *Regatta Saint Malo*, which received the prestigious Jessie Dow award. In the same exhibition, Suzor-Coté showed his noted *Winter Landscape* (FIG. 2), inspiring the comment:

The sun of a winter afternoon is striking upon a snow-covered hill, while in the valley a river is bursting its icy bands. There is a reality in this virile scene that makes it one of the most interesting snow scenes that has ever been hung in the gallery.[30]

Helen McNicoll, winner of the Jessie Dow award the previous year, was represented by four paintings which were also much appreciated: "Miss McNicoll… has certainly caught the spirit of the modern French impressionistic school. Her work is characterized by simplicity of composition and breath of treatment, allied with undoubted strength and an eye for the poetic in common objects…."[31]

Evidence that the acquisition and exhibition of Impressionist paintings influenced Canadian artists is minimal. For example, would William Brymner have been inspired by the large Renoir pastel of two young girls reading, *The Sisters*, formerly in the Van Horne collection (now unlocated)? The subject was of interest to this Canadian artist, as well as to numerous European painters under the inspiration of Henri Fantin-Latour. The experimental nature of Brymner's

technique—watercolor on linen—for his painting *The Picture Book* (FIG. 3) certainly facilitated the integration of the figures into the background. But this interior scene exhibited color values much less vivid than those of the Impressionists.

Impressionism and the Canadian Press

Impressionism was introduced to Canadians by the press, as well as by the exhibitions of European paintings described above.[32] *Arcadia*, a magazine edited by the composer, musicologist and choir-master Joseph Gould and published in Montreal from May 1892 to March 1893, offered a few articles in defence of Impressionism, such as those by Philip L. Hale, the noted Boston Impressionist, who contributed a column from Paris.[33]

As Canadian collectors became more receptive to the New Painting, some artists began defending the style. The Ontario landscape painter Homer Watson, for example, became an enthusiastic defender of the aesthetic, stating:

> [John Everett] Millais, [Frederic Lord] Leighton, J. [*sic;* i.e., George Frederick] Watts cling more to the old way of painting as exemplified by the early masters, but the younger men with an eye and idea of getting something new and fresh in the world of art have studied the laws of light and evanescence, *i.e.*, the way objects melt into the subtle medium of atmosphere in which they are environed. In landscape it is no longer a question of painting a view, or well-known scene, that takes with those well qualified to judge as to the merits or demerits of this art. It is rather the expression of some idea or of some mood of nature and generally of some simple subject in which scope is given for the full play of what artists now consider the great essential thing, and that is the value of objects as they show as colour tones. To represent these with a full brush, suggesting by well studied strokes nature's infinity of detail rather that niggling at the lesser truths, attention to which breeds conflict always with the larger essential truths. Rendering

FIG. 2 Marc-Aurèle Suzor-Coté (1869–1937), *Winter Landscape*, 1909, oil on canvas, 28 ½ × 37 ½ in. (72.4 × 95.3 cm), National Gallery of Canada, Ottawa.

> a thing in this way has been called impressionism. When done with masterly [*sic*] as in the best examples of Whistler and the three men named [George Clausen, Arthur Douglas Peppercorn and J.(?) Hitchcock (i.e., George Hitchcock or Lucius Wolcott Hitchcock?), with whom Watson had exhibited at the Goupil Gallery of London], it conveys a sense of lasting joy.... The true impressionist is he who leaves on his canvas a large array of what has been discovered to be the most artistic truths of nature, all expressed by the knowledge, sought out, that a feeling for spontaneity and breadth of handling gives.[34]

Impressionism, for Watson, involved a new attitude towards nature, coupled with freedom of technique. However, his understanding of the movement was based on the way it was practiced by British artists, who did not adopt the various stylistic and formal aspects developed in France, such as the use of bright colors and the dissolution of form.

Discussions of Impressionism focused on technique. No doubt this was one of the forms by which it was most easily recognized, while other formal and iconographic aspects inherent to it (framing, composition, urban and contemporary subjects, subjectivity, and spontaneity) received little attention in Canadian publications.

FIG. 3 William Brymner (1855–1925), *The Picture Book*
(Formerly titled *Two Girls Reading;* also exhibited as
Sisters.), 1898, watercolor on linen, 40½ × 29¼ in.
(102.9 × 74.3 cm), National Gallery of Canada, Ottawa.

For example, the conservative Toronto journalist who signed her columns with the humorous pen-name of Lynn C. Doyle (i.e., "linseed oil") referred to Impressionism as encompassing a range of technical means. Her comments, aimed at abating the controversy associated with the topic, identified a number of the movement's characteristics:

> Of Impressionism there are many kinds. One of the plein-air artists conveys a wonderful sense of atmosphere by the light key of the work, by a certain blue mistiness that never precludes good drawing and solid modelling. There is another kind that looks as though soft balls of red and orange and purple and green had been thrown at the canvas and had splattered in all directions.... Another reaches its effect with hatching—a succession of lines crossing or in the same directions, of pure colors sometimes, which, if properly handled, gives the pulsing effect of atmosphere, of vibrant air, either in portrait or landscape.[35]

This critic was forgetting that the Impressionists did not limit their work to bucolic and ethereal scenes. The works by Degas, Cassatt, Monet, and Renoir collected in Montreal reveal a wide variety of subjects. Reducing Impressionism to *plein-air* painting, an extension of the Barbizon School and rural landscape, was a useful short-cut in Canada, where the latter genre was dominant from the 1890s.

The Dissemination of Impressionism by Canadian Artists

The 200-odd Canadian artists resident in Paris before World War I were influenced relatively little by French Impressionist paintings. The teaching in independent academies, such as Julian's and the Colarossi, and at the École des Beaux-Arts, reinforced their academic training, which stressed craftsmanship and copying from the old masters.[36]

This exhibition features paintings by such Paris-trained Canadian artists as Henri Beau, William Blair Bruce, W.H. Clapp, M.-A. Suzor-Coté, and Maurice Cullen, who adopted certain aspects of the new aesthetic.[37] Some twenty years after the appearance of the movement, Impressionism was on its way to becoming an international school, with a number of varieties and adaptations. Canadian artists were exposed not only to Impressionism as interpreted by their French counterparts but, through travel and personal connections, they also came into contact with the works of American, British, Scandinavian and even Spanish artists—for example, John Singer Sargent, Fritz Thaulow or Joaquín Sorolla—who worked in the Impressionist style, thus multiplying the potential sources of influence.

Blair Bruce (PLATES 2–5), who was among the first Canadians to paint *en plein-air*, adapted his palette to accommodate brighter colors. Well aware of the shock this might produce back in Canada, he appeared reluctant to send home this new style of work. On 24 June 1887 he wrote to his mother from the village of Giverny, a site Monet would soon make famous, which he described as:

this [is the] most beautiful part of France, the river Seine running almost at our door. The village is far far ahead of Barbizon in every respect.... You will no doubt wonder why no paintings of mine have been sent home as yet, but I assure you it requires more time to do that sort of thing than one imagines, and many which I had intended to send I have held back knowing well that I might have more suitable ones as I continued working.[38]

In the early 1890s, Impressionist-inspired paintings were already being created in Canada by a few artists, such as Frederick S. Challener and Mary Bell Eastlake, who, at the 1894 spring show of the Art Association of Montreal, exhibited light-filled pictures that seemed a hybrid of Renoir and Jules Bastien-Lepage.

During the winter of 1896–97 in Québec, Maurice Cullen and James Wilson Morrice adapted the Impressionist style to the interpretation of Canadian scenery. Both artists were inspired by the dazzling winter sunlight of the countryside (PLATE 41) and by the pictorial potential of Quebec City, dominated by the Citadel (FIG. 4). The relationship between the two artists' work was analyzed by Lucie Dorais as follows:

> ...in Beaupré, in January 1897, away from Robert Henri and the Anglo-Saxons of Paris who worshipped Whistler, Morrice yielded to the Impressionist creed—Cullen's version. *Sainte-Anne-de-Beaupré* and *Citadel, Québec* are proof of the enthusiasm with which he suddenly took to a motif and a style completely new for him. However, we cannot really classify these light-filled paintings as real Impressionism, since neither Cullen *nor* Morrice used the broken brush-stroke—Cullen on principle (it would have destroyed the three-dimensional space), Morrice...because he was influenced by Cullen and perhaps, more simply because he did not know the technique, never having the opportunity (or at least the interest) to see the works of the Impressionist masters in Paris.[39]

Cullen, who had returned from France in January 1896, had already started to explore the Canadian

FIG. 4 James Wilson Morrice (1865–1924), *Quebec Citadel by Moonlight*, 1897, oil on canvas, 22 × 15½ in. (55.9 × 39.4 cm), Musée du Québec, Quebec City.

wilderness. With Morrice, he centered his work on the river shores around Quebec and Levis, finding points of interest in shipyards, sawmills and ferryboats (PLATE 27)—scenes where industrial smoke blended with river mist and hazy, snowy skies.[40] The shapes of the landscape were welded in thick impasto. "Mr. Cullen's work is very direct," noted a journalist, "and he gets his values true and strong without any hesitation."[41] While the press recognized the novel aspects of Cullen's compositions, noting the use of lively colors and impastoed surfaces, commentators did not agree as to the results. Robertine Barry, a *La Patrie* reporter and a pioneer of women's journalism in Canada, lauded the pictorial character of these paintings, which avoided the usual literary baggage. "Mr. Cullen," she wrote, "is a conscientious Impressionist of the French modern school. I could never interpret for you the extraordinary effect of his paintings. His winter scenes possess an astoundingly powerful coloring; we can feel that he paints what he sees and as how he sees it, being his only concern to render nature sincerely."[42]

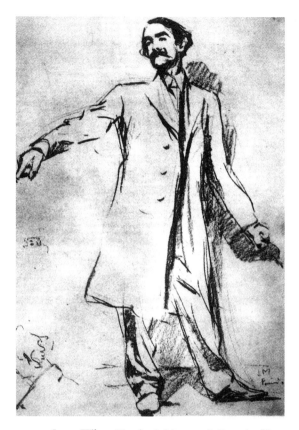

FIG. 5 James Wilson Morrice (1865–1924), *Portrait of James McNeill Whistler*, 1903, black chalk on paper, 11 3/4 × 8 1/4 in. (29.8 × 20.7 cm). Reproduced in *Christie's (Canada) with Montreal Book Auctions/ L'Encan des Livres de Montréal: Important Paintings, Prints, Drawings & Watercolours by Canadian Artists...* (Montreal: Christie, Manson & Woods [Canada] Ltd., 1969), p. 23, lot 20.

Artistic honesty and sincerity in observation and rendering are compelling touchstones in the definition of modern art, but they did not authorize Canadian artists to abandon all conventions. G. de Werthemer in *Les Nouvelles* was more guarded towards Cullen's work and iterated the oft-repeated comment about the lack of drawing, the spatial distortion and the clumsiness of the handling:

> We are fully in Impressionism, and a good one. I do not know Quebec but it appears to me that with such colors, a much richer atmosphere of lightness and *distance* should emanate from it than what is given to us by Mr. Cullen, who reveals himself in this canvas as a strong and very fine colorist, but as an inadequate draftsman. His ship's hull, his foregrounds are really *loose* and his stream of violet mountains, fading in the

horizon, seem to us much too dry, too rough, not enough *floating* in the air. This is detrimental to perspective and makes it appear too close. We could recommend for Mr. M. Cullen a little less knife-work and a little more brush.[43]

Cullen's winter scenes were admired. He would come to be described as one of the most experimental interpreters of nature. Referring to the 1904 exhibition of the Royal Canadian Academy, one writer noted:

> Mr. Cullen has a number of things in the collection, and all of them are characteristic. He is, perhaps, Montreal's foremost exponent of the impressionistic school. All show startling originality in composition, treatment and color scheme. He is in no small degree a mood-painter.[44]

J.W. Morrice's work was often associated with that of Whistler (FIG. 5). Many viewed him as a painter of atmosphere, capable of capturing and transmitting in pictorial terms feelings and ambience emanating from the different scenes and sites that inspired him. A grey or snowy sky (FIG. 6) or the sunlit landscape along the St. Lawrence River were translated into paint by soft brushwork.

Morrice was represented by eleven paintings at the 1909 spring show of the Art Association of Montreal, and returned during the next five years with three or four canvases that were acclaimed as masterpieces. Viewing *Near the Fort, Saint-Malo*, William R. Watson expressed astonishment:

> I hardly know what to say of this painting. I cannot muster language mellifluous enough to describe its almost ineffable beauty. Mr. Morrice is an artistic epicure. His art may perhaps be described as a vehicle for conveying to the eyes certain delicate arrangements of tone. Let me use the metaphor or analogy of music which Whistler was so fond of. He arranges his passages of tone, his notes of color so as to create delicate "symphonies" and "movements" which strangely captivate the artistic sense. Not the least delightful pictures producing chords of optical sensation— so the clear blue darkness of a summer's night, with a sky which you may look through....[45]

Morrice's paintings were described as inspired but classic, as spontaneous but also rigorous.

The snow scene [*Snow, Quebec*] is one of the most beautiful pictures Morrice has exhibited for years, a perfect harmony of tone, and vitally pregnant with the intensive feeling which accompanied its conception.... Technically, his spontaneous and almost luscious touch, the refinement and chastity of his color and sensitiveness of tone, will call for intelligent admiration. Though the chosen manner of Mr. Morrice is extremely treacherous, like the literary parallel of the sonnet, incapable of hiding the slightest error or forgiving a fault in melody—his complete mastery over line and color rarely permits the record of failure. His work appeals both to the intellect and the heart, while the superlative beauty of his coloring gives intense gratification and solace to the artistic senses.[46]

What critics found most difficult to come to terms with was the choice of bright colors and the use of varied pictorial techniques. Henri Beau, who favoured an orange, blue, green, mauve, and pink palette applied with a divisionist touch, was often taunted by the press. At the 1897 spring show of the Art Association of Montreal, the "Impressionist" painting *Reader* was vilified: "The master Impressionists have done some beautiful things," admits Louis Fréchette:

If not more definite sensations, they at times provide a sense of dream; and dreaming has its place in the range of human impressions, this I know. But the Impressionist school's fault is to have no formula. Thus follows systematically incoherence, extravagance, oddity and quaintness.... Of all paintings of this school shown at the Show, incontestably it is that of Mr. Beau which is the least unpleasant; but I regret to see this young artist, which has once demonstrated an agreeable and sincere ability, losing himself in the nonsense of a fashion that will never be a serious manifestation of art.[47]

A few years later, Beau's painting *The Picnic* (PLATE 55), shown at the Art Association of Montreal

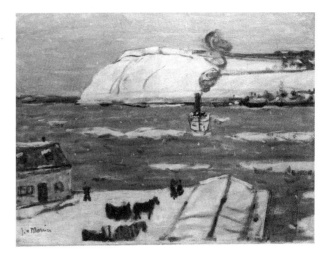

FIG. 6 James Wilson Morrice (1865–1924), *The Ferry, Quebec*, 1906, oil on canvas, 24 × 32 in. (61.0 × 81.3 cm), National Gallery of Canada, Ottawa.

in 1905, divided the critics. At least a few appreciated the true subject of the canvas, one writing that "Mr. Beau has dealt with an exceedingly hard subject, light and shadow,"[48] and another that "The effects of light through the foliage of the trees, reveal a master."[49] Others, however, voiced reproofs, even rejection, for his manipulation of pictorial matter that related not to the nature of represented objects, but to the painting itself:[50]

In the present Spring Exhibition there are not a few paintings less likeable and successful because of the "little more," [a reference to the poet Robert Browning] and a notable example, we think, is "The Picnic," of Mr. Henri Beau. It is a very attractive picture, of which much that is congratulatory may be said, and the medicine must be all the more palatable on that account. The trouble is that Mr. Beau worked too long over it, until now the texture of his surface resembles low relief, or rough-cast.... Mr. Beau set out to obtain the stippled or mottled effect that is often seen on a hot day.[51]

Among the other Montreal artists who utilized Impressionist techniques were Harriet Ford, Suzor-Coté and Clapp. Ford, for example, composed a painting of peasants by placing colored strokes side by side. This work had been integrated in the fireplace

FIG. 7 Marc-Aurèle Suzor-Coté (1869–1937), *Fall Ploughing in Arthabaska*, 1909, oil on canvas, 24 × 34 ¼ in. (61.0 × 87.0 cm), Le Musée d'art de Joliette, Joliette, Quebec.

mantelpiece of the summer villa of Charles Porteous at Sainte-Pétronille (Ile-d'Orléans).[52] Suzor-Coté also used the divisionist technique in certain of his landscapes and portraits of peasants (PLATE 65), although at times Impressionism was unsuited to such subjects. As noted in the *Montreal Gazette*, "Suzor-Coté … in 'Autumn Ploughing' [FIG. 7]… showed a stronger leaning towards the modern French school, and is running into danger by the trickery of stipple-work. When will the invidious influence of this 'pastry' method be purged from Canadian Art?"[53] In fact, in his spatula-produced paintings Suzor-Coté realistically combined the movement and matter of the subject, which he then integrated in his composition. The drawing was inscribed in the thickness of the impasto, which suggested the rapid movement of icy water (PLATE 48), or the fleeting of shadows across the snow (FIG. 8).

William Henry Clapp, winner of the Jessie Dow award in 1908, earned a reputation as an innovator, "allied to the Post-Post Impressionists,"[54] by alternating between a divisionist and a pointillist style of painting, and especially by using a palette of pure colors. For him, form dissolved in bright hues: "Mr. Clapp has several 'plein air' pictures in the modern French style, blazing with light and color,"[55] was one comment made by a member of the Montreal press, who were finally becoming resigned to the capture of fleeting natural effects seized by the subjective eye of the artist and preserved for posterity on canvas. It was his parents' move to California, rather than the poor reception of his work, that made Clapp leave

Montreal for good in 1917.[56] Artists such as William Brymner, Clarence Gagnon, A.Y. Jackson, and Robert Pilot viewed him as an original and innovative painter, totally dedicated to his art.

IN 1909 ROBERT HARRIS, the dean of Canadian portrait painters and one of the country's most honored artists, acknowledged the benefit Impressionism had brought to the development of painting in Canada. He wrote:

> Within the past few years, none can have failed to observe in our exhibitions, what, indeed, is noticeable in most collections of modern pictures, the lightening of the palette and an added brilliance in color, especially in the treatment of outdoor subjects. For this great gift of new vision, art is, of course, beholden to the impressionist movement.[57]

Olivier Maurault penned this appraisal a few years later: "Our contemporary landscape artists do not ignore what good Impressionism has done to art; they have borrowed from it a few processes and a love for beautiful, lively colors."[58]

In Canada, the winter landscape, a subject explored by such artists as Cullen, Morrice, Suzor-Coté, Gagnon (PLATE 30), J.E.H. MacDonald (PLATE 39) and others, was certainly a genre that furthered the acceptance of Impressionist-inspired painting

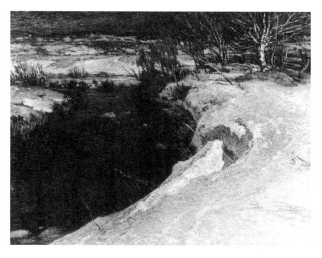

FIG. 8 Marc-Aurèle Suzor-Coté (1869–1937), *Passing Shadows (End of Winter, Gosselin River)*, 1918, oil on canvas, 40 × 54 ½ in. (101.6 × 138.4 cm), Edmonton Art Gallery Collection, Edmonton, Alberta. Gift of Dr. R. B. Wells, 1927.

after 1895. Winter landscapes had value because they paid tribute to a typical Canadian reality. The subject was especially appealing to critics who sought a national art specific to Canada. This choice of motif allowed young artists to pursue the formal and chromatic explorations to which they had been introduced in France. By combining and adapting the techniques of painting in high keys to their perception of the Canadian landscape, certain artists were able to contribute both to the spread of Impressionism and to the affirmation of modern painting in the country that was their home.

Translation by Monique Nadeau and Alphonse Saumier, revised by Maggie Keith

NOTES

I am grateful to my colleague Esther Trépanier (of the Université du Québec à Montréal) for her comments on the first version of this essay.

1 William A. Sherwood, "A National Spirit in Art," *Canada: An Encyclopedia of the Country*, ed. J.C. Hopkins, vol. 4 (Toronto: Linscott, 1898), pp. 366–70. See also the same author's article of the same title in *Canadian Magazine* 3 (October 1894): 498–501.

2 Articles on the subject include: Delta, "Art Notes," *The Week*, 21 May 1885; and Thomas Turnbull, "Historical Art in Canada: To the Editor of Arcadia," *Arcadia*, 1 March 1893, p. 449. The French-language press criticized the French-Canadian population for its weak support for the arts: see Amateur, "Art Association," *La Patrie*, 28 April 1894, p. 1; or Madame Dandurand's columns in *Le coin du feu* in 1895.

3 John Rewald, *The History of Impressionism*, 4th ed. (New York: Graphic Society, 1973); Hélène Adhémar and Anthony M. Clark, *Centenaire de l'Impressionnisme* (Paris: Éditions des musées nationaux, 1974); Charles S. Moffett, *The New Painting: Impressionism, 1874–1886* (San Francisco: The Fine Arts Museums of San Francisco, 1986); Henri Loyrette and Gary Tinterow, *Origins of Impressionism* (New York: The Metropolitan Museum of Art, 1994).

4 See, among other sources, the impressive bibliography published in *World Impressionism: The International Movement, 1860–1920*, ed. Norma Broude (New York: Harry N. Abrams, 1990), pp. 416–19, and Dennis Reid's essay on Impressionism in Canada (pp. 92–113).

5 This is made evident, for example, with the line-reproduction of Mary Cassatt's *Mother and Child*, in the Van Horne collection, published in the 20 November 1895 issue of *Montreal Daily Witness*, under the heading, "The Paintings: Lovers of Art View the Works of Great Masters."

6 Michel Melot demonstrated how Pissarro, for example, attempted with Degas's assistance to broaden his market through printmaking, beginning in 1880; see "La pratique d'un artiste: Pissarro graveur en 1880," *Histoire et critique des arts*, no. 2 (June 1977): 14–38. See also Melot's *L'estampe impressionniste* (Paris: Flammarion, 1994).

7 In the 1910s, while Post-Impressionism, Futurism and Cubism were also criticized, the word Impressionism remained associated to these movements and shared their rejection, as it was perceived as the style that brought about the degeneration of art. Incomprehension and disapproval of Impressionism persisted, as can be seen from the fact that, as late as 1915, the painter Henri Fabien, a columnist for *Le Devoir*, could write, "There is with our painters a tendency towards Impressionism; but happily, it is an Impressionism that is related to great art, that is perfected, completed and not haphazard." ("Beaux-Arts: Le vernissage à l'Académie royale," 19 November 1915, p. 1).

8 William R. Watson, "Notable Canvases in Art Exhibit," *The Gazette* (Montreal), 13 April 1910, p. 4.

9 This conclusion rests, for the time being, on an incomplete survey of the printed media. Notwithstanding its importance, this source must be considered with care. Articles are often unsigned and relate to circumstances that would bear more extensive consideration. Quoted extracts would require that each article be quoted more extensively and that the author be identified, as well as the ideological trend of the cited publication. An *Arcadia* magazine observer severely criticizes the quality of articles in the daily press and compares their lack of judgment to that of their readers: "As for newspaper critics—after their recent exploits in print, comment is needless. Newspaper critics mirror the want of aesthetic thought and art education of the masses they cater for." ("On Popular Picture," *Arcadia*, 16 May 1892, p. 33.)

10 "Exhibition of Art: Some Brilliant Canvases Dazzle Eye in the 24th Spring Exhibit in Art Gallery," *The Gazette*, 20 March 1908, p. 10. The relationship between Impressionist painting and Debussy's music has often been noted. It was, for instance, the subject of a lecture accompanied by musical extracts (*Pelléas et Mélisande*, *L'enfant prodigue*, *Romance*) given at the Art Association of Montreal by Prof. H.C. Perrin of McGill University. (See "Impressionism and Musical Art," *Montreal Daily Witness*, 14 March 1913.)

11 Works by John Lyman, Randolph Hewton and A. Y. Jackson were mostly responsible for the scandal created. The three artists were exhibiting works produced during their stay in France (Lyman) and Italy (Hewton and Jackson). Newspapers were filled with a lively controversy, fielding the critics H. Mortimer Lamb and Morgan S. Powell as well as the painter John Lyman. ("Post Impressionists Shock Local Art Lovers at the Spring Exhibition," *Montreal Daily Witness*, 26 March 1913; "The New Style of Painting," *Montreal Daily Witness*, 8 April 1913; S. Morgan-Powell, "Some Post Impressionistic Thoughts on the Post Impressionist Movement," *Montreal Daily Star*, 10 May 1913, p. 12; "Mr. John G. Lyman in Defence of Post Impressionist Painting," *Montreal Daily Star*, 17 May 1913, p. 12.)

12 Having sought, with reason, to keep his distance from the "Impressionist" label, with which his work has little relation, Raffaëlli took advantage of the fame of his youthful acquaintances and the commercial success of the movement to become a protagonist of this "school." During a North American promotional tour of his work, he gave a talk on 2 May 1895 at the Art Association of Montreal. The extensive report published by the *Montreal Daily Star* ("Rafaëlli [sic] on Impressionism, An Interesting Lecture at the Art Gallery," 3 May 1895, p. 7) mentions his view that Impressionism had become a very broad concept: "Impressionism…represents the complete development of each artistic temperament, and a perfect liberty to say what we have to say in our own way." Montreal's recognition of Raffaëlli as a representative of Impressionism is attested to in a *Montreal Daily Witness* report ("The Spring Exhibition," 17 March 1903) that ascribed to this artist the paternity of the pointillist technique then used by the Montreal artist William R. Hope (1863–1931): "the artist has turned for the time being from that legitimate English school which he was following with so much promise and actual success to represent for us his idea of June greenery, which we understand in its present guise is one of the latest of Parisian fads. Or is it the latest? We wonder that one of our men

has not thrown away his palette, brushes, tubes, and other paraphernalia to take up the new method introduced by M.J.J. Rafaelli [*sic*], who has contrived to put oil colors in small solid stitchlike crayons."

13 See Janet Brooke, *Discerning Tastes: Montreal Collectors, 1880–1920* (Montreal: Musée des beaux-arts de Montréal, 1989).

14 Brooke, *Discerning Tastes*, pp. 175–76, 52–53, 182–84, 71–75, repr.

15 Brooke, *Discerning Tastes*, pp. 90–91, col. repr. pl. XV.

16 *Lucerne and Poppies* (1887), formerly in the Sir George A. Drummond collection; and *Cottage at Sainte-Adresse* (1867), *The Seine at Bougival, Evening* (1869–70), *Gardener's House at Antibes* (1888), and *Two Haystacks, End of Day, Autumn* (1891), all acquired by Sir William Van Horne between 1892 and 1911. (Brooke, *Discerning Tastes*, pp. 216, 134–36, repr.)

17 Brooke, pp. 223, 224, 229, repr.

18 Manet's work does not appear to have been well-known in Canada. In his 1896 lecture, William Brymner (see endnote 23) briefly describes the strong effect of his visit to the Manet retrospective in Paris in 1884.

19 Brooke, p. 178, repr. p. 145. With reference to Cassatt, Pissarro and Renoir, Lynn C. Doyle commented in an article that, "Among the Montreal connoisseurs in art[,] Sir William Van Horne seems to be almost alone in his admiration of that phase of the modern French School, impressionism." (*Saturday Night*, 25 April 1896, p. 9).

20 A.Y. Jackson, *A Painter's Country* (Toronto: Clarke Irwin and Company, 1976), p. 18.

21 A full survey of the Toronto collections of that period is still to be carried out. An item in *The Bystander* (January 1890, p. 133) reaches the conclusion that the slow development of visual arts in Toronto is due to the attitude of art-lovers: "The Canadian millionaire when he goes to Europe can buy under good advice as well as with an infinitely greater choice." In a report on visits to Toronto collectors, published in *Toronto Saturday Night* (21 December 1895, p. 3), Lynn C. Doyle also mentions a number of works, but none in the Impressionist style. Toronto's major art collector of the time, Sir Edmund Walker, kept in his library— which was decorated with George Reid murals—a collection of prints that included etchings by a few contemporary masters.

22 Robert J. Lamb, in *The Canadian Art Club (1907–1916)* (Edmonton, Alberta.: Edmonton Art Gallery, 1988), reviewed the important role played by this group of exhibitors in having the early stage of modern painting recognized in Canada.

23 The painter William Brymner made these comments in a public lecture: "The 'Old Chelsea Bridge,' by Pissarro, is all done in a multitude of dots and spots and lines of different colors, which, when seen close at hand seem to have no meaning. Why did he not paint a plain bridge and have done with it? In looking at the bridge in the evening, Pissarro felt that 'plain bridge' was a very small part of what he was looking at, and that the bridge was not what attracted him to the subject. For had he not often seen the bridge in the morning and at noon, and had never thought of making a picture of it? What attracted him now, was the play of light around every object before his eyes. The bridge and the river were all shimmering with light, and to represent this light was his principal difficulty." ("Re Impressionism What It Is and in What it Differs from Other Schools," *The Gazette*, 12 March 1896, p. 2.) This same lecture contains the statement from which my main title is drawn.

24 Brooke, 1989, pp. 90, 208, 216, and 224. During the fall of 1895 a selection of works from Montreal private collections was shown in Toronto. Lynn C. Doyle appraised the Montreal collections (*Saturday Night*, 18 April 1896, p. 9): "with few exceptions there seem to be little admiration for the modern French Schools, for the luminarists, the impressionists, the Monet-ists (if there is such a word)."

25 "The Impressionists," *Arcadia* (December 1892): 325.

26 Manet's *The Tragic Actor (Hamlet)* (1865–66) was especially noticed by the press. "The Impressionists at Art Gallery," *Montreal Daily Star*, 14 February 1906, p. 3; "Loan Exhibition: Twenty-Nine Examples of French Impressionist School," *The Gazette*, 13 February 1906, p. 7. Another article, headed "What is Art?" (*Montreal Daily Witness*, 12 February 1906), seized the opportunity to note a few traits of the evolution of French painting: "Although impressionism seems only as of yesterday, yet a quarter of a century ago it gave us Néo-Impressionism, with a new feature, 'Pointillism,' or the division of color into very small spots of equal size, like a mosaic.... [T]he work of the impressionists during the past forty years has had a broadening effect upon all painting...."

27 Rodin's *Le Penseur* and Lalique jewelery were the main features of the exhibition containing more than 500 works. The press mentioned with enthusiasm the Impressionist paintings, mostly by quoting the comments of guest-curator Louis Hourteloup and of Louis Gillet, then visiting professor at Laval University. See: "L'exposition de l'art français et les Canadiens-Français," *Le Canada*, 8 February 1909, p. 4; "Magnificent Exhibition of Modern French Art Opened in Montreal," *Montreal Daily Witness*, 30 January 1909; "L'exposition d'art français officiellement ouverte hier soir," *Le Canada*, 30 January 1909, pp. 15–16; M. Jenkins, "Impressionist Art Exhibition," *Canadian Courier* (Toronto), 20 February 1909, p. 11. The most interesting comment on this exhibition was written by E.B. Greenshields, "Art and the Recent French Exhibition," *Montreal Daily Witness*, 18 May 1909.

28 "Sir William Van Horne on Canadian Art," *Toronto Saturday Night* 22 (5 June 1909), p. 5.

29 "Pictures that Are Being Talked About," *Montreal Daily Witness*, 15 April 1909. See also: "Art Exhibition of Much Merit," *Montreal Daily Herald*, 5 April 1910; "Art Exhibit Opens," *The Gazette*, 5 April 1910, p. 7.

30 "Art Exhibit Opens," p. 7.

31 "Art Exhibit Opens," p. 7.

32 The pioneering role played by an article, "Studio Notes: Impressionism," published in the short-lived magazine *Arion*, in September 1881 (pp. 89–90), should be noted. However, this article does not seem to have had any immediate repercussions.

33 The ideas it promoted were not always the most enlightening or the most reliable, as seen in this excerpt by an unnamed critic: "They call themselves the '*plein air* school,' and are, in a sense, disciples of Ruskin, with that deftness of brush and a disregard of perspective characteristic of the Flowery Kingdom." ("The Impressionists," *Arcadia* 1 (15 December 1892): 325. See Carol Lowrey, "Arcadia and Canadian Art." *Vanguard* 15 (April/May 1986): 19–22.

34 Homer Watson, *The Week*, 11 November 1892, p. 795. Watson had just returned from a trip to England. The Canadian press did not whole-heartedly endorse Impressionism, however. Only a few months later, this same newspaper supported a totally opposite point of view (3 February 1893, p. 229) by reprinting from *Scribner's Monthly* an article by W.C. Brownell, of which the following extract is representative: "A theory of technique is not a philosophy, however systematic it may be. It is a mechanical, not an intellectual point of view." This, Brownell believed, is where Impressionist fails; in his work we do not discern, as in the great pictures, "the attitude of the painter towards life and the world in general."

35 Lynn C. Doyle, "Art Notes," *Toronto Saturday Night* (11 May 1895), p. 9. William R. Watson summarizes in an article the influence of the Impressionist technique in different but comparable terms that testify to the difficulty of naming the pictorial experience proposed by Impressionism: "Meantime, artists here and there in the world were striving for a more felicitous mode of expression; experimenting in all directions and with varying results. Round-spot impressionism, founded on an analysis of the solar-spectrum, touch impressionism, flanging crude pigments, struggling to express radiating light, back again to the low tones

of Valasquez [sic], and once more to the spot and Mass-Impressionism of the Scotch movement as typified by Ferguson and Hornel." ("Post-Impressionism Review of a Movement Which Has Stirred Controversy," *The Gazette*, 30 March 1912, p. 2.)

36 See Laurier Lacroix, "Les artistes canadiens copistes au Louvre (1838–1908)," *Journal of Canadian Art History* 2 (Summer 1975): 54–70; Sylvain Allaire, *Les artistes canadiens aux Salons de Paris, de 1870 à 1914*, thesis, Université de Montréal, 1985.

37 The newspaper *Paris-Canada* regularly called to its readers' attention the progress made by Canadian artists in Paris. Paintings by Cullen and Suzor-Coté were the noted for their "leaning towards Impressionism." (20 December 1890, p. 1, 13 February 1892, p. 1, 9 June 1894, p. 1.)

38 W. Blair Bruce, *Letters Home: 1859–1906. The Letters of William Blair Bruce*, ed. Joan Murray (Moonbeam, Ont.: Penumbra Press, 1982), p. 123. See also William H. Gerdts, *Monet's Giverny: An Impressionist Colony* (New York: Abbeville Press, 1993).

39 Lucie Dorais, *James Wilson Morrice: les années de formation*, thesis, Université de Montréal, 1980, p. 237; quoted in translation by Sylvia Antoniou, *Maurice Cullen: 1866–1934* (Kingston, Ont.: Agnes Etherington Art Centre, Queens University 1982), p. 46. The latter offers a detailed analysis of the artist's production and acceptance.

40 Depictions of aspects of the modern city raised a serious problem for the art critic for whom the coloring and the veil of mystery enveloping the cityscape does not warrant the choice of the subject for a landscape. A critic for the *Montreal Daily Witness* ("Art Exhibition," 24 March 1904) made these comments on Cullen's *Quebec from Levis* (The Montreal Museum of Fine Arts):

> Then there is the ugly, uncompromising elevator, which should have been left out of a scene which suggests poetical intent. The mere outline of an elevator is fatal to any pretension to loveliness; but the realists of to-day, as a protest against the classic brown tree, and all that sort of thing, go to the opposite extreme, and "make game" of a painter who omits any trivial detail from his note book. The most serious defect in this picture, however, is in the representation of the city, which was meant to be made to appear mystical, if not somewhat fantastical.

41 "The Spring Exhibition, Some of the Striking Pictures of the Exhibition." *Montreal Daily Star*, 2 April 1897, p. 6.

42 Françoise [Robertine Barry's pen-name], "Chronique du lundi," *La Patrie*, 12 April 1897, p. 2.

43 G. de Werthemer, "L'exposition annuelle de peintures à l'*Art Association*," *Les Nouvelles*, 4 April 1897, pp. 2–3.

44 "Art Exhibition Annual Display of Royal Canadian Academy Opens at the Art Gallery," *The Gazette*, 18 March 1904, p. 6; "Mr. Maurice Cullen shows examples of the 'plein air' school different from anything else in the gallery and strong vigorous and broad in their treatment," "Hold Private View," *The Gazette*, 13 March 1903, p. 5; "Mr. Maurice Cullen, a Montreal experimentalist, has got six pictures past the committee [of the Royal Canadian Academy]. That Mr. Cullen is honestly and industriously experimenting for a new effect, and will probably get it some day, one cannot doubt; but one does not understand the reason for horizontal lines of alternating smooth and rough brushwork right across his pictures," "The Royal Canadian Academy," *Toronto News*, March 21, 1904, p. 4.

45 Watson, "Notable Canvases in Art Exhibit," *The Gazette*, 13 April 1910, p. 4. For a more detailed account of how Morrice was greeted by the Canadian media, see Rosalie Smith McCrea's master's thesis, "James Wilson Morrice and the Canadian Press, 1888–1916: His Role in Canadian Art," Carleton University, Ottawa, 1980.

46 Watson, "Artists' Work of High Order," *The Gazette*, 10 March 1911, p. 7.

47 Louis Fréchette, "Le Salon," *La Presse*, 10 April 1897, p. 4.

However, Fréchette muddles the subject, in that an onieric art is more related to Symbolism than to Impressionism.

A Toronto critic was even harsher: "The four oils of Mr. Beau have been left for separate mention, because Mr. Beau, in defiance of his name, has constituted himself the apostle of the ugly. His 'Madame F.' is a piece of brutality in flesh and yellow which should scarcely have been admitted to the gallery on grounds of decency if not of art.... Mr. Beau's work is not poetic." ("The Royal Canadian Academy," *The Toronto News*, 21 March 1904.)

48 "Twenty-Second Spring Exhibition of Paintings Opened at the Art Gallery Last Evening with Private View," *Montreal Daily Star* (18 March 1905), p. 12.

49 Albert Laberge, "À la Galerie des arts, brillante ouverture de l'Exposition annuelle de peinture," *La Presse* (Montreal), 20 March 1905, p. 10.

50 "Mr. Bean's [sic] works are of great interest though it is open to question whether any of them are successful. In his effort to seize the elusive moving qualities of hot atmosphere, he is getting nearer and nearer to a valid and pleasing, not too highly original effect." ("Spring Show a Thing of Extremes," *Montreal Daily Herald*, 18 March, 1905, p. 4)

51 "Art Exhibition," *Montreal Daily Witness*, 21 March 1905.

52 See Janet Braide, *William Brymner* (Kingston, Ont.: Agnes Etherington Art Centre, Queen's University, 1979), p. 45. The villa was also decorated with murals by Brymner and Maurice Cullen.

53 "Notable Canvases in Art Exhibit," *The Gazette*, 13 April 1910, p. 1.

54 Watson, "Artists' Work of High Order," *The Gazette*, 10 March 1911, p. 7. "Mr...Clapp does not get very far, or attain any definitive results, with his experimental Impressionist and quasi-Post-Impressionist efforts. His work lacks depth." ("Art Association Shows Notable Features," *Montreal Daily Star*, 25 March 1913, p. 3.)

55 "Pictures that Are Being Talked About," *Montreal Daily Witness*, 15 April 1909.

"Devotees of the impressionist school will find much to admire in three examples of Mr. Clapp's latest work, hung in the old gallery near the entrance, 'The New Church', 'Bird Nesting' and 'Afternoon.' They are the most advanced work of their school in the exhibition." ("Art Exhibit Opens," *The Gazette*, 5 April 1910, p. 7.)

56 On the subject of Clapp, see the many references to him in Nancy Boas, *The Society of Six Colorists* (San Francisco: Bedford Arts, 1988).

57 Robert Harris, "Canadian Painters," *Montreal Daily Witness*, 18 May 1909.

58 Olivier Maurault, p.s.s., "L'art au Canada," *Marges d'histoire* (Montreal: Librairie d'Action canadienne-française, 1928), p. 303. See also, in the same anthology, "Tendances de l'art canadien," p. 24.

THE SENSATIONS PRODUCED BY (THEIR OWN) LANDSCAPE

Some Alternative Paths to—and Away from—Canadian Impressionism

ROBERT STACEY

CONSCIOUSLY OR UNCONSCIOUSLY, the seekers after a genuinely Canadian school of painting modelled their image on that of the hardy Nor'wester, a now-vanished breed of freelance woodland over-winterer who, in the words of the poet Douglas LePan, "in youth travels the canoe routes westward…and who only when he is middle-aged returns to settle permanently in Montreal and to build himself a big house on the side of the mountain where he can look out and see the River of Canada flowing by and remember when he was young and lived hard and was ready for anything that might come at the next portage or the next turn of the river."[1] Trailblazer, pathfinder, *voyageur*: from archetype, as Marshall McLuhan famously did not say, to cliché.

Ironically, the rugged conformists who built Canada tended, once established in urban comfort, to surround themselves with status-confirming symbols of Old World civilization (i.e. Scottish, Barbizon and Hague School paintings), as if the wilderness where they had struck it rich were too far beyond the pale of polite culture for depictions of it to be admitted into their neo-baronial halls. The pioneering artists who emulated the *coureur de bois* were intent on changing that attitude by reminding the ex-bushwhackers of the spiritual wealth still lying untapped at the heart of the "Great Canadian Outback." One of the ways in which they sought to effect this conversion was by pushing for the replacement of those woolly Highland cattle, murky Dutch sheep-scapes and wispy Corot-esque pastorales with vibrant Impressionist sunlight: first French, then, in due time, Canadian. Before images of northern-Ontario rocks and pines could make their way onto collectors' walls, Seine-reflections and Giverny haystacks had to find acceptance where, and among those whom, such approbation counted.

Charles William Jefferys
Wheat Stacks on the Prairie,
detail, 1907

The participants in this nationalizing project were the first to admit that the venture was not an avant-garde breaking away into new aesthetic territory, but a searching rather, for what could best express the nature of the land and its impact on the character of its inhabitants. This undertaking had been in progress since at least the 1870s, more than a decade before the first rumors of French Impressionism reached the ears and eyes of incredulous Montrealers and Torontonians. The new(ish) mode would be conscripted to assist in the quest, but as a means to an end rather than an end in itself—another quality that distinguishes Canadian Impressionism from its U.S. counterpart.

Canadian Impressionism has tended to be treated as "only a phase" in the country's artistic development, situated somewhere between outmoded Victorianism and outlandish modernism. In their eagerness to get on with the story of how Canadian painting actually "begins" with the Group of Seven, art historians until recently made a habit of dating Impressionism's arrival on these shores too late, of crediting the wrong artists with adopting it first, and of concentrating exclusively on those figures who took the direct—i.e., the French—route to the source. This despite the fact that, as Norma Broude has written, "Influences during the Impressionist era, of course, did not flow only from one source and in one direction, that is to say, only from France out to the rest of the world," and hence the need for an appreciation of "a third, less Francocentric and more truly universal, phase in the critical discourse about Impressionism."[2]

The conventional account nets most of the big fish, but it leaves out too much and allows too many exceptions—both schools and single instances—to slip through the mesh. Blanket statements such as the claim that "Every serious young artist in Canada aspired to study in Paris, and by the early 1890s they all did,"[3] ignore the fact that *not* all Canadians so aspired, and that many who did were unable to afford the luxury and so were forced to seek instruction on this continent. By disregarding the availability of "alternative" routes and variant sources of information about the movement, we disregard the possibility that these byways may sometimes have seemed

more direct and apt to artists working in northern North America. For as Impressionism spread, it became evident that the painters who adopted the technique without considering the specific conditions of their own regions tended to produce a generic, derivative dilution of the Gallic original.

The intervening years have confirmed that the non-French strains which prove the true universality of Impressionism are those that *adapted* the new language "to record directly out-of-doors the unique and particularized light of the homeland, to articulate in painting the special character of its landscapes, both rural and urban."[4] By the end of the new century's first decade, even essentially conservative arbiters were beginning to assert the necessity of just such a homeward-turning, one that fostered the affirmation of a national identity. Ammunition for this argument was supplied by Canada's performance in the First Great War, during which trial-by-fire the fifty-year-old dominion "found her consciousness, found herself, and found her secure place in the great world."[5]

Small wonder, then, that the Impressionism of northern Europe, especially that of Finland and Norway, should have offered examples more pertinent to Canadian art than that of France itself. As Canada struggled to establish its national and cultural identity, it turned to stimuli autonomous both of its colonial parents and of the commercially dominant United States. These alternative paths to a Canadian subspecies of Impressionism included a wide range of source materials and referents: color reproductions, newspaper reports and reviews, and the standard range of periodicals (in particular, the international edition of *Studio Magazine*); teachers and colleagues who had studied and travelled abroad and were now adapting their tutelage to local conditions; the numerous art colonies that boasted summer schools wherein outdoor sketching was a fixture of the curriculum; and the existence of art institutions that offered *plein-air* instruction by teachers of an Impressionist persuasion. Of the latter, none was more popular among Canadians than the Art Students League of New York, which was staffed by many of the leading American subscribers to the creed, notably William Merritt Chase, John H. Twachtman and J.

Alden Weir. As Laurier Lacroix establishes in his contribution to this catalogue, from the 1890s onward Canadian artists working in Canada had a limited degree of access to Impressionist paintings in occasional exhibitions and such private collections as would admit them, but what they would have seen was predominately French. Hence the necessity of their taking a leadership role in bringing other, more geographically germane Impressionist schools to the attention of the public, the critics and the curators.

Nor was there consensus that only by following the example of the modern French masters could painters learn to render natural light and local and apparent color. In many parts of Canada, there was nothing unusual about artists working out-of-doors as a matter of course. After all, field-sketching had venerable roots in this country, having been transplanted to its rocky soil in the eighteenth century by the British military topographers who recorded the lie of the land for personal as well as for strategic and documentary purposes. And, as in France and the United States, the example of Turner and Constable and the teachings of Ruskin continued to exert a powerful sway well into the modern era.

In keeping with the best intentions of the first Impressionists in France and elsewhere, a style of painting "that emphasizes contemporary life, light, and color" could grow "independently out of indigenous sources"[6] and from the spontaneous seizure of time and place, as the achievements of a number of Canadian painters with none of the usual European antecedents attest. They also remained faithful to the dictum of the French critic J.-A. Castagnary, who claimed of the participants in the first Impressionist exhibition in 1874 that "They are 'impressionists' in the sense that they render not the landscape, but the sensations produced by the landscape."[7]

Although the emphasis here is on artistic perception rather than scientific observation or replication, there was an underlying, secondary significance, which can be brought to light through the interpolation of the modifier "their own" before "landscape"—words that are implicit in the original French, which assumes there is but one "true" landscape, that of *la douce France*. Thus altered, the defi-nition becomes globally applicable: *the landscape itself*, one's own "home and native land"—not generic "scenery" or a romantically (or classically) idealized fatherland, but individual, specific places experienced through the filtering media of climate, altitude, latitude, longitude—alone can produce sensations that translate into vibrant creative expression. One must, in other words, begin at home, or find one's way there. For what national art movement has not sprung from admonishments to painters that they render what is before them, i.e., "what they know" but heretofore have not clearly seen? That Impressionism, the most international of modes, should have played the role of midwife in the birth of so many native schools is a tribute less to its adaptiveness than to its originating principles, which, after all, were devised by the lovers of individual, specific, often under-appreciated places.

The list of artists touched on here is necessarily selective and therefore incomplete. In reflection of the officially bilingual nature of Canada, the province of Quebec does not figure in this account, both because its Impressionists, francophone and anglophone alike, are discussed elsewhere in this catalogue, and because that province's artists took their Impressionism from Paris far more consistently than their Maritime, Ontario and western-Canadian counterparts. Similarly, British Columbia's most significant Impressionist painter, Emily Carr (who like so many of her contemporaries soon went over to Post-Impressionism), was among those who made the trans-Atlantic passage in search of an art education not locally obtainable. If, in this truncated scenario, certain individuals and groups appear privileged over others, this is an unavoidable consequence of attempting, in a short space, not so much to revise the canon as to suggest an alternative or additional reading. This much we know: Impressionism arrived in Canada before Canada was prepared to embrace it, and came in more ways and from different directions than can be accounted for by the orthodox narrative. One of those ways, insufficiently accounted for in the standard histories, was by immigration.

Thanks to the north-south rail connections established in the late 1870s, the major centers of the

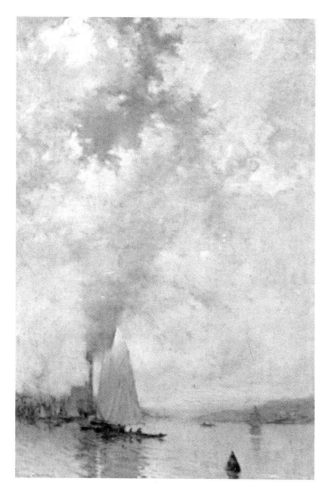

FIG. 1 Henry M. Rosenberg (1885–1947), *Halifax Harbour*, 1909, oil on canvas, 32 × 22 ¼ in. (81.2 × 56.5 cm), Nova Scotia Museum, Halifax.

Atlantic provinces maintained closer social and economic ties with nearby Boston and New York than with more distant Montreal and Toronto. The message of Aestheticism and Whistlerian Tonalism, if not of Impressionism *per se*, was brought to Halifax, Nova Scotia, by a New Yorker, Henry M. Rosenberg, when this New Jersey native was hired as the third principal of the Victoria School of Art and Design in 1898. Rosenberg had studied in Chicago before travelling to Munich to attend the informal art school established there in 1878 by the German-American painter-etcher Frank Duveneck. Like many other "Duveneck Boys," he followed his master to Venice in 1880, where they were joined at the Casa Jankovitz by J.M. Whistler.

On his return to New York in 1886, Rosenberg befriended a young expatriate Canadian by the name of Ernest Lawson (PLATES 11–12), who moved as a youth from his Halifax birthplace to Kingston, Ontario, where he began to paint seriously. Lawson's introduction to Impressionism in 1891 is said to have come about through Twachtman and Weir at the Art Students League and then at their summer art school at Cos Cob, Connecticut, two years before his arrival in Paris, but his prior contact with Rosenberg must have helped to steer him in that direction. On his return from studying in Paris he lived briefly in Toronto but settled in Manhattan, where he specialized in urban landscapes painted with his famous palette of "crushed jewels." Although Lawson decided that "As with medicine, French influence kills if taken in too large a dose," he subsequently made his mark in New York as "the most orthodox Impressionist of the Eight."[8] (His subsequent connection with his homeland was through the activities of the Canadian Art Club, and the works in the present exhibition exemplify the types of pictures he contributed to this society from 1911 to 1915.)

Rosenberg, on the other hand, committed himself to a trying twelve-year tenure as the leading promulgator of "the Art Idea" in a provincial backwater still steeped in British colonial tradition. Although his position left him with scant studio time, he succeeded in completing a small number of crisply handled figure compositions and atmospheric marines (FIG. 1), including those he sketched in company with Lawson during the latter's visit to his home province in 1924. These works led the dean of Canadian art historians, J. Russell Harper, to compare Rosenberg to another Whistlerian, the New Brunswick painter John Hammond (1843–1939), who had studied in Holland and Paris before becoming director of the Owen's Art Institute in Saint John in 1886. "Unfortunately both Hammond and Rosenberg worked in comparative isolation," Harper writes, "and had little or no opportunity either to expound such theories to other painters or to themselves gain new insight into subsequent discoveries. They reached a static point in their own development. The local art scene was unappreciative of their innovations, and they were unable either to penetrate into the wider Canadian community and so influence painting on a national scale...."[9]

Another expatriate American who played a semi-

nal role in bringing new art ideas northward, this time to the national capital of Ottawa, was Peleg Franklin Brownell. Born in New Bedford, Massachusetts, Brownell entered the Boston Museum School in 1877, a year after its establishment. Records do not indicate his graduation date or course selections, but one of his instructors would have been Thomas Dewing, who taught nights at the school from September 1877 to March 1878. Although Boston would become the leading center for the dissemination of Impressionism in the United States during the 1880s, Brownell just missed this development, heading to Paris, where in 1880 he enrolled at the Académie Julian. Like that of William Blair Bruce, who entered Julian's a year later, his Impressionism derived from the same kind of extramural contact, access to illustrated periodicals, and sensitivity to the artistic *zeitgeist* that converted such multitudes of foreign students to the doctrine of Monet and Pissarro during the 1880s and '90s.

Unable to find a teaching job in the United States, Brownell accepted the principalship of the art school of the Art Association of Ottawa in 1886, replacing an American named Charles E. Moss. There, he strove to renovate the school's moribund academic regimen, introducing a method and style more attuned to the local environment. Still better known for his richly toned, Frank Benson-esque domestic interiors and his sensuous, high-keyed interpretations of Antilles scenery than for his treatments of such subjects as Ottawa's *By Ward Market* (PLATE 19), the Gaspé and Gatineau regions of Quebec, and eastern Ontario's Algonquin Park, Brownell is an insufficiently appreciated transitional figure who acted as an intermediary between American and Canadian culture and between several generations of Canadian artists.

The temporary lack of a proper art school in Toronto induced the architecturally trained George A. Reid to study at the Pennsylvania Academy of Fine Arts in Philadelphia, where he and his compatriot W.E. Atkinson placed themselves under the tutelage of Thomas Eakins, who promoted the French method of direct painting of the live, undraped model and the sketching of landscape backgrounds in natural light. In both studio and outdoor sessions, Eakins commu-

FIG. 2 Mary Hiester Reid (1854–1921), *Chrysanthemums, A Japanese Arrangement*, n.d., oil on canvas, 18 × 24 in. (45.7 × 61 cm), Art Gallery of Ontario, Toronto, Gift of Friends of Mary Hiester Reid, 1923.

nicated his commitment to a "scientific" but luminous *pleinairisme* that has been described as "a forerunner of American Impressionism, a prelude to the full symphony of color that emerged in the late 1880s."[10] This species of *American* Impressionism, anticipated by Asher B. Durand and perfected by Winslow Homer, was, in Barbara Novak's view, "a different brand entirely from the imported genre of Hassam and Twachtman later in the century,"[11] and appealed to anglophone Canadians of Reid's generation for reasons similar to those that attracted its U.S. adherents.

Although, in his ensuing career as an interpreter of "folklore in paint," documenting his own pioneer rural background in large canvases and murals, Reid would show the influence more of Jules Bastien-Lepage, Thomas Anshutz, J. Alden Weir and Winslow Homer than of Eakins, his debt to his master can be appreciated from a comparison of Eakins's *Sailboats (Hikers) Racing on the Delaware* (1874; Philadelphia Museum of Art) and Reid's *Toronto Bay* (1887; Metropolitan Toronto Reference Library).

Reid's American-born wife, Mary Hiester Reid, painted landscapes, domestic interiors and still lifes in a predominantly Tonalist mode. The prevailing influence of such Aesthetic Movement icons as the Japanese print and the Whistlerian blue-china craze is evident in one of her finest floral studies, the undated *Chrysanthemums, A Japanese Arrangement* (FIG. 2).

Mary Reid's penchant for Whistler is also denoted by such titles as *A Harmony in Gray and Yellow* and *A Study in Gray*, but her adoptive Canadianness found expression in more vigorously rendered works—for instance, her *Pines at Sunset* (Government of Ontario Art Collection).

Eager to share with Toronto what they had learned in Philadelphia and in Europe, the Reids offered their own studio as a school where aspiring painters could meet, learn and work. Among their most successful pupils was Frederic S. Challener (1869–1959), who later achieved success as a decorative muralist. This versatile artist also mined a more intimate vein in such canvases as *A Song at Twilight* (1893; National Gallery of Canada) and *A Sewing Lesson* (see FIG. 10, pg. 32). E.F.B. Johnston described Challener as possessing "perhaps the keenest sense of light and brilliancy of color of any of the Canadian painters.... Nearly all his pictures are impressed with a sense of sunlight, and while they are not the most virile examples of art, they possess a wonderful charm and are delightful from a decorative point of view."[12]

Reid's second star pupil was Charles W. Jefferys, another English emigré who later would collaborate with Challener on the painting of mural decorations on historical themes. After studying informally with the Reids, he joined the Toronto Art Students' League in 1888. Founded in 1886 on the model of its New York and Philadelphia counterparts, the League was largely intended for the benefit of artists employed, like Jefferys, in illustration and the engraving and lithography trades. Essentially an outdoor sketching club, it was one of the first such organizations in the country to champion the cause of Canadian subject matter and themes.

Harking back in 1944 to this formative period, Jefferys recalled that

> During the late 1880s a new influence began to affect us. We became aware of what seemed to be a daring and radical group:—the French Impressionists. Some of the Canadian art students who had been to Europe brought back with them the new methods of open-air painting in oil; touches of pure primary colour placed in juxtaposition, which viewed at the proper distance, gave a more brilliant representation of light and atmosphere. It was a seductive method, which seemed peculiarly adapted to the expression of the high-keyed luminosity and sharp clear air of mid-Canada, though perhaps it was rather dangerous for the beginner who had not been trained to sound constructive draughtsmanship. But it helped break down the undue emphasis on form, the rigidity of outline, and the microscopic detail of the English School, qualities which the student naturally exaggerated.

It was not the French or American Impressionists, however, who truly awakened Jefferys and his contemporaries to the latent potential of their own materials and motifs. Rather, as Jefferys related,

> the first potent stimulus that we younger men experienced came in 1893. At the Colombian Exposition in Chicago were shown for the first time on this continent pictures by contemporary Scandinavian painters.... Here we saw the work of artists dealing with themes and problems of the landscape of countries similar in topography, climate and atmosphere to our own: snow, pine trees, rocks, inland lakes, autumn colour, clear air, sharply defined forms. Carl Larssen, Bruno Liljefors, Fritz Thaulow were painting subjects that might have been found in Canada. Our eyes were opened. We realized that on all our painting, admirable as much of it was, lay the blight of misty Holland, mellow England, the veiled sunlight of France, countries where most of our painters were born or had trained.[13]

The partiality for Hague School fog was accompanied by an implied prejudice against specifically Canadian treatments of nordic landscapes similar to the ones that the Scandinavian Neo-Romantics had been celebrating since the 1880s. Indifference to the work of local explorers of these subjects and conditions—especially the winter climate, described by Jefferys as "a sort of family skeleton"—was not, however, the chief cause of the flight from Toronto of so many gifted artists in the 1890s. Rather, the economic

FIG. 3 C.W. Jefferys (1869–1951), *Autumn's Garland*, 1914, oil on canvas, 36¼ × 24¼ in. (92.1 ×61.6 cm), Nutana Collegiate Institute, Saskatoon, Saskatchewan.

depression that had gripped the city early in the decade precipitated a talent-exodus to New York, Boston and Chicago.

Among these reluctant immigrants was Jefferys, who put his experience as an artist-reporter for the Toronto *Globe* to good use in securing a similar position with the *New York Herald* in the fall of 1892. He remained with this paper until 1899, working alongside his compatriot Jay Hambidge (formulator of the compositional theory of Dynamic Symmetry) and the future co-founder of the Ash Can School, William Glackens. But his daily schedule of assignments did not prevent him from furthering his art education through his enrollment in the New York Art Students League from 1893 to 1894, and his participation in the summer painting school conducted by G.A. Reid at the artists' colony of Onteora, in the Catskill Mountains of New York. Jefferys is known

to have signed on for Reid's Impressionist-oriented outdoor classes—among the first conducted by a Canadian—in September-October 1893. He was joined at these sessions by such compatriots as F.S. Challener, Harriet Ford and Mary E. Wrinch, who would also have benefited from the opportunity to rub shoulders with the leading American Impressionist J. Carroll Beckwith, another member of the Onteora Club. As late as 1914 Jefferys was employing the lessons he had absorbed in Reid's company, as can be seen from his *Autumn's Garland* (FIG. 3), an Impressionist evocation of a central-Canadian Red Pine basking in what this preacher of the "gospel of spruce and pine" liked to describe as "a clear, northern light."[14]

From his summer base just outside the enclave (many of whose Shingle Style buildings he designed), Reid completed many Onteora-area landscapes in a loose *alla prima* manner, yet his happiest exercises in the mode were more finished canvases where the structure lacking in the panels asserts itself, as in his flickeringly sunlit *Idling* (PLATE 63) and the dark-toned *Portrait of Henrietta Vickers* (PLATE 64), painted in his Toronto studio. During the period of his involvement with Onteora, which came to an end in 1914, Reid enjoyed a considerable success with his large, complex canvases depicting scenes from his own rural past, rather than for his smaller landscapes and genre subjects. His reversion to decorative academic naturalism after the turn of the century, followed by a largely unsuccessful attempt to emulate the raw reductivism of the Group of Seven, led his former followers to look elsewhere for validation. European examples could not guide them, given the cumulative resolve to depict Canada *qua* Canada that had formed during the 1890s and would solidify in the 1910s and '20s. The influence of American Impressionist snow-painters, such as Twachtman, Willard Metcalf, Birge Harrison, Walter E. Schofield, George Gardner Symons and Edward Redfield, on their Canadian contemporaries during this transitional period deserves a closer look.

Another Canadian whom the example of G.A. Reid indirectly inspired to decamp to New York was David B. Milne, whose conversion to the artistic life

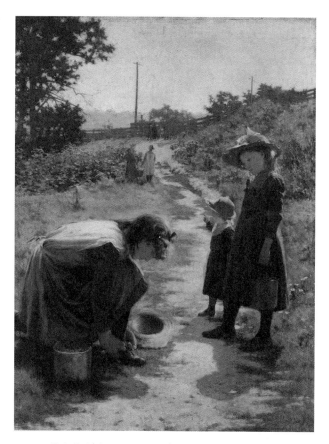

FIG. 4 G.A. Reid (1860–1947), *The Berry Pickers*, 1890, oil on canvas, 66 × 50 in. (167.6 × 127 cm), Government of Ontario Art Collection, Toronto, on permanent loan to Nipissing University College Collection, North Bay, Ontario.

took place in the unlikely confines of the Ontario Legislative Building in Toronto. In the gloom of this Richardson Romanesque pile he encountered Reid's radiant *The Berry Pickers* of 1890 (FIG. 4), at least one detail of which remained bright in his memory. "I was impressed," Milne recalled a half-century later, "by the vividness of the raspberries reflected on the new tin pail. This was my first real kick from an oil painting and my first enjoyment of texture in art."[15]

The descendant of poor Scottish immigrants who had settled, like Reid's parents, in rural western Ontario, Milne went on to achieve a cosmopolitan sophistication in his art which, like the poetry of Wallace Stevens and the music of Charles Ives, did not require a hegira to the cultural meccas of Europe. Milne's lonely sojourn in Manhattan, from 1903 to 1916, saw his brief flirtation with Impressionism and his first, tenuous brush with local fame, which later

would take more enduring form with his posthumous recognition as "something of the artist-laureate of the Bronx."[16] Those thirteen eventful years also witnessed the emergence of his mature style, neatly encapsulated by an unidentified critic in 1912: "David Milne employs a kind of telegraphic notation by dots and dashes of color and broken-up masses that results in dramatic force of description.... [His paintings] are quite violently alive, and send the pictures around them back into a shadowy and invalid region."[17]

Like Hambidge, Jefferys, Lawson and other Canadian artists before him, Milne had gone to New York to study at the Art Students League and seek work as a commercial illustrator. His deeper ambition, however, was to position himself as one who would, in John O'Brian's words, "stand out from the dreary regions inhabited by most contemporary painting" by aligning himself with those who were "championing the notion that subject matter in art might be merely a pretext for formal invention rather than an end in itself."[18] Milne's objective in pursuing this goal was paraphrased in 1948 by the Canadian literary critic H. Northrop Frye as "an expansion of meaning from the desire to paint, rather than a desire to say something with paint...."[19]

In trying to define "what it meant for Milne to be a modern artist who was also Canadian," O'Brian posits that this quest "is inseparable from the account of Milne's place in the broader tradition of modern painting, from the account of his adherence to that tradition of anti-traditionalism which began in the mid-nineteenth century in Europe and which was reflected in the conscious desire of certain artists, not least Milne himself, to find new formal and symbolic expressions appropriate to the period in which they lived."[20] But for Milne, as for so many other Canadians who experimented with Impressionist strategies, the technique ultimately did not satisfy his craving to express his own responses to "things in themselves." Initially, however, it suggested a means of dealing with the Baudelairean "heroism of modern life."

During his New York period, he attuned himself to the currents then swirling through the city, notably the formation of the breakaway Eight American

Painters in 1907, the exhibitions of French modernist painting at Alfred Stieglitz's Little Galleries of the Photo-Secession at 291 Fifth Avenue, and the epoch-making Armory Show of 1913. Yet, for all his keen awareness of his surroundings, the resolutely independent Milne mentioned few contemporary American (and fewer Canadian) artists in his correspondence, diaries and other writings. Instead, as early as 1907, Milne was revelling in the opportunity to view in New York the work of Cézanne, van Gogh, Gauguin, Matisse, Picasso and Brancusi at "291," where, as he said on behalf of his generation, "for the first time we saw courage and imagination bare, not sweetened by sentiment and smothered in technical skill."[21]

The influence of these masters can be found in Milne's minimalist "arrangements" in red, blue, yellow and black wherein the human figure served merely as a foil for the play of line and color, as in his *Interior With Paintings* of 1914 (PLATE 62) and *Red* (1914; Milne Family Collection, Cantley, Quebec). The richness of his palette at this time is evidence of his relative prosperity; thereafter, his real and pressing poverty would declare itself in the almost monochromatic austerity of his oils.

This switch of direction, however, did not take place immediately upon Milne's adjustment of the changing of the artistic *garde*. At least until 1910, O'Brian contends, "Milne was more absorbed with Impressionism than with its aftermath." *Bright Garden*, for instance,

> is composed entirely in an Impressionist manner. By painting chromatically with small dabs of blue-grey, pink and acid green hues mixed only with white, Milne distinguishes his forms and conveys the illusion of a fleeting evanescent moment. The painting was undoubtedly influenced by the example of Monet. Milne, looking back on his work, traced a turning point in his development to an exhibition at Durand-Ruel of some of Monet's "Haystack" paintings.... He recalled that the unity of the paintings and the compression they gained by the forcing of all the detail to work to one end struck him as revolutionary.[22]

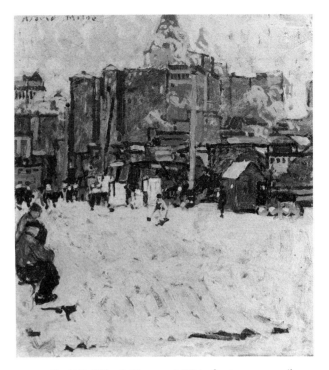

FIG. 5 David B. Milne (1882–1953), *Waterfront*, ca. 1910, oil on canvas, 20 × 18 in. (50.8 × 45.7 cm), National Gallery of Canada, Ottawa, Gift from the Douglas M. Duncan Collection, 1968.

Much later, Milne would proclaim that "The thing that 'makes' a picture is the thing that 'makes' dynamite—compression. It isn't a fire in the grass: it is an explosion. Everything must hit at once."[23] O'Brian continues:

> In Milne's *Waterfront* [FIG. 5], executed approximately one year after *Bright Garden*, the influence of Monet was no longer strongly apparent. In this painting one is struck instead by the blunt solidity of the buildings, their edges drawn in firm outline. Rather than contributing to an atmospheric effect, the buildings, by refusing to succumb to the dissembling light of a grey day, are used to emphasize structure and composition. In this respect, the painting probably owes more to the domesticated Impressionism of Theodore Robinson...and of J. Alden Weir, John Henry Twachtman, Willard Metcalf and Childe Hassam than to Monet. Milne recalls having seen their work in the galleries when they were exhibiting as members of The American Ten.

Thereafter, other, less local influences came more to bear, although the sources for these revelations were as near to hand as Greenwich Village, 291 and the Montross Gallery. "Between 1910 and 1912," O'Brian informs us,

Milne deliberately began to squeeze the Impressionist air out of his paintings. Instead of atmospheric effects, his paintings increasingly began to show a concern for form and structure, becoming bolder, flatter and increasingly abstracted from nature.... He started to embrace the modernist conviction that, regardless of what is depicted, a painting must be an independent emotional and formal entity; in other words, that it must express itself primarily through colour and form.[24]

Among the causes of this shift were the exhibition of Cézanne's watercolors—the first in North America—mounted by Stieglitz in March 1911, the frequent showings at Stieglitz's gallery of Matisse, and the emergence of the Newfoundland-born Maurice Prendergast (1859–1924) as a major New York Impressionist and founder-member of The Eight.[25] Milne's new direction was further affirmed in February-March 1913 by his inclusion in the *International Exhibition of American Art*, held at the Armory of the 69th Infantry under the auspices of the Association of American Painters and Sculptors. In Milne's recollection, his "own tendency toward freer work must have been formed previous to [it], because I was invited to exhibit in the show and was well represented.... Apparently it had little direct effect on my own painting, perhaps because I was already familiar with much of it, even more because I had my feet quite firmly planted on a path of my own."[26] Still (as with Lawson's Bronx and Hudson River vistas), there are clear affinities between Prendergast's lapidary New York street and park scenes and Milne's no less mosaic-like reductions of similar subjects—for instance, his *Billboards* (National Gallery of Canada, Ottawa)—sufficient to induce a critic to pair them as representative of American "extremist" painters in the exhibition.[27] John O'Brian speculates that *Billboards* may have been exhibited at the Armory Show under the title *Columbus Circle*. "If it was, then it

was congruent with Prendergast's *Central Park*...[1902; The Metropolitan Museum of Art] in the manner of titling as well as in more significant ways. In subject matter, in mood, and in style the paintings are strikingly similar."[28] These elements are no less evident in Milne's *Columbus Monument* (PLATE 13), which as easily as *Billboards* could have been the canvas exhibited as *Columbus Circle*.[29]

The other key events of 1913 for the artists who would plead the modernist cause in English-speaking Canada were more geographically focused affairs than the Armory Show. First came the exhibition of contemporary Canadian painters at New York's MacDowell Club. Press response was mixed, the major criticism being that most of the artists had failed to capture "the spirit of their land" and that there was a deficiency of characteristically "Canadian" subject matter.[30] These reproaches must have played a role in convincing the participants to concentrate on their own landscapes rather than seeking foreign recognition on stylistic rather than thematic grounds.

The message was even more forcefully driven home by the *Exhibition of Contemporary Scandinavian Art*, held at the Albright Art Gallery, Buffalo. Although Canadian artists had already taken note of their Northern European counterparts, this show had so galvanizing an effect on Lawren Harris and J.E.H. MacDonald, the two leaders of the nascent nationalist art movement that would be formalized as an exhibiting collective in 1920, that a third member of the founding triumvirate, A.Y. Jackson, could state that, "if there was a starting point for the Group of Seven, that would be it."[31]

Even before this revelation, however, Toronto's younger painters were drawing their inspiration "from the backwoods," whereas their Montreal colleagues "were more familiar with the work of the French impressionists [*sic*], a few samples of which drifted into the country...."[32] Harris, who had received his art education in Berlin in 1904–7 but returned to his native Canada without having absorbed French Impressionism, professed that MacDonald's first one-man exhibition of oil sketches, held at Toronto's Arts and Letters Club in 1911, had affected him "more than any painting" he had "ever seen in Europe,"

while C.W. Jefferys noted with approval the "refreshing absence of Europe, or anything else, save Canada" in these modestly scaled paintings.[33]

The contents of this show are not known, but we can surmise from MacDonald's previous submissions to exhibitions that it included not only mid-northern lake and lumbering scenes but examples of his intimate evocations of the rolling High Park landscape by moonlight and at sunset (FIG. 6, PLATE 39). MacDonald had come home to Toronto from a five-year stint as a commercial artist in London (1903–7) apparently without much Impressionist baggage, having been attracted instead to the Hampstead Heath oil sketches of John Constable and the forest landscapes of the Barbizon painter Diaz, which he had seen in an exhibition in 1906 and which gave him the "feeling faint and far off, that someday, I too would be an artist and produce similar things."[34] Within four years of this declaration he was grappling with wilderness and winter subjects akin to those approved by the Scandinavian painters whose exhilarating work he and Harris "discovered" in 1913.

It was less the poetic treatment of ambient light in MacDonald's early landscapes that impressed Jefferys and Harris than his choice of themes, which were, in the former's often-cited words, "native—as native as the rocks, as the snow, or pine trees, or the lumber drives"[35] that would go on to assume an almost iconic significance in the paintings and sketch panels of Tom Thomson (who died before he could be conscripted into the Group) and the seven artists who formed the original lineup.[36] Hence the excited acknowledgment of the Scandinavian forerunners, whose work, Harris recalled, "gave body to our rather nebulous ideas. Here were paintings of northern lands created in the spirit of those lands. Here was landscape as seen through the eyes, felt in the hearts, and understood by the minds of people who knew and loved it. Here was an art bold, vigorous, and uncompromising, embodying direct experience of the great north."[37] In MacDonald's analysis, what mattered was the living art of lived experience, and its effect on the imaginations of impressionable painters who "had feelings of height and breadth and depth and colour and sunshine and solemnity and new wonder about our own country...

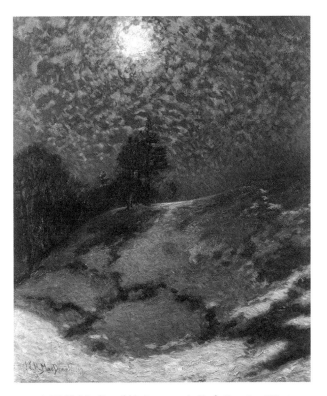

FIG. 6 J.E.H. MacDonald (1873–1932), *Early Evening, Winter*, 1912, oil on canvas, 33 × 28 in. (83.8 × 71.1 cm), Art Gallery of Ontario, Gift of the Canadian National Exhibition Association, 1965.

Except in minor points, the pictures might all have been Canadian, and we felt, 'This is what we want do to with Canada.'"[38]

And this, substantially, is what they did. The story of that adventure soon leaves Impressionism behind, but not "isms" *per se.* While still under foreign influences, Harris and MacDonald would paint not only their most sensitively decorative pictures, but also gritty urban subjects that indicate a familiarity with the "New York realism" of the Ash Can school: for instance, Harris's *The Gasworks* (FIG. 7) and *The Eaton Manufacturing Building from the Ward* (PLATE 33), and MacDonald's *Tracks and Traffic* (PLATE 38). Although, on the surface, the last-named canvas could be described as a paean to the Machine Age—a Whitmanesque celebration of the rise of Canada as an industrial and transportation power—the deeply spiritual MacDonald (a devotee of Emerson and Thoreau) was following Monet in finding ways of using color to unify diverse structural elements, and of rendering light and atmosphere partly natural and partly man-made.

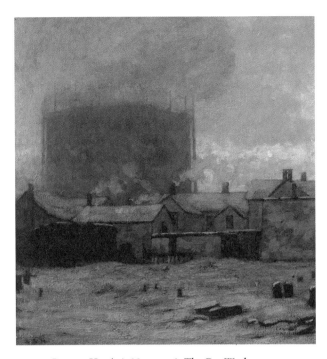

FIG. 7 Lawren Harris (1885–1970), *The Gas Works*, 1911–12, oil on canvas, 23 1/16 × 22 3/16 in. (58.6 × 56.3 cm), Art Gallery of Ontario, Gift of the McLean Foundation, 1959.

As with Harris, Jackson and Lismer, the experience of painting in the mid-northern Ontario hinterland of Algoma would drive MacDonald in a stylistic direction that led inexorably away from the modulated atmospherics of Tonalism and Impressionism to a new kind of painting that incorporated elements of both, but which reached outward to embrace a bolder attack and a broader vision. Both the necessity of Impressionism and its limitations are captured in this gripping account by the Paris-trained A.Y. Jackson of the hunt for some formula of form in the Algoman boreal "jungle:"

Sketching here demanded a quick decision in composition, an ignoring or summarizing of much of the detail, a searching-out of significant form, and a colour analysis that must never err on the side of timidity. One must know the North country intimately to appreciate the great variety of its forms. The impression of monotony that one receives from a train is soon dissipated when one gets into the bush. To fall into a formula for interpreting it is hardly possible. From

sunlight in the hardwoods with bleached violet-white tree trunks against a blaze of red and orange, we wander into a denser spruce and pine wood, where sunlight filters through—gold and silver splashes—playing with startled vividness on a birch trunk or a patch of green moss. Such a subject would change entirely every ten minutes, and unless the first impression was firmly adhered to, the sketch would end in confusion. Turning from these to the subtle differences in a frieze of pine, spruce and cedar, or the slighter graceful forms of the birch woods, one had to change the method of approach in each case; the first demanded fulness and brilliancy of colour, the second depth and warmth, the next subtlety in design and colour; and these extreme differences we found commingled all through.[39]

Small wonder that some critics have described the Algoma period as the Group-to-be's Fauvist phase, to be followed by an Expressionist period, in which the underlying structure and rhythms of the land would be stressed over its evanescent particulars of form and

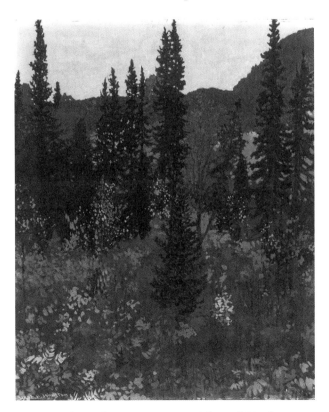

FIG. 8 Frank H. Johnston (1888–1949), *The Dark Woods, Interior*, ca. 1921, gouache on masonite, 22 × 18 3/8 in. (55.9 × 46.7cm), Art Gallery of Ontario, Gift from the Reproduction Fund.

hue. Subtle effects, gentle transitions, diffusive drawing and flecked brushwork could not convey the strong feelings elicited by such dramatic scenery.

Of the painters who participated in the four box-car trips to Algoma that Lawren Harris funded between 1918 and 1921, only Frank Johnston continued, during this interval, to employ a modified Impressionist vocabulary in his oils and gouaches. The flat patterning and pointillistic delicacy of these underrated works—see, for instance, his *The Dark Woods, Interior* (FIG. 8)—are Johnston's distinguishing marks, which reveal the lingering influence of his studies in 1912 with Daniel Garber and Phillip Hale at the Philadelphia Academy of Fine Arts. His allegiance to other styles and methodologies, and his reaction to the press controversy stirred up by the Group of Seven's exhibitions, led to Johnston's resignation from the collective in 1924, after a remove of four years to the prairie province of Manitoba. Before his departure, he had completed, as an official war artist, two Impressionist anthems to the age of manned flight: *Beamsville* (1918–19; National Gallery of Canada, Ottawa) and *The Fire Ranger* (circa 1920; National Gallery of Canada, Ottawa).

With Tom Thomson, whose mastery of his métier came by a rapid process of osmosis, we are at a loss to pinpoint any specific knowledge of Impressionism. Yet for a few years he painted as if born to the mode, pushing it to the limits of its ability to convey meaningful information about what is being depicted. Reflecting his lack of formal training, Thomson's initial oils were somewhat stiff and muddy, but, after the example of Jackson and MacDonald, his sketch panels and easel canvases soon exploded into a primal shout of cadmium red and yellow, alizarin crimson, emerald green and ultramarine blue.

Most of Thomson's Impressionist pictures—typified by *Byng Inlet, Georgian Bay* (FIG. 9), *The Pool* (National Gallery of Canada, Ottawa), *The Pointers* (PLATE 50), and *Chill November* (Sarnia Public Library and Art Museum, Sarnia, Ontario)—date from the last two years of his life, during which he carried out an ambitious exercise in Monet-like serialism: an Algonquin Park season-cycle that was tragically cut short by his death by drowning in July 1918. Studying

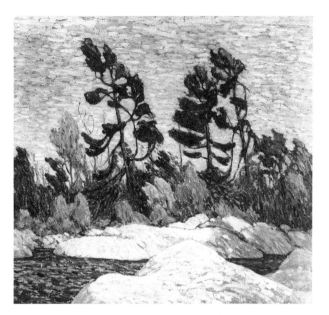

FIG. 9 Tom Thomson (1877–1917), *Byng Inlet, Georgian Bay,* 1914–15, oil on canvas, 28 ⅛ × 30 in. (71.5 × 76.3 cm), McMichael Canadian Art Collection, purchased with the assistance of the donors and Wintario, 1977.

these exhilarating works, one finds it hard to believe that this autodidact was unfamiliar with Divisionism and the French Fauves, yet it is entirely possible that he came up with these effects independently and, as it were, *sui generis.* Or, as he himself might have expressed it, the land, the light and the seasons *made* him paint as he did. Support for the popular thesis that Thomson was an intuitive genius through whom nature found a direct channel of expression is supplied by the parallel evidence of the Yorkshire-born Arthur Lismer, who had studied at the Sheffield School of Art before emigrating to Canada in 1912 to further his career in "pictorial publicity." True, Lismer had studied the works of van Gogh while enrolled at the latter's alma mater, the Académie des Beaux-Arts in Antwerp, in 1906–07, and had taken in the Post-Impressionist exhibition organized by Roger Fry at London's Grafton Gallery in 1909, but the "substratum of excitement" these modernist pictures had created in this Yorkshire émigré would take an ocean voyage and an aesthetic sea-change to work their way "into and through…his later interpretations of nature."[40]

Lismer's first Canadian oil, *The Banks of the Don* (National Gallery of Canada, Ottawa), painted in Toronto in 1912, is but a muted, tentative presage of the exuberant muscularity of paint-wrangling that

FIG. 10 Arthur Lismer (1885–1969), *Sumach and Maple, Huntsville*, 1915, oil on canvas, 50 × 40 in. (127 × 101.6 cm), The Thomson Gallery, Toronto. Reproduced with permission of Thomson Works of Art Ltd., Toronto.

was soon to come. While bearing traces of the British Romantic tradition and the Impressionism of Sisley and Pissarro, this tiny sketch-panel nonetheless is redolent "of the feeling of the land of Canada itself, particularly its difference from the English country-side," which, Barry Lord insists, "is a factor at least as important as the inheritance of painting schools or the influence of contemporary styles."[41] Like MacDonald and Jackson immediately before him, Lismer had his "first real taste of the Canadian North" in September 1913, when he vacationed at Georgian Bay. Although he attempted to "come to terms with the grandeur and immensity of the northern sky" in a manner reminiscent of the sparkling harbor scenes of Phillip Wilson Steer, his 1914 trip to Algonquin Park with Jackson and Varley to visit Tom Thomson really freed him as an Impressionist. "The country," exclaimed the normally phlegmatic Varley, "is a revelation to me, and completely bowled me over—We have been busy 'slopping' paint about and Tom is rapidly developing

into a *new* cubist." Lismer, however, was "finding it far from easy to express the riot of full colour & still keep the landscape in a high key."[42]

This difficulty is not evident in Lismer's scintillating *The Guide's Home* (PLATE 36), his Thomson-esque *Sunglow* (1915; Art Gallery of Nova Scotia), the glorious meandering tangle of *Sumach and Maple* (FIG. 10), the Schofield-like *Sackville River* (1917; Art Gallery of Nova Scotia, Halifax), or his numerous renderings of "dazzle"-camouflaged warships in Halifax Harbour, even the large mural he painted for the Green Lantern Restaurant during his term as principal of the Victoria School of Art and Design (1916–19). These works belie Lismer's own later claim that, despite having been given "even stronger excitement" by such Canadian practitioners as Morrice, Gagnon, Cullen and Suzor-Coté, "Impressionist technique…does not transplant well to Canada. It is emotionally unstable, however scientific it may be, in our clear air and amid our solid forms of land and water."[43]

Moving westward: prairie Canada's only native Impressionist of consequence was the Winnipeg-born Lionel LeMoine FitzGerald, who, in the words of the critic Paul Duval, "practised Impressionism by the seat of his pants, his familiarity with it coming mainly from reproductions."[44] FitzGerald was not alone in being able to assimilate the principles of the system from secondary sources, including the work of immediate precursors. His application of broken brushwork and an undiluted palette to the treatment of so unlikely a subject as the Canadian wheatfield landscape was antici-

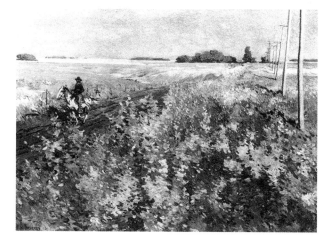

FIG. 11 C.W. Jefferys (1869–1951), *A Prairie Trail ("Scherzo")*, 1912, oil on canvas, 35¾ × 50¾ in. (90.8 × 128.9cm), Art Gallery of Ontario.

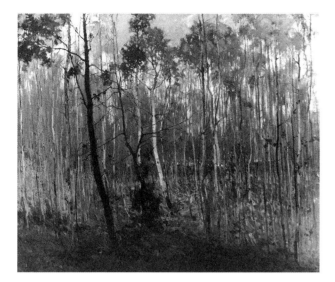

FIG. 12 L.L. FitzGerald (1890–1956), *Late Fall, Manitoba*, 1917, oil on canvas, 30 × 36 in. (76.2 × 91.4cm), National Gallery of Canada.

pated by C.W. Jefferys, whose strongly Impressionist canvases inspired by the sweeping expanses of southern Saskatchewan are unique in North American art.

During Jefferys' first western expeditions, which took him to central Manitoba in 1906 and 1907, he fixed upon the motif of blue-shadowed golden grainstacks and stooks standing in recently harvested fields that stretch to the far horizon under blazing skies. *Wheat Stacks on the Prairie* (PLATE 35) is an obvious salute to Monet but is in no way derivative. Light becomes even more the subject of the sequence of southern Saskatchewan landscapes painted between 1912 and 1915, including *Western Sunlight, Last Mountain Lake* (National Gallery of Canada), *A Prairie Trail ("Scherzo")* (FIG. 11) and *A Prairie Sunset* (Art Gallery of Ontario). With its brilliant splash of foreground flowers, its intense blue sky and all-suffusing solar glow, *A Prairie Trail* is one of the most purely Impressionist paintings by a Canadian, and perhaps truer to the creed than Frederic Remington's late exercises in the idiom, by which it nonetheless clearly was influenced.[45]

Jefferys' attempt to capture in words the essence of the tawny, undulating Qu'Appelle Valley of Saskatchewan again illustrates the fact that much of Canada's indigenous Impressionism was precisely that: not only a natural but a *necessary* expression or outgrowth of the land itself. "Always," he explained,

the eye seeks that golden crown. Though the day be cloudy and the hillslopes grey and dun colored and sober this upland rim is brilliant as though with sunshine. It is sunshine, caught and absorbed: the concentrated essence of sunlight distilled through the innumerable slender tubes of wheat stalks and stored in the capsules of myriads of wheat ears. As one climbs out of the valley, the band of wheaten gold widens and lengthens until it loses itself in the wavering uncertain horizon when the sky is no more blue, merges into a vague, unnameable, unpaintable clarity of light and air.[46]

Yet the painter of whom Jefferys was immediately reminded by such a vegetal palette was not Monet but Whistler, by whose memorial exhibition at the Boston Museum of Fine Art in 1904 he had been profoundly impressed.

Less typically the products of western inspiration are the Winnipeg-born Lionel LeMoine FitzGerald's *Late Fall, Manitoba* (FIG. 12) and *Summer, East Kildonan* (FIG. 13), the former a woodland interior of

FIG. 13 L.L. FitzGerald, *Summer, East Kildonan*, 1920, oil on canvas, 50¼ × 42 ¼ in. (127.6 × 107.3 cm), private collection, Toronto.

somber palette, the latter a swirling vortex of sun-beam-poked foliage and dappled furrows which has been identified as his major Impressionist work. On the other hand, both title and subject matter leave no doubt as to the locale of FitzGerald's *Summer Afternoon: The Prairie* (PLATE 29), an almost pointillistic treatment of a wide western sky. The vertical format of this sun-saturated canvas draws the eye on to the low-horizoned land itself but to the source of its illumination and the billowing cumuli that distribute and diffuse its intensity. FitzGerald explained that "the prairie has many aspects, but intense light and the feeling of great space are dominating characteristics and are the major problems of the prairie artist...."[47] Major problems, but also, as successive generations of western painters have demonstrated, major assets, which a pilgrimage to Giverny or Grèz would not necessarily have made more accessible.

Presumably FitzGerald picked up his second-hand Impressionist technique from his omnivorous readings and at the evening classes conducted in Winnipeg by A.S. Keszthelyi, a Hungarian emigré who had taught at the Carnegie Institute in Pittsburgh and the Art Students League in New York. FitzGerald religiously sketched out-of-doors but, once in the studio, where he worked up these studies utilizing his meticulous "dab" technique, his response to the clarity and brilliance of the dry, mid-continental atmosphere was to tone down his palette and modulate his line. "The only way I can account for the extreme delicacy of the pencil drawing," he explained, "is because of the terrific light we have."[48] As with the Jefferys, Beatty, Thomson and the Group of Seven in northern Ontario, the quality of the light as it defined shapes and spaces dictated the manner of its treatment, not vice versa.

Like most of his eastern- and central-Canadian counterparts, FitzGerald did not so much abandon Impressionism as evolve in directions dictated both by subject matter and by the desire to keep pace with international stylistic trends. In his case, the parting can be attributed to his trip, late in 1921, to New York to study at the Art Students League under the classical realists Kenneth Hayes Miller and Boardman Robinson. As important as the instruction FitzGerald received there were his visits to American art galleries and museums, of which belated visual education he exclaimed, "For the first time in my life I was seeing painting that was neither English [n]or Scottish. I got a sudden jolt into everything."[49]

After his return to Winnipeg in 1922, FitzGerald turned increasingly to Nature for inspiration. Nonetheless, his work underwent what the Toronto critic F.B. Housser characterized as "a change of direction along more modern lines," which had the effect of carrying FitzGerald "ahead of the public and consequently into greater obscurity."[50] Although this turn of events did not prevent him from adapting aspects of Post-Impressionism, Precisionism and Pointillism to his own use, "within his chosen subject matter," as one western commentator observed in 1982, "he found all the room he needed for experimentation."[51] From 1945 until FitzGerald's death in 1956, the influence of Cézanne and Seurat came to the fore, resulting in the development of a sort of atomic semi-abstraction. It is somehow fitting that one of his final works, a pointillistic pen-and-ink drawing completed in the year of his death, should be entitled *A Prairie Trail* (National Gallery of Canada, Ottawa).

CHANGE OF A DIFFERENT SORT than FitzGerald's had transpired in the decade between 1913, when the participants in the MacDowell Club show were chastised for not being "Canadian" enough in their choice of subject manner and handling of pigment, and 1923, when the core group of painters featured in *A Collection of Work by Canadian Artists* mounted by the Kansas City Art Institute were characterized in the catalogue as being so closely associated with "our northern sister nation" as to be accountable among its "vast natural resources." The latter display, featuring paintings by six members of the Group of Seven and four invited contributors from Montreal, was described as portraying "the vigorous environment of the Northland...in a robust manner, with glowing color. One may see the traditions of England here and there, but in general the work may be said to represent the Canadian's attitude toward

his own environment."[52] The works chosen also revealed the degree to which the Impressionism that dominated the earlier show had evolved from being a classifiable style to a way of claiming native identity in paint.

If Walt Whitman's individualist credo—"*I stand in my own place with my own day before me*"— could be quoted in defense of this nationalist project, as Housser did in 1926, its borrowing can be interpreted as the declaration of independence by a cadre of painters who, having respectfully credited what artists "on other shores...have wafted hither," set out with feet firmly planted on an open road—or at least a "next portage"—of their own. Determined to "do with Canada" what other schools had done with their own countries and regions, these homeward-looking visionaries were demonstrating that they were Castagnarian Impressionists in both the broadest and the truest sense, according to my modification of his famous phrase: painters who rendered *the sensations produced by [their own] landscape*.

That an imported, broadly interpreted style of brief currency but profound and lingering impact should have assisted in the necessary process of self-discovery through art contradicts neither the need to break away from formative influences nor the obligation to acknowledge sources, debts and bloodlines, both obvious and obscure. For what national art movement anywhere has not waged war against foreign domination with weapons patterned on foreign models? It is as true in Canada's case as in the United States' that a landscape cannot be perceived until it has been imagined. And yet, in teaching imaginations to perceive, the sensations produced by landscapes prepare painters for the sensations their landscapes produce. The many paths of Impressionism led both to and—inevitably—away from it.

NOTES

1 Douglas LePan, "In Frock Coat and Moccasins," *Canada: A Guide to the Peaceable Kingdom*, ed. William Kilbourn (Toronto: Macmillan of Canada, 1970).

2 Norma Broude, "A World in Light: France and the International Impressionist Movement, 1860–1920," *World Impressionism: The International Movement, 1860–1920*, ed. Norma Broude (New York: Harry N. Abrams, 1990), pp. 31, 10.

3 Dennis Reid, "Impressionism in Canada," *World Impressionism...*, p. 94.

4 Broude, "A World in Light," pp. 31, 30.

5 Jan Smuts, Foreword to Hugh M. Urquhart, *Arthur Currie: The Biography of a Great Canadian* (Toronto: J.M. Dent & Sons [Canada] Ltd., 1950).

6 Broude, "A World in Light," p. 30.

7 Jules-Antoine Castagnary, "L'exposition du boulevard des Capucines: les impressionistes," *Le Siècle* (29 April 1874).

8 William H. Gerdts, *Impressionist New York* (New York: Abbeville Press, 1994), p. 88.

9 J.R. Harper, *Painting in Canada: A History* (Toronto: University of Toronto Press, rev. ed., 1977), pp. 227–28. For a lengthier discussion of Rosenberg and such impressionistically included students as Lewis Smith and Gyrth Russell, see Robert Stacey, "Eighty: 1887–1967," in *Eighty/Twenty: 100 Years of the Nova Scotia College of Art and Design* (Halifax: Art Gallery of Nova Scotia, 1988), pp. 40–46, 114–20.

10 Richard J. Boyle, *American Impressionism* (Boston: New York Graphic Society, 1982), p. 47.

11 Barbara Novak, *American Painting of the Nineteenth Century: Realism, Idealism and the American Experience* (New York: Praeger, 1974), p. 89. Impressionism as commonly understood would not infiltrate the Pennsylvania Academy until 1892, when its annual exhibition included work that a newspaper advertisement somewhat anachronistically proclaimed as heralding "The Dawn of a New American Art[:] Impressionism!" See Susan Danly, "American Impressionism and the Pennsylvania Academy," *Light, Air and Color: American Impressionist Paintings from the Collection of the Pennsylvania Academy of the Fine Arts* (Philadelphia: Pennsylvania Academy of the Fine Arts, 1990), pp. 11–23.

12 E.F.B. Johnston, "Painting and Sculpture in Canada," in *Canada and its Provinces, vol. 11* (Toronto: The Publishers' Association of Canada, 1913) p. 623.

13 C.W. Jefferys, ["The Toronto Art Students' League"]. Untitled holograph MS of a lecture delivered on 15 May 1944, London, Ontario. Jefferys Estate Archive, E.P. Taylor Reference Library, Art Gallery of Ontario, Toronto.

14 Appearances are deceptive, however: although the setting could be taken for a northern-Ontario fir forest, this was painted in a farm field just across the road from Jefferys' residence at York Mills, just north of the Toronto city limits, near the banks of the west branch of the bucolic Don River. One of the few Canadian painters to apply the broken-brush tenets of Impressionism to watercolours as well as oils, he completed a season-cycle of Don River views in both media.

15 David B. Milne, "Art Influences," holograph MS, circa 1947, Milne Family Papers, Cantley, Quebec.

16 Gerdts, *Impressionist New York*, p. 198.

17 From a review of the 45th annual exhibition of the American Water Color Society, New York, 25 April–12 May 1912, *New York Times*, 28 April 1912.

18 John O'Brian, *David Milne and the Modern Tradition in Painting* (Toronto: Coach House Press, 1983), p. 22.

19 H. Northrop Frye, "David Milne: An Appreciation," *The Bush Garden: Essays on the Canadian Imagination* (Toronto: Anansi, 1971), p. 206.

20 O'Brian, *David Milne...*, pp. 18–19.

21 Milne to Vincent and Alice Massey, 20 August 1934, Milne Family Papers, University of Toronto Archives.

22 O'Brian, *David Milne...*, pp. 56–57.

23 Quoted in David Silcox, Introduction, *David Milne: 1882–1953* (Kingston, Ont.: Agnes Etherington Art Centre, Queen's University, 1967).

24 O'Brian, *David Milne...*, pp. 57, 60–61.

25 O'Brian observes (*David Milne...*, p. 63, n. 34) that "The similarities of style between Prendergast and Milne have been frequently noted in the literature on Milne. In his writings Milne made only one passing reference to Prendergast.... However, Rosemarie Tovell has informed me that Milne once told [the painter] Carl Schaefer that he had known Prendergast."

26 Milne to Vincent and Alice Massey, 20 August 1934.

27 *Christian Science Monitor*, 24 February 1913.

28 O'Brian, *David Milne...*, p. 64.

29 The only Milne painting that can be cited with any near certainty as having been in the 1913 exhibition is *Distorted Tree*, which was acquired by the National Gallery of Canada in 1983.

30 Participating in this show were J.W. Beatty, William Brymner, W.H. Clapp, Maurice Cullen, Clarence Gagnon, E. Wyly Grier, C.W. Jefferys, Lawren Harris and J.E.H. MacDonald.

31 Jackson, "A Starting Point for the Group of Seven," in *Voice of the Pioneer*, ed. Bill McNeil (Toronto: Macmillan Co. of Canada, 1979), p. 200.

32 F.B. Housser, *A Canadian Art Movement: The Story of the Group of Seven*, repr. (Toronto: Macmillan Co. of Canada, 1974), pp. 56.

33 Lawren Harris, *The Story of the Group of Seven* (Toronto: Rous & Mann Press Ltd., 1964), p. 14; Jefferys, "MacDonald's Sketches," *The Lamps* (Toronto: Arts and Letters Club) 1 (December 1911): 12.

34 J.E.H. MacDonald to his wife, Joan MacDonald, 1906; quoted in Nancy Robertson Dillow, "J.E.H. MacDonald," unpublished MS, revised 1969, p. 10.

35 Jefferys, "MacDonald's Sketches."

36 Franklin Carmichael, Harris, Jackson, Frank H. Johnston, Arthur Lismer, MacDonald and Frederick H. Varley.

37 Harris, "The Group of Seven in Canadian History," *The Canadian Historical Association, Report of the Annual Meeting Held at Victoria and Vancouver, June 16–19, 1948. With History Papers*, ed. Dr. A. Preston (Toronto: University of Toronto Press, 1948), p. 30.

38 MacDonald, "Scandinavian Art," lecture delivered at the Art Gallery of Toronto, 17 April 1931, first published in *Northward Journal*, No. 18/19 (November 1980): 9. This issue also includes my article "A Contact in Context: The Influence of Scandinavian Landscape Painting on Canadian Artists Before and After 1913": 36–56.

39 Jackson, "Sketching in Algoma," *Canadian Forum* 2 (March 1921): 175.

40 John A.B. McLeish, *September Gale: A Study of Arthur Lismer and the Group of Seven*, 2nd ed. (Toronto: J.M. Dent & Sons [Canada] Ltd., 1973), p. 15.

41 Barry Lord, "Georgian Bay and the Development of the September Gale Theme in Arthur Lismer's Painting, 1912–21," *National Gallery of Canada Bulletin* 8 (1967): 28.

42 F.H. Varley to Dr. James MacCallum, n.d. [October 1914], National Gallery of Canada.

43 Arthur Lismer, speech delivered at the Art Gallery of Toronto, 30 January 1942; quoted in Paul Duval, *Canadian Impressionism* (Toronto: McClelland & Stewart, 1990), p. 124.

44 Duval, *Canadian Impressionism*, p. 136.

45 Unfortunately, because of this work's prominence in a permanent installation, the Art Gallery of Ontario, its owner, would not lend it to this exhibition.

46 Jefferys, "Trip to Saskatchewan," undated [1910] MS, Jefferys Papers, Manuscript Division, National Archives of Canada, Ottawa.

47 L.L. FitzGerald, "Painters of the Prairie," radio interview broadcast over the Midwest Network of the Canadian Broadcasting Corporation, 1 December 1954; transcript in the FitzGerald Study Centre, University of Manitoba, Winnipeg, published as Appendix B in Michael Parke-Taylor, *In Seclusion with Nature: The Later Work of L. LeMoine FitzGerald, 1942 to 1956* (Winnipeg: Winnipeg Art Gallery, 1988), pp. 49–51.

48 FitzGerald to Bertram Brooker, 17 June 1935, quoted in Patricia E. Bovey, "Lionel LeMoine FitzGerald: Some European Influences on his Work," *Lionel LeMoine FitzGerald (1890–1956): The Development of an Artist* (Winnipeg: Winnipeg Art Gallery, 1978), p. 78.

49 FitzGerald, quoted by Robert Ayre, "Lionel LeMoine FitzGerald," unpublished typescript, n.d., p. 8, Ayre Papers, Queen's University, Kingston.

50 Housser, "The Amateur Movement in Painting," *The Yearbook of the Arts in Canada*, ed. Bertram Brooker (Toronto: Macmillan of Canada, 1929), p. 89.

51 Maggie Callaghan, *Lionel LeMoine FitzGerald: His Drawings and Watercolours* (Edmonton: Edmonton Art Gallery, 1982), p. 7.

52 Foreword, *A Collection of Representative Work by Canadian Artists* (Kansas City: Kansas City Art Gallery, 1923), p. 2. That the "traditions" of France were not detected in this selection is noteworthy, as is the fact that the show was put together by the National Gallery of Canada, which meanwhile had invited the Group of Seven to lead the Canadian contingent at the British Empire Exhibition held at Wembley, England in 1924 (much to the chagrin of the Royal Canadian Academy's conservative old guard).

PLATES

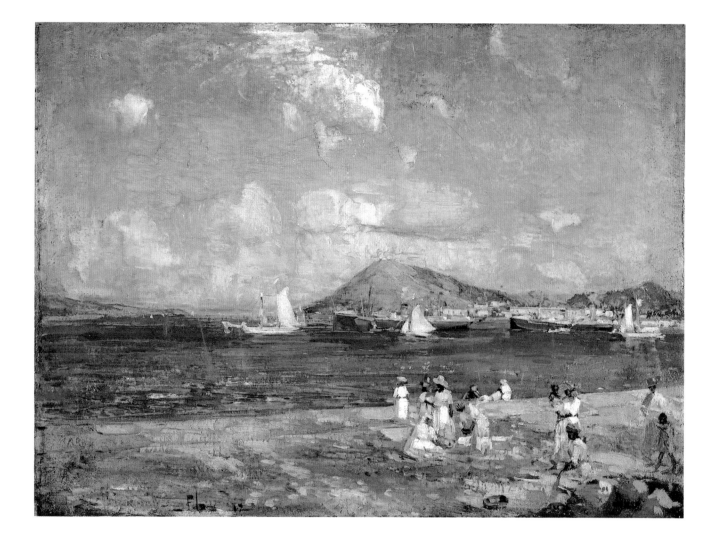

1

PELEG FRANKLIN BROWNELL

St. Thomas Harbour, 1912

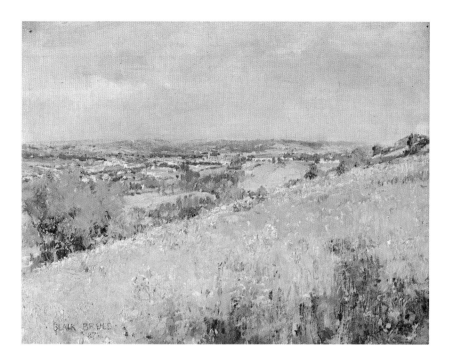

2

WILLIAM BLAIR BRUCE

Giverny, France, 1887

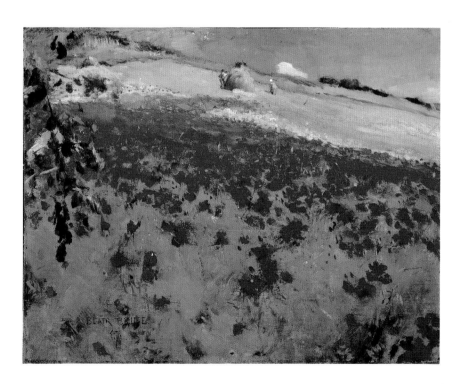

3

WILLIAM BLAIR BRUCE

Landscape with Poppies, 1887

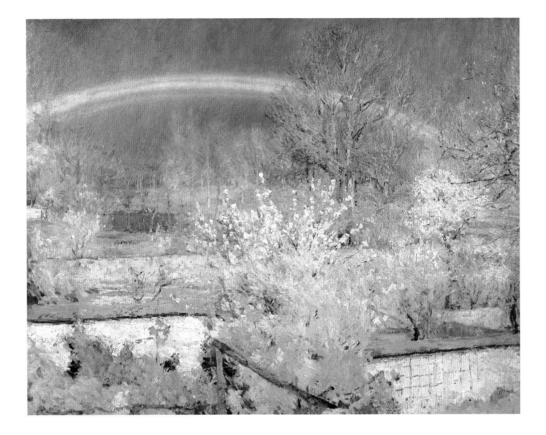

4

WILLIAM BLAIR BRUCE

The Rainbow, circa 1888

5

WILLIAM BLAIR BRUCE

Summer Days, France

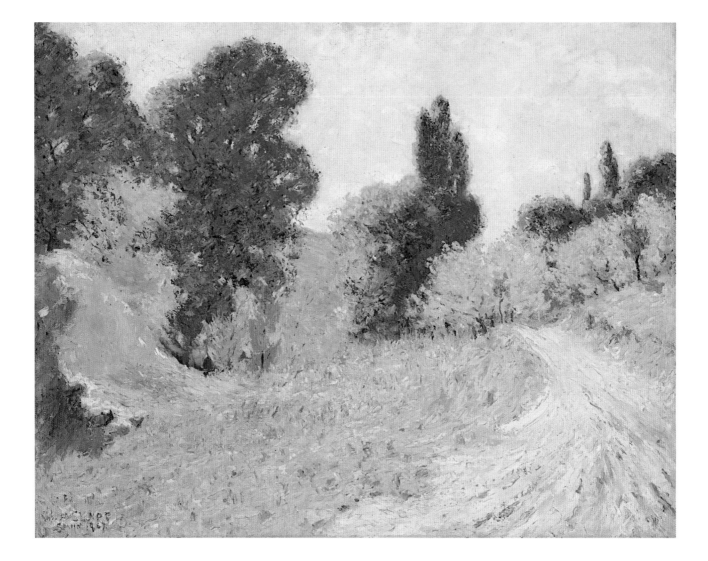

6

WILLIAM HENRY CLAPP

A Road in Spain, 1907

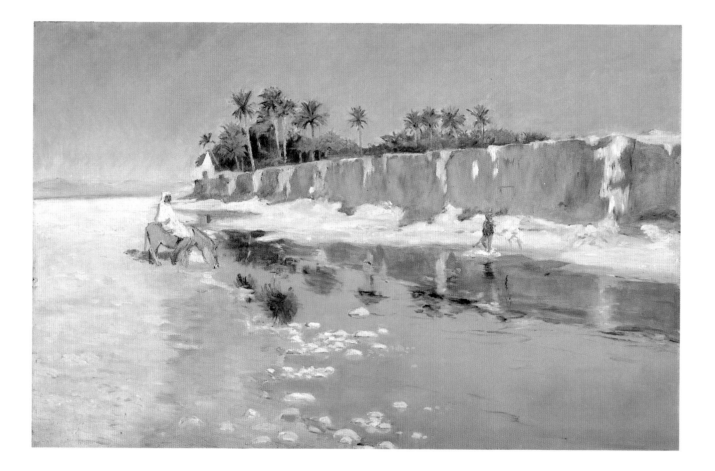

MAURICE GALBRAITH CULLEN

Biskra, 1893

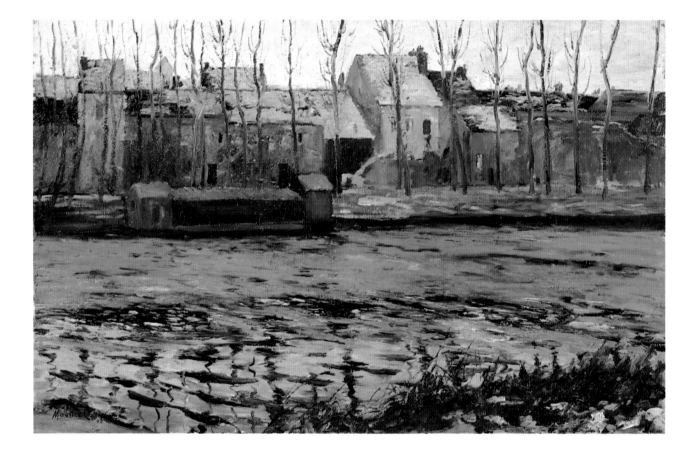

8

MAURICE GALBRAITH CULLEN

Moret, Winter, 1895

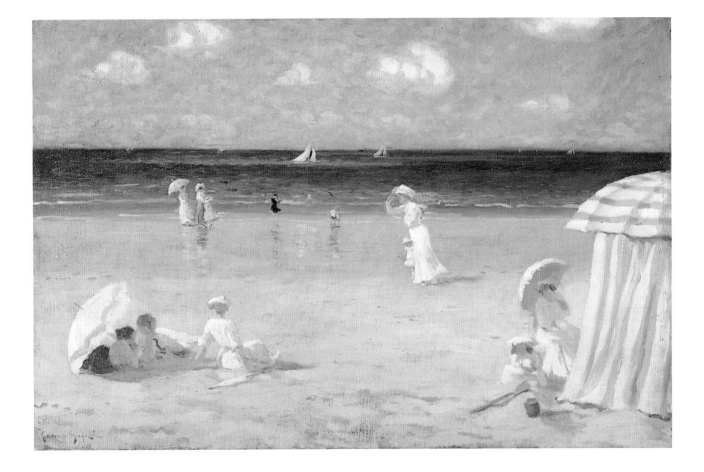

CLARENCE ALPHONSE GAGNON

Summer Breeze at Dinard, 1907

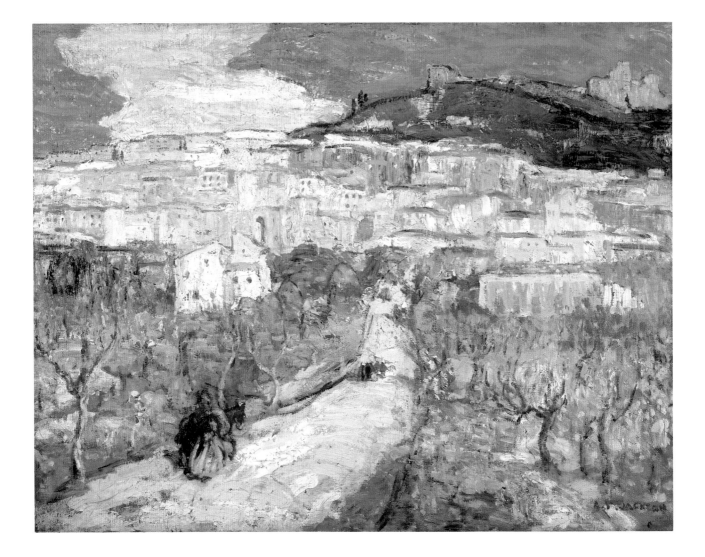

ALEXANDER YOUNG JACKSON

Assisi from the Plain, 1912

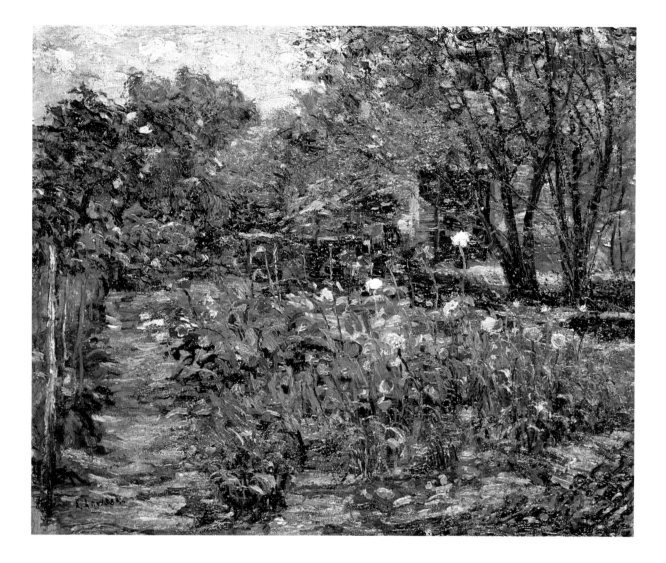

11

ERNEST LAWSON

Garden Landscape, circa 1895

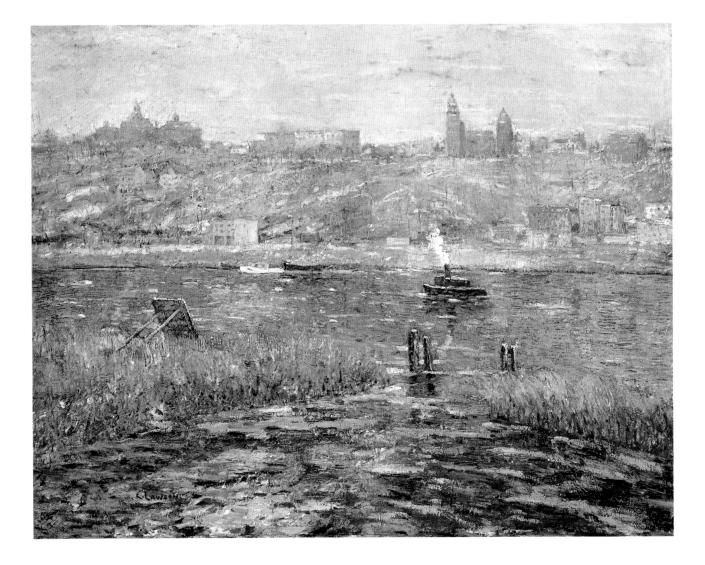

12

ERNEST LAWSON

Harlem River, circa 1913–15

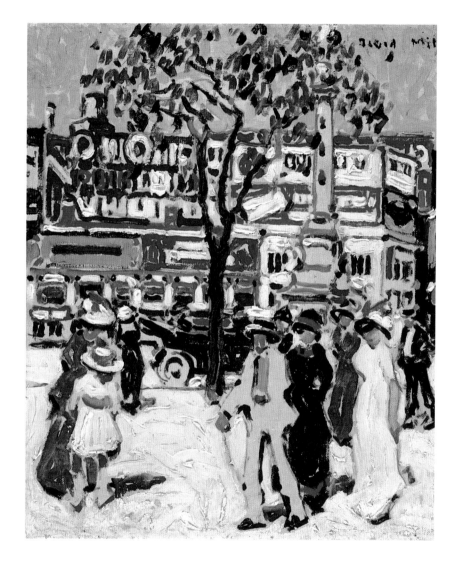

DAVID B. MILNE

Columbus Monument, circa 1912

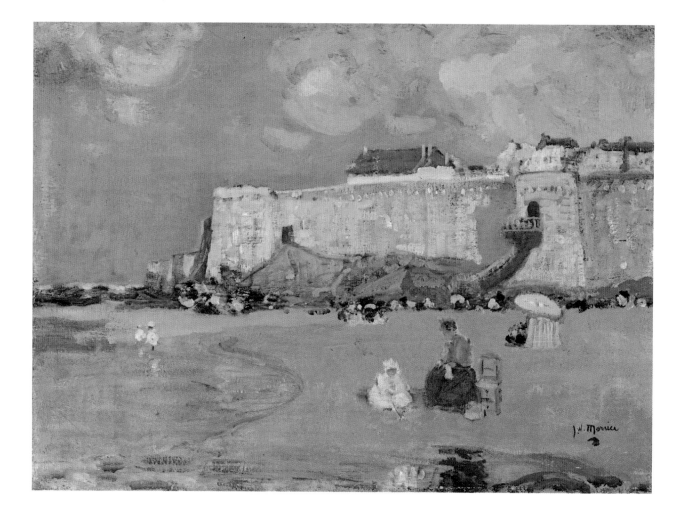

14

James Wilson Morrice

Beneath the Ramparts, Saint-Malo, circa 1898–1899

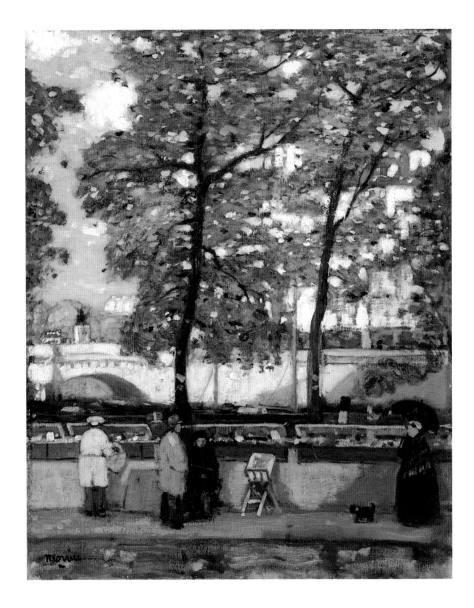

15

JAMES WILSON MORRICE

Le Quai des Grands Augustins, Paris, circa 1901

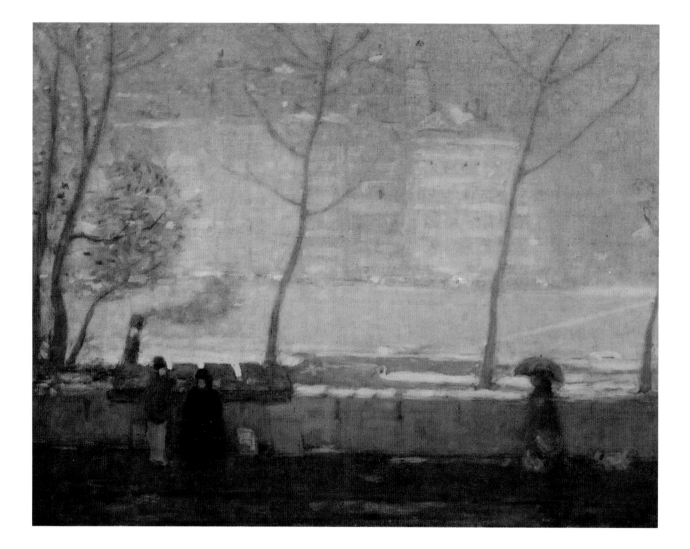

JAMES WILSON MORRICE

Quai des Grands-Augustins, circa 1904

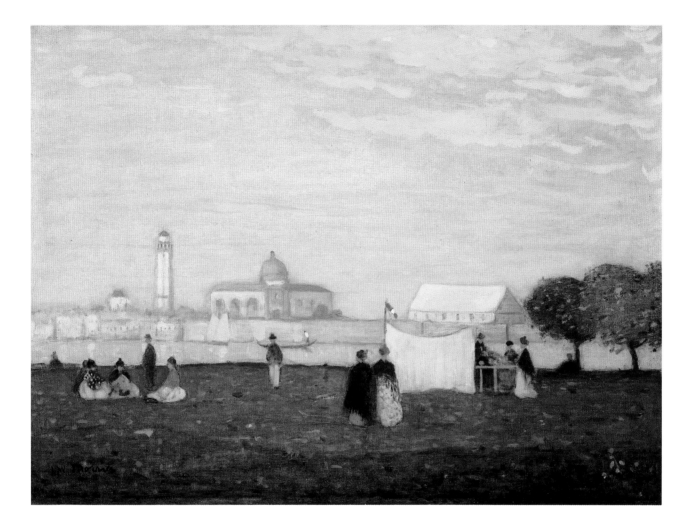

JAMES WILSON MORRICE

Church of San Pietro di Castello, Venice, circa 1904–05

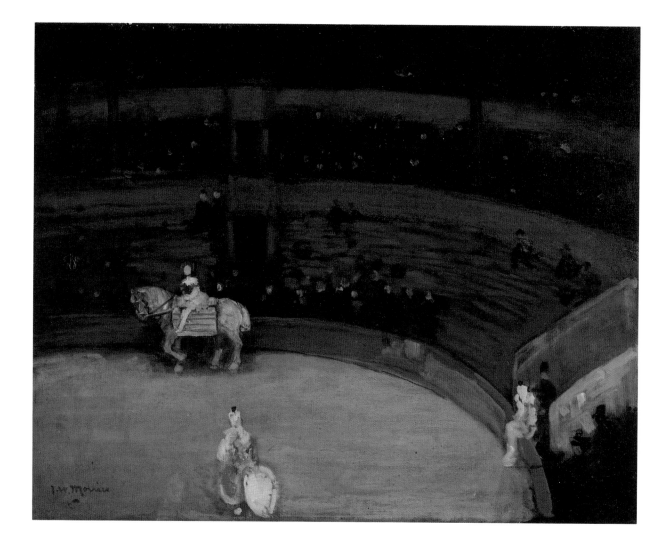

JAMES WILSON MORRICE

The Circus, Montmartre, circa 1905

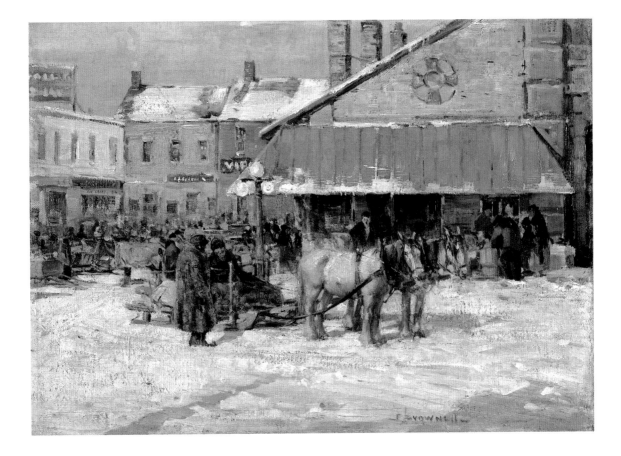

PELEG FRANKLIN BROWNELL

By Ward Market, Ottawa

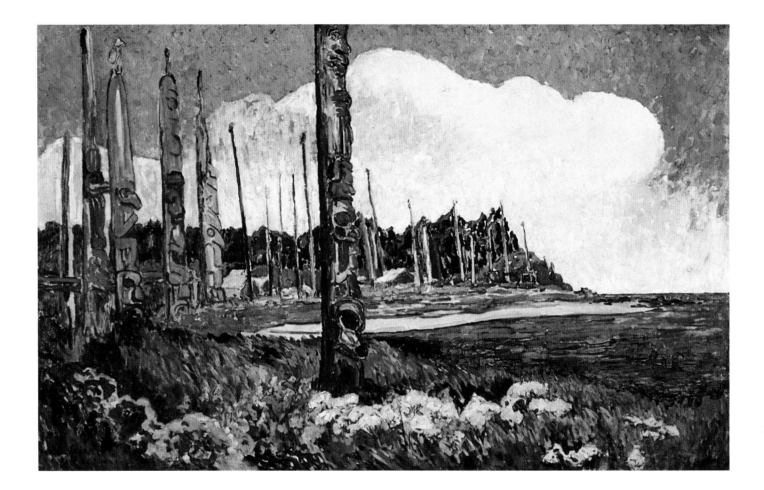

20

EMILY CARR

Yan, Queen Charlotte Islands, 1912

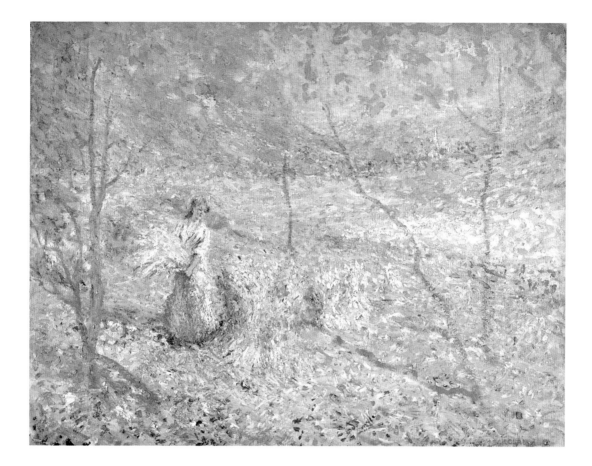

WILLIAM HENRY CLAPP

La Moisson, circa 1905

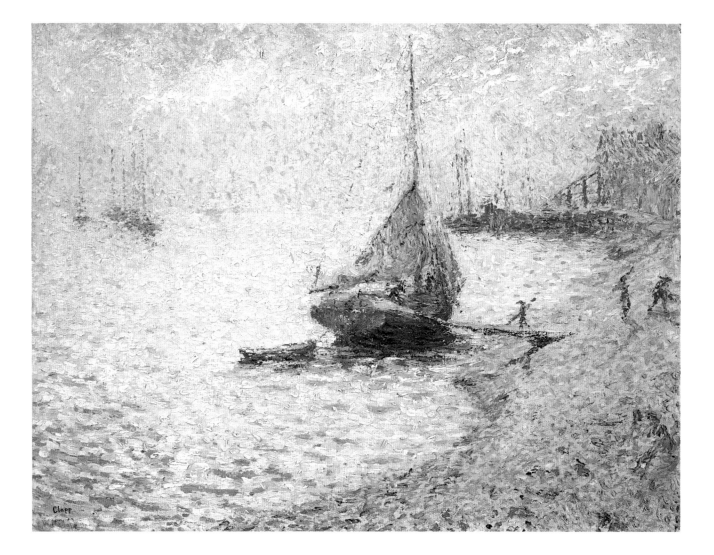

WILLIAM HENRY CLAPP

Loading Lumber (Lumber Boats), circa 1909

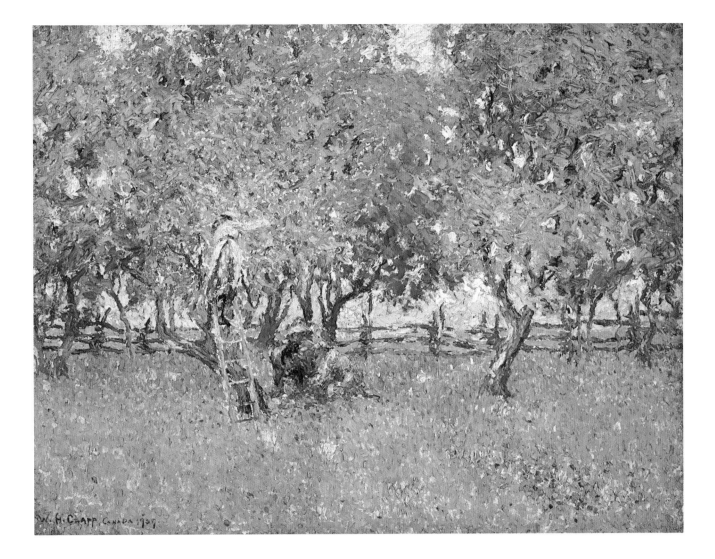

WILLIAM HENRY CLAPP

In the Orchard, Quebec, 1909

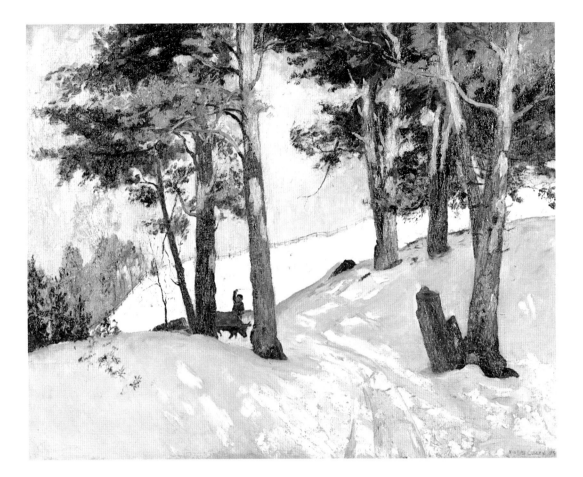

MAURICE GALBRAITH CULLEN

Logging in Winter, Beaupré, 1896

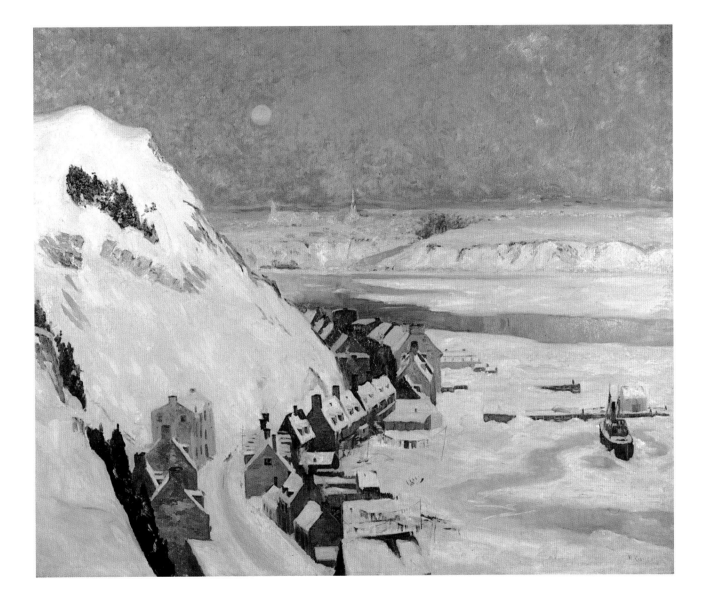

MAURICE GALBRAITH CULLEN

Cape Diamond, 1909

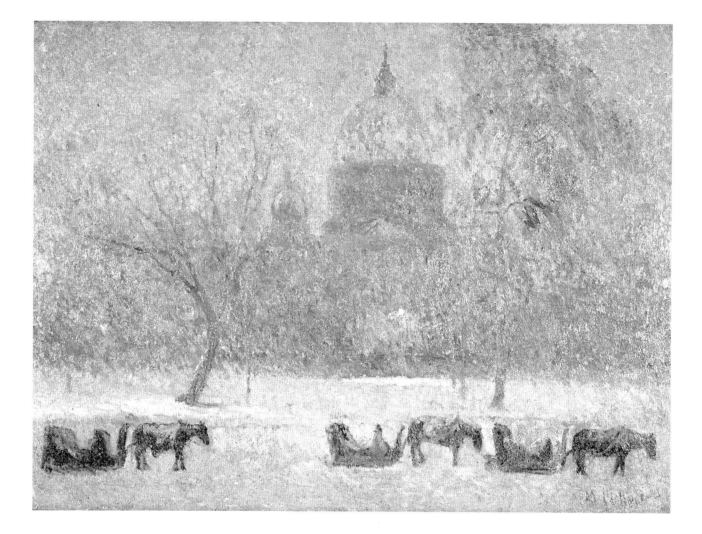

26

MAURICE GALBRAITH CULLEN

St James Cathedral, Dominion Square, Montreal, circa 1909–12

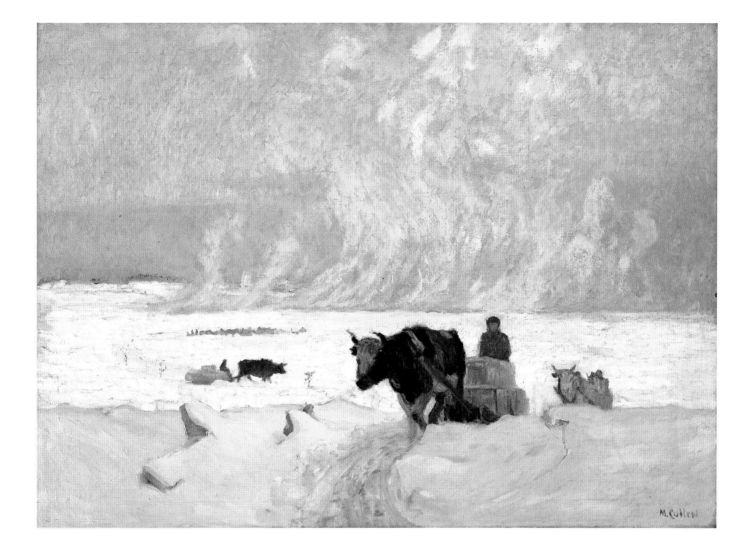

MAURICE GALBRAITH CULLEN

The Ice Harvest, circa 1913

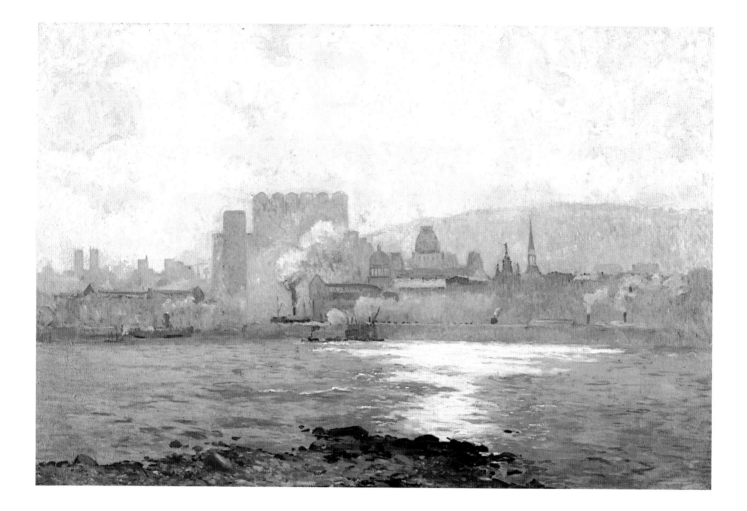

28

MAURICE GALBRAITH CULLEN

Montreal Harbour, 1915

LIONEL LEMOINE FITZGERALD

Summer Afternoon - The Prairie, 1921

30

CLARENCE ALPHONSE GAGNON

Winter, Village of Baie St. Paul, Quebec, 1910

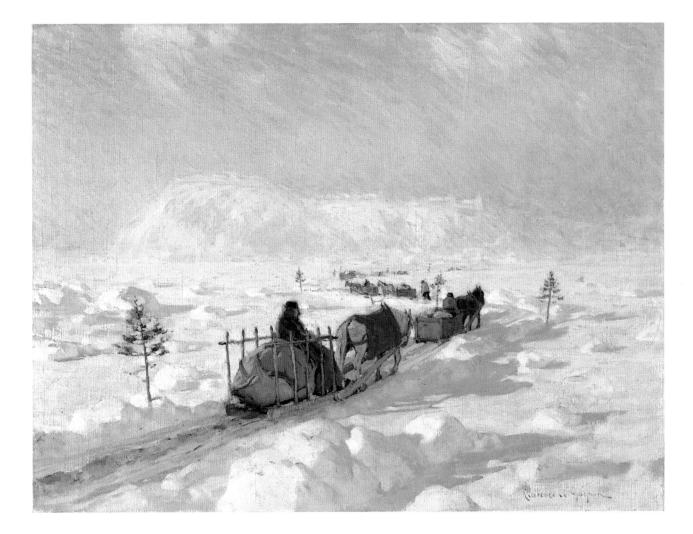

CLARENCE ALPHONSE GAGNON

Le pont de glace à Québec, 1921

JOHN SLOAN GORDON

Niagara Falls, 1907

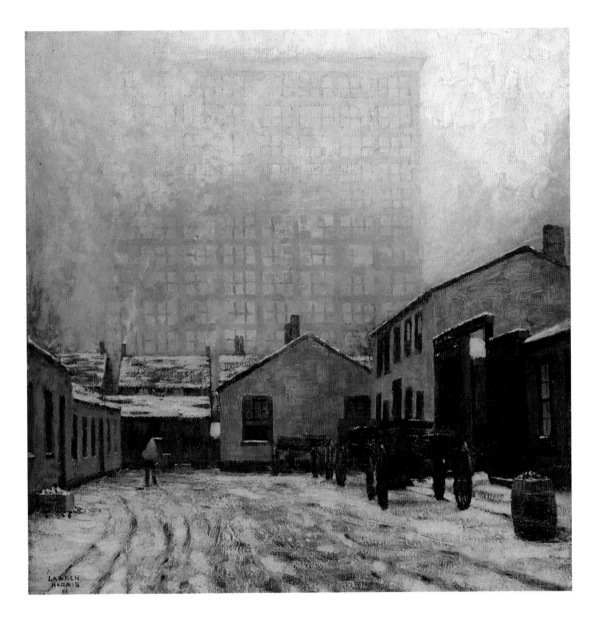

LAWREN STEWART HARRIS

The Eaton Manufacturing Building from the Ward, 1911

34

LAWREN STEWART HARRIS

Hurdy Gurdy, 1913

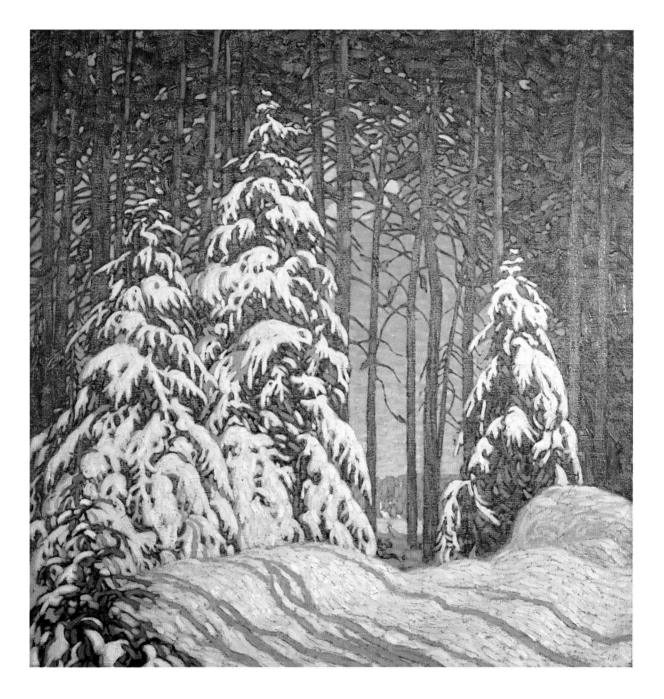

LAWREN STEWART HARRIS

Winter Sunrise, 1918

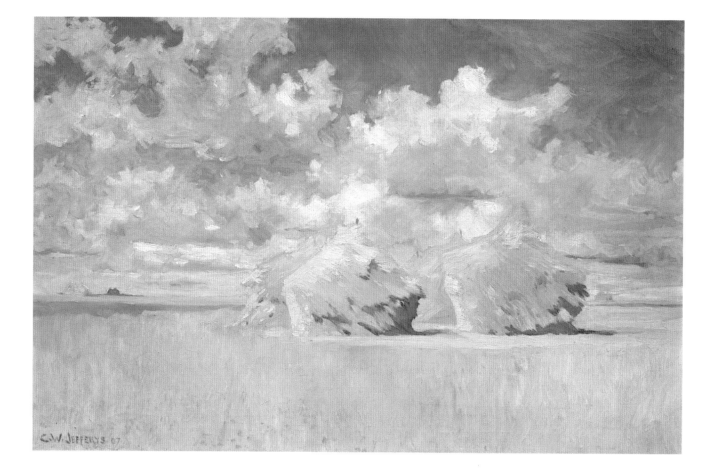

36

CHARLES WILLIAM JEFFERYS

Wheat Stacks on the Prairie, 1907

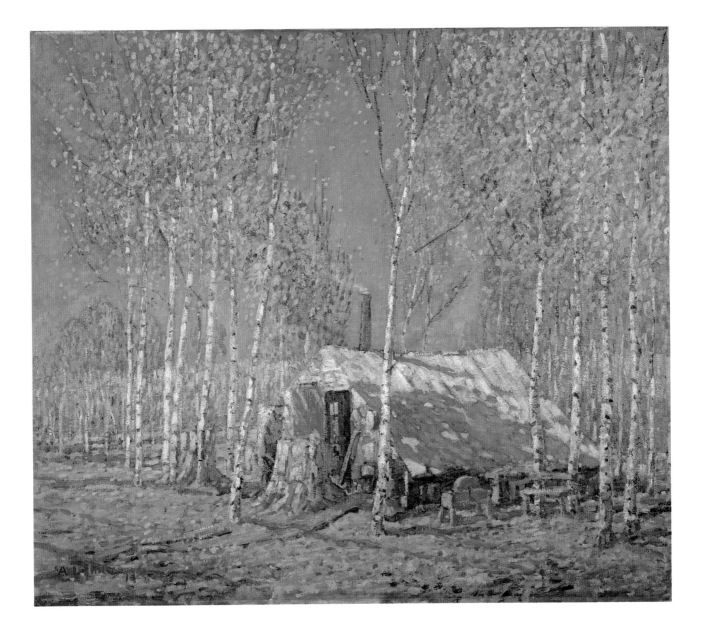

ARTHUR LISMER

The Guide's Home, Algonquin, 1914

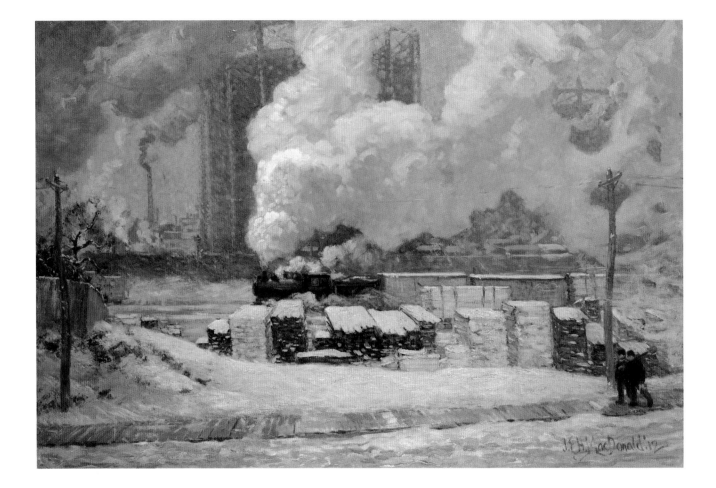

JAMES EDWARD HERVEY MACDONALD

Tracks and Traffic, 1912

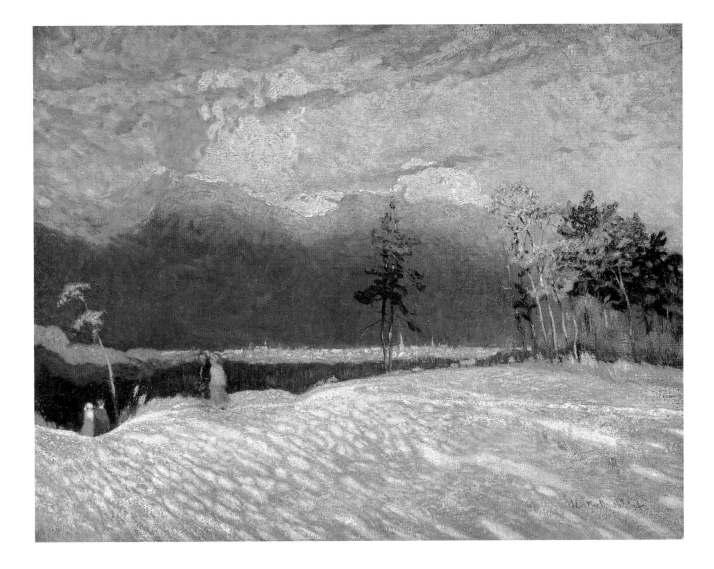

JAMES EDWARD HERVEY MACDONALD

Edge of a Town: Winter Sunset, No. 2, 1914

JAMES EDWARD HERVEY MACDONALD

Asters and Apples, 1917

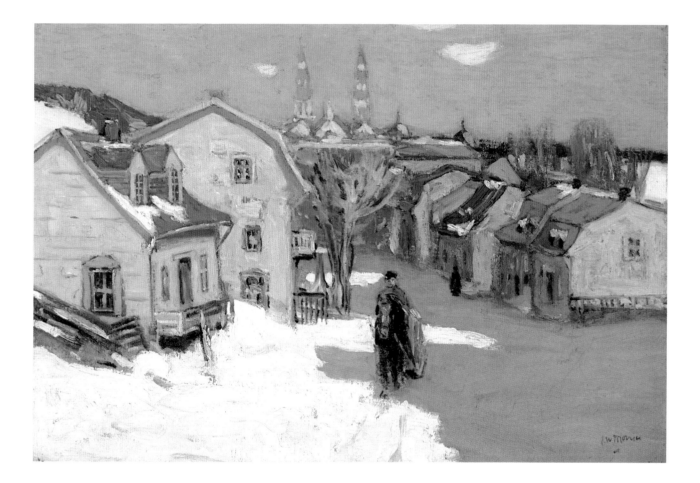

41

JAMES WILSON MORRICE

Saint Anne-de-Beaupré, 1897

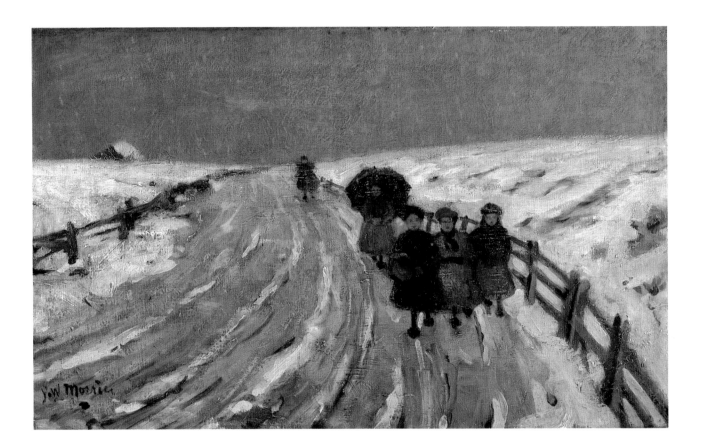

42

JAMES WILSON MORRICE

Return from School, 1900–03

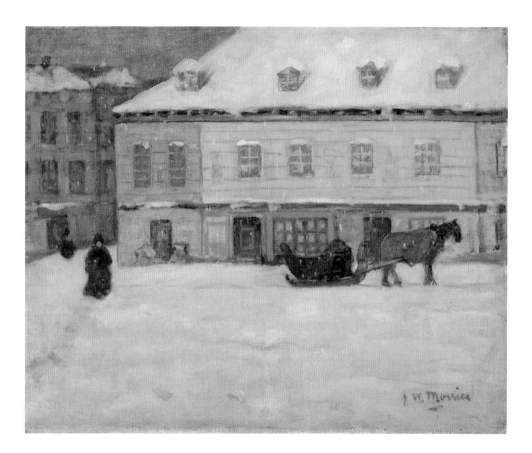

JAMES WILSON MORRICE

Canadian Square in Winter, circa 1906

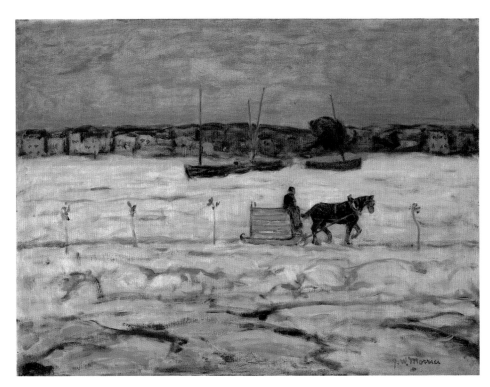

44

JAMES WILSON MORRICE

Ice Bridge over the St. Charles River, 1908

45

ALBERT HENRY ROBINSON

Montreal Fruit Seller, circa 1919

46

MARC-AURÈLE SUZOR-COTÉ
Le dégel, soir de mars, Arthabaska, 1913

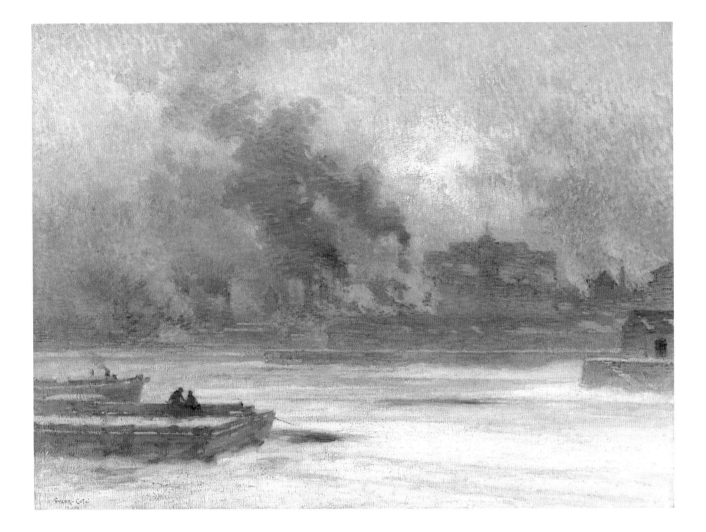

47

MARC-AURÈLE SUZOR-COTÉ

Fumées du port de Montréal, 1914

MARC-AURÈLE SUZOR-COTÉ

Le dégel (Rivière Nicolet, Arthabaska au Printemps), 1915

49

MARC-AURÈLE SUZOR-COTÉ

Dégel d'avril, 1920

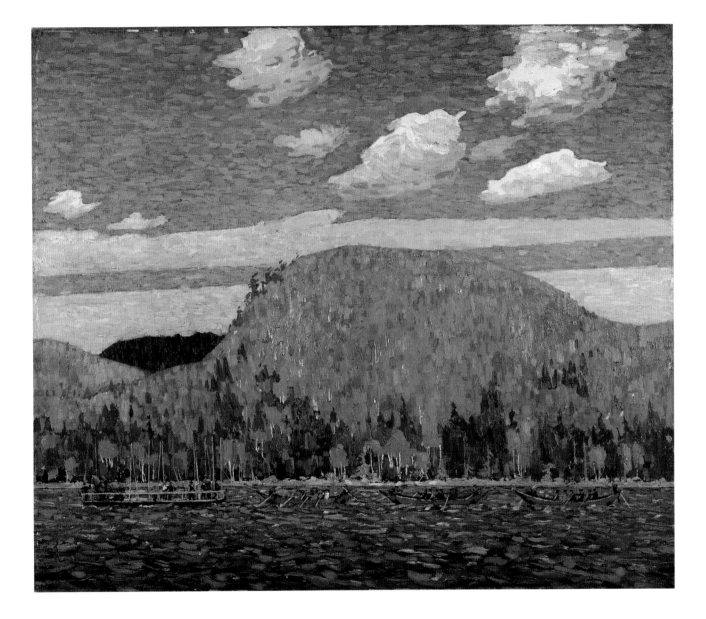

50

TOM THOMSON

The Pointers (Pageant of the North), 1915

51

ERNEST PERCYVAL TUDOR-HART

Springtime in Canada, 1903

52

FRANCES M. JONES BANNERMAN

The Conservatory, 1883

53

VITAL-ACHILLE-RAOUL BARRÉ

Au bord de la mer, 1911

HENRI BEAU

Woman with a Parasol, 1897

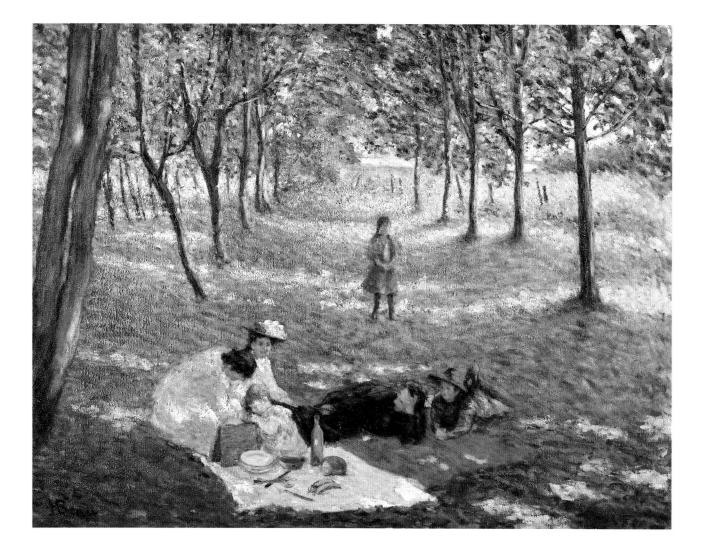

55

HENRI BEAU

The Picnic, circa 1905

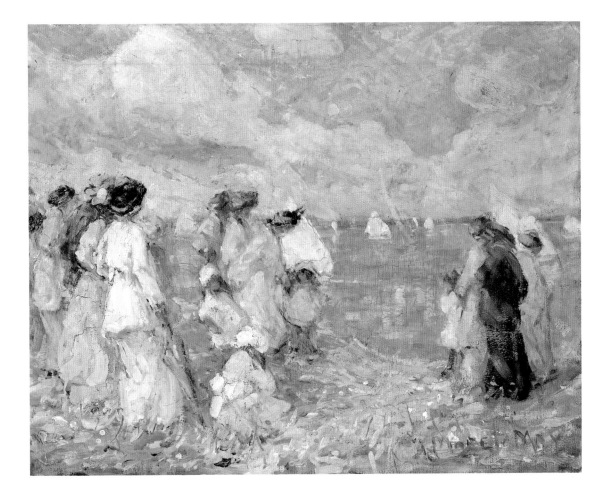

HENRIETTA MABEL MAY

The Regatta, circa 1913–14

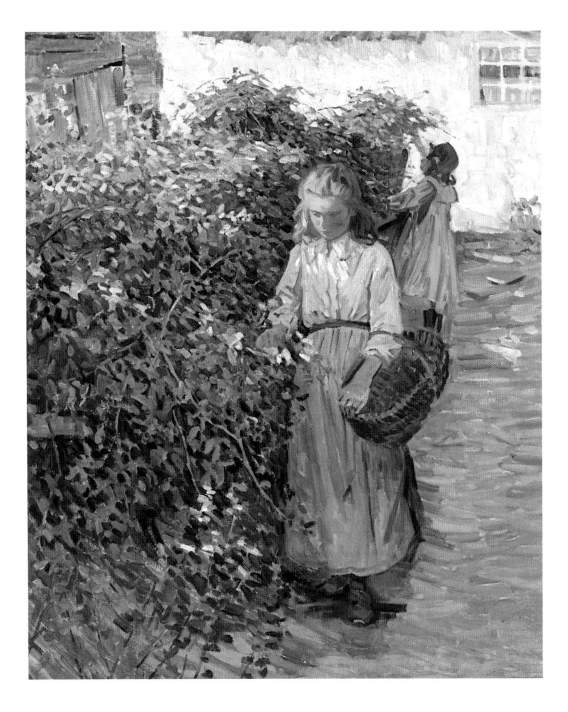

57

HELEN GALLOWAY McNICOLL

Picking Berries, 1910

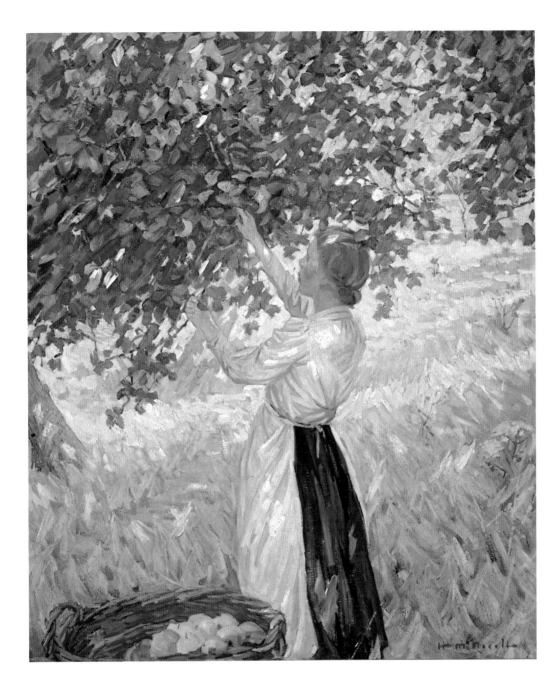

58

HELEN GALLOWAY McNICOLL

The Apple Gatherer, circa 1911

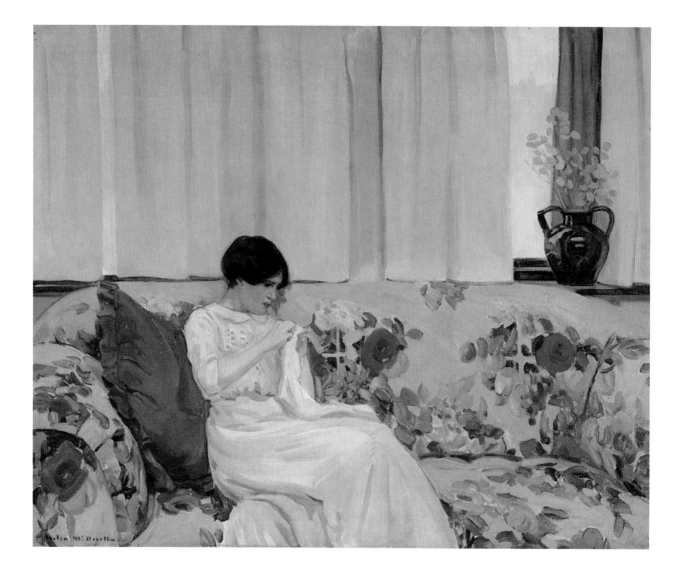

59

HELEN GALLOWAY McNICOLL

The Chintz Sofa, circa 1912

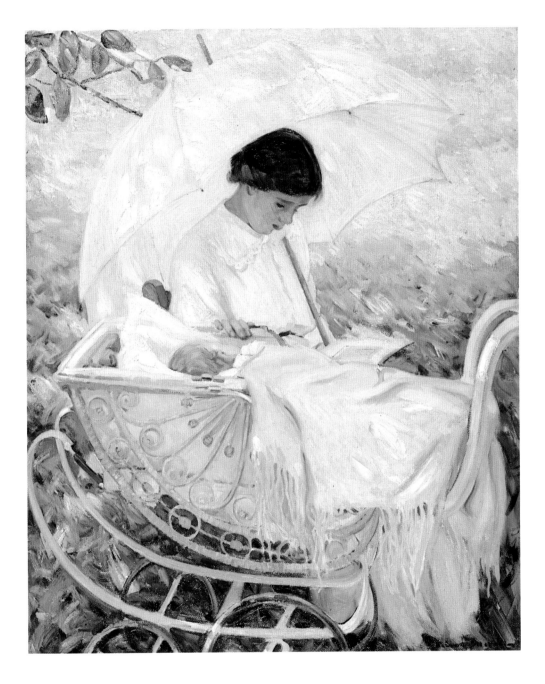

HELEN GALLOWAY MCNICOLL

In the Shadow of the Tree, circa 1914

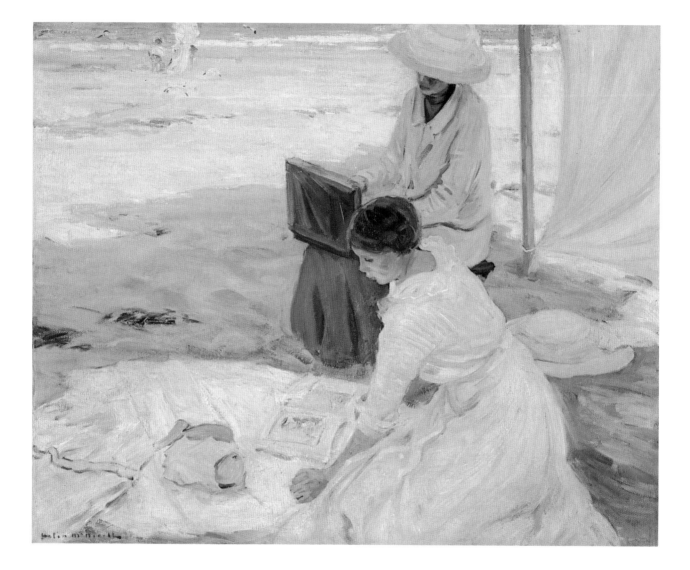

61

HELEN GALLOWAY McNICOLL

Under the Shadow of the Tent, 1914

DAVID B. MILNE

Interior with Paintings, 1914

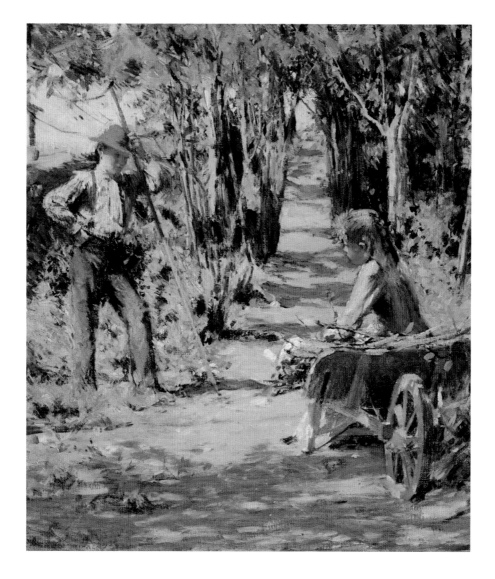

63

GEORGE AGNEW REID

Idling, 1892

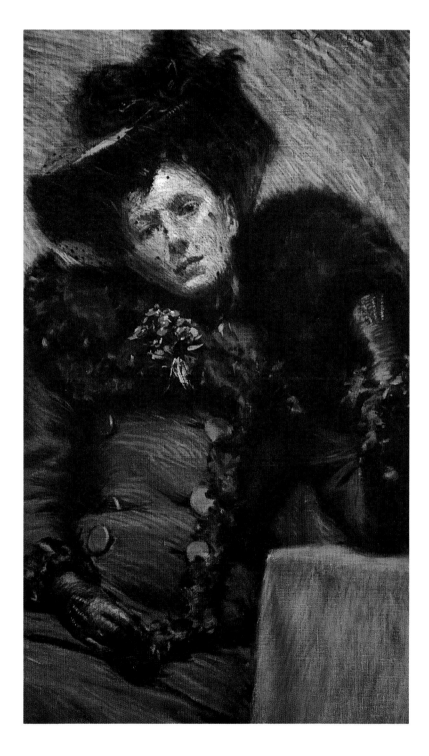

GEORGE AGNEW REID

Portrait of Henrietta Vickers, Artist, circa 1894

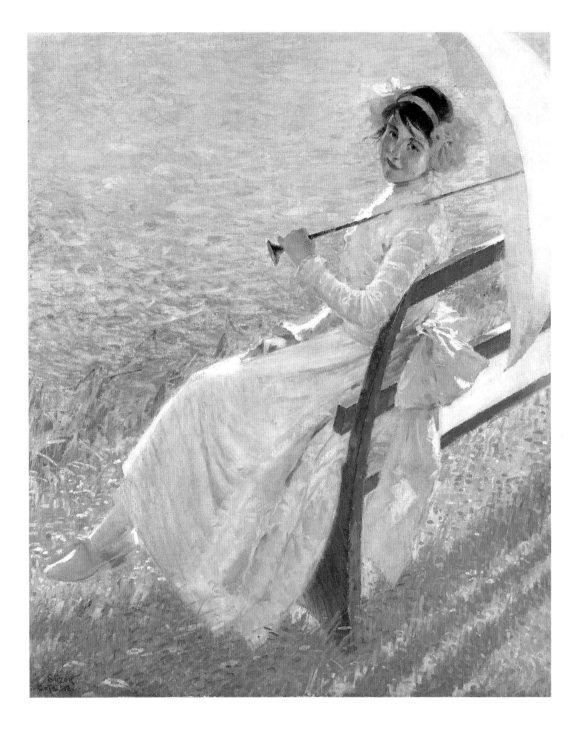

65

MARC-AURÈLE SUZOR-COTÉ

Youth and Sunlight, 1913

WORKS IN THE EXHIBITION

Canadians Abroad

PELEG FRANKLIN BROWNELL

1 *St. Thomas Harbour*, 1912
Oil on canvas
20 × 26 ¼ inches (50.8 × 66.5 cm)
National Gallery of Canada, Ottawa

WILLIAM BLAIR BRUCE

2 *Giverny, France*, 1887
Oil on canvas
10 ½ × 13 ½ inches (26.5 × 34.6 cm)
Art Gallery of Hamilton, Bruce Memorial, 1914

3 *Landscape with Poppies*, 1887
Oil on canvas
10 ¾ × 13 ⅓ inches (27.3 × 33.8 cm)
Collection Art Gallery of Ontario, Toronto, Purchase
with assistance from Wintario, 1977

4 *The Rainbow*, circa 1888
Oil on canvas
28 ¼ × 36 ¾ inches (71.8 × 93.2 cm)
The Robert McLaughlin Gallery, purchased with the
assistance of the Government of Canada through the
Cultural Property Export and Import Act, 1986

5 *Summer Days, France*, n.d.
Oil on canvas
79 ¼ × 99 ½ inches (201.1 × 253 cm)
Art Gallery of Hamilton, Bruce Memorial, 1914

WILLIAM HENRY CLAPP

6 *A Road in Spain*, 1907
Oil on canvas
28 ¼ × 36 inches (71.5 × 91.4 cm)
The Montreal Museum of Fine Arts Collection, Gift of
Henry Morgan & Co. Ltd.

MAURICE GALBRAITH CULLEN

7 *Biskra*, 1893
Oil on canvas
21 ¼ × 32 inches (54 × 81.3 cm)
National Gallery of Canada, Ottawa

8 *Moret, Winter*, 1895
Oil on canvas
23 ½ × 36 ¼ inches (59.7 × 92.1 cm)
Collection Art Gallery of Ontario, Toronto,
Gift from the J.S. McLean, Canadian Fund, 1957

CLARENCE ALPHONSE GAGNON

9 *Summer Breeze at Dinard*, 1907
Oil on canvas
21 ¼ × 32 inches (54 × 81 cm)
Collection Musée du Québec, 37.01

ALEXANDER YOUNG JACKSON

10 *Assisi from the Plain*, 1912
Oil on canvas
25 ½ × 31 ¾ inches (64.7 × 80.6 cm)
Collection Art Gallery of Ontario, Toronto,
Purchase, 1946

ERNEST LAWSON

11 *Garden Landscape*, circa 1895
Oil on canvas
20 × 24 inches (50.8 × 61 cm)
The Brooklyn Museum, Bequest of Laura L. Barnes
67.24.10

12 *Harlem River*, circa 1913–15
Oil on canvas
40 ⅛ × 50 inches (102.1 × 127 cm)
Manoogian Collection

DAVID B. MILNE

13 *Columbus Monument*, circa 1912
Oil on canvas
20 × 18 inches (50.8 × 45.5 cm)
Milne Family Collection

JAMES WILSON MORRICE

14 *Beneath the Ramparts, Saint-Malo*, circa 1898–1899
Oil on canvas
24 × 32 ¾ inches (61 × 83.5 cm)
The Montreal Museum of Fine Arts Collection,
William J. Morrice Bequest

15 *Le Quai des Grands Augustins, Paris*, circa 1901
Oil on canvas
24 ½ × 20 inches (62.2 × 50.8 cm)
Gift of Miss Olive Hosmer, The Beaverbrook Art Gallery,
Fredericton, New Brunswick, Canada

16 *Quai des Grand-Augustins*, circa 1904
Oil on canvas
25 ½ × 31 ½ inches (65 × 80 cm)
Collection Musée d'Orsay, Paris, Purchase, 1904
Quebec City and New York only

17 *Church of San Pietro di Castello, Venice*, circa
1904–1905
Oil on canvas
24 × 32 inches (60.8 × 81.4 cm)
Power Corporation du Canada/Power Corporation
of Canada

18 *The Circus, Montmartre*, circa 1905
Oil on canvas
20 × 24 ¼ inches (50.7 × 61.4 cm)
National Gallery of Canada, Ottawa

Impressionist Canada

PELEG FRANKLIN BROWNELL

19 *By Ward Market, Ottawa*
Oil on canvas
16 ¼ × 21 ¼ inches (41.3 × 53.7 cm)
Collection Art Gallery of Ontario, Toronto, Gift of the
Canadian National Exhibition Association, 1965

EMILY CARR

20 *Yan, Queen Charlotte Islands*, 1912
Oil on canvas
39 × 60 inches (98.8 × 152.5 cm)
Art Gallery of Hamilton, Gift of Roy G. Cole, 1992

WILLIAM HENRY CLAPP

21 *La Moisson*, circa 1905
Oil on canvas
29 × 37 inches (73.8 × 94.2 cm)
Collection Musée du Québec, 51.127

22 *Loading Lumber (Lumber Boats)*, circa 1909
Oil on canvas
28 ¾ × 36 ¼ inches (73 × 91.8 cm)
Art Gallery of Hamilton, Gift of Mr. & Mrs. Don
Schroder, 1960

23 *In the Orchard, Quebec*, 1909
Oil on canvas
29 × 36 inches (73.5 × 91.5 cm)
Art Gallery of Hamilton, Gift of W.R. Watson, 1956

MAURICE GALBRAITH CULLEN

24 *Logging in Winter, Beaupré*, 1896
Oil on canvas
25 ¼ × 31 ½ inches (64 × 80 cm)
Art Gallery of Hamilton, Gift of the Women's
Committee, 1956

25 *Cape Diamond*, 1909
Oil on canvas
57 × 68 ¾ inches (144.9 × 174.5 cm)
Art Gallery of Hamilton, Bequest of H.L. Rinn, 1995

26 *St James Cathedral, Dominion Square,
Montreal*, circa 1909–12
Oil on canvas
30 ¼ × 40 ¼ inches (76.8 × 102.2 cm)
Gift of Miss Olive Hosmer, The Beaverbrook
Art Gallery, Fredericton, New Brunswick, Canada

27 *The Ice Harvest*, circa 1913
Oil on canvas
30 × 40 ¼ inches (76.3 × 102.4 cm)
National Gallery of Canada, Ottawa

28 *Montreal Harbour*, 1915
Oil on canvas
45 ¼ × 67 ¼ inches (114.9 × 171 cm)
Collection Musée du Québec, 34.114

LIONEL LeMOINE FITZGERALD

29 *Summer Afternoon - The Prairie*, 1921
Oil on canvas
42 ¼ × 35 ¼ inches (107.2 × 89.5 cm)
Collection of the Winnipeg Art Gallery

CLARENCE ALPHONSE GAGNON

30 *Winter, Village of Baie St. Paul, Quebec*, 1910
Oil on canvas
28 ¾ × 36 ¼ inches (72.9 × 91.9 cm)
Power Corporation du Canada/Power Corporation
of Canada

31 *Le pont de glace à Québec*, 1921
Oil on canvas
22 ¼ × 29 ¼ inches (56.4 × 74.5 cm)
Collection Musée du Québec, 34.636

JOHN SLOAN GORDON

32 *Niagara Falls*, 1907
Oil on canvas
20 × 15 inches (50.8 × 38.1 cm)
Kenneth W. Scott, Toronto

LAWREN STEWART HARRIS

33 *The Eaton Manufacturing Building from the Ward*, 1911
Oil on canvas
30 × 29 ½ inches (76.2 × 75 cm)
Eaton's of Canada, Ltd., Toronto

34 *Hurdy Gurdy*, 1913
Oil on canvas
30 × 34 inches (76.2 × 86.3 cm)
Art Gallery of Hamilton, Gift of Roy G. Cole, 1992

35 *Winter Sunrise*, 1918
Oil on canvas
50 × 47 ½ inches (127 × 120.7 cm)
MacKenzie Art Gallery, University of Regina Collection,
Regina, Saskatchewan

CHARLES WILLIAM JEFFERYS

36 *Wheat Stacks on the Prairie*, 1907
Oil on canvas
23 ¼ × 36 inches (61.9 × 91.4 cm)
Government of Ontario Art Collection, Toronto

ARTHUR LISMER

37 *The Guide's Home, Algonquin*, 1914
Oil on canvas
39 ½ × 44 ½ inches (102.6 × 114.4 cm)
National Gallery of Canada, Ottawa

JAMES EDWARD HERVEY (J.E.H.) MACDONALD

38 *Tracks and Traffic*, 1912
Oil on canvas
28 × 40 inches (71.1 × 101.6 cm)
Collection Art Gallery of Ontario, Toronto, Gift of
Walter C. Laidlaw, 1937

39 *Edge of a Town: Winter Sunset, No. 2*, 1914
Oil on canvas
32 ¼ × 40 ½ inches (81.8 × 102.7 cm)
National Gallery of Canada, Ottawa

40 *Asters and Apples*, 1917
Oil on beaverboard
21 × 26 inches (53.4 × 66.1 cm)
National Gallery of Canada, Ottawa

JAMES WILSON MORRICE

41 *Saint Anne-de-Beaupré*, 1897
Oil on canvas
17 ½ × 25 ¼ inches (44.4 × 64.3 cm)
The Montreal Museum of Fine Arts Collection,
William J. Morrice Bequest

42 *Return from School*, 1900–1903
Oil on canvas
18 ¼ × 29 inches (46.4 × 73.7 cm)
Collection Art Gallery of Ontario, Toronto, Gift from
the Reuben and Kate Leonard Canadian Fund, 1948

43 *Canadian Square in Winter*, circa 1906
Oil on canvas
20 × 22 inches (50.8 × 55.8 cm)
Power Corporation du Canada/Power Corporation
of Canada

44 *Ice Bridge over the St. Charles River*, 1908
Oil on canvas
23 ½ × 31 ¾ inches (60 × 80.6 cm)
The Montreal Museum of Fine Arts Collection,
Gift of the Estate of James Wilson Morrice

ALBERT HENRY ROBINSON

45 *Montreal Fruit Seller*, circa 1919
Oil on canvas
17 ¾ × 20 ¾ inches (45.1 × 52.9 cm)
Collection Musée du Québec, 40.03

MARC-AURÈLE SUZOR-COTÉ

46 *Le dégel, soir de mars, Arthabaska*, 1913
Oil on canvas
28 ¾ × 36 ¼ inches (72.9 × 91.9 cm)
Power Corporation du Canada/Power Corporation
of Canada

47 *Fumées du port de Montréal*, 1914
Oil on canvas
39 × 51 ¾ inches (99 × 131.4 cm)
Collection Musée du Québec, 38.18

48 *Le dégel (Rivière Nicolet, Arthabaska au Printemps)*, 1915
Oil on canvas
24 ½ × 34 ½ inches (62.3 × 87.5 cm)
Le Musée d'art de Joliette, Québec

49 *Dégel d'avril*, 1920
Oil on canvas
31 ¾ × 39 ¾ inches (80.8 × 100.7 cm)
Collection Musée du Québec, 34.591

TOM THOMSON

50 *The Pointers (Pageant of the North)*, 1915
Oil on canvas
40 ¼ × 45 ½ inches (102.2 × 115.6 cm)
Hart House Permanent Collection,
University of Toronto

ERNEST PERCYVAL TUDOR-HART

51 *Springtime in Canada*, 1903
Oil on canvas
38 ½ × 53 ¼ inches (97.9 × 135.4 cm)
Art Gallery of Hamilton, Gift of the Estate
of the Artist, 1973

Figures and Portraits

FRANCES M. JONES BANNERMAN

52 *The Conservatory*, 1883
Oil on canvas
18 ¼ × 31 ¾ inches (46.5 × 80.6 cm)
Public Archives of Nova Scotia, Halifax

VITAL-ACHILLE-RAOUL BARRÉ

53 *Au bord de la mer*, 1911
Oil on canvas
20 × 24 inches (51.1 × 61.1 cm)
Collection Musée du Québec, 34.03

HENRI BEAU

54 *Woman with a Parasol*, 1897
Oil on canvas
16 ¼ × 12 ½ inches (41 × 32 cm)
The Montreal Museum of Fine Arts Collection,
Purchase, Horsley and Annie Townsend Bequest

55 *The Picnic*, circa 1905
Oil on canvas
28 ½ × 36 ⅜ inches (72.5 × 92.5 cm)
Collection Musée du Québec, 86.43

HENRIETTA MABEL MAY

56 *The Regatta*, circa 1913–14
Oil on canvas
18 × 22 inches (46 × 56.3 cm)
National Gallery of Canada, Ottawa

HELEN GALLOWAY McNICOLL

57 *Picking Berries*, 1910
Oil on canvas
40 ¼ × 34 ¼ inches (102.3 × 87 cm)
Private Collection, Hamilton, Ontario

58 *The Apple Gatherer*, circa 1911
Oil on canvas
42 ¼ × 36 ¼ inches (107 × 92 cm)
Art Gallery of Hamilton, Gift of G.C. Mutch, Esq., in
memory of his mother Annie Elizabeth Mutch, 1957

59 *The Chintz Sofa*, circa 1912
Oil on canvas
32 × 39 inches (81.3 × 99 cm)
Private Collection

60 *In the Shadow of the Tree*, circa 1914
Oil on canvas
39 ½ × 32 ½ inches (100.4 × 82.6 cm)
Collection Musée du Québec, 51.140

61 *Under the Shadow of the Tent*, 1914
Oil on canvas
32 × 40 inches (81.3 × 101.6 cm)
The Montreal Museum of Fine Arts Collection, Gift of
Mr. and Mrs. David McNicoll

DAVID B. MILNE

62 *Interior with Paintings*, 1914
Oil on canvas
20 × 24 inches (50.8 × 61 cm)
Collection of the Winnipeg Art Gallery; acquired with
the assistance of the Women's Committee and The
Winnipeg Foundation

GEORGE AGNEW REID

63 *Idling*, 1892
Oil on canvas
18 × 16 inches (45.7 × 40.6 cm)
Private Collection

64 *Portrait of Henrietta Vickers, Artist*, circa 1894
Oil on canvas
34 ½ × 21 ¼ inches (87.6 × 54 cm)
Government of Ontario Art Collection, Toronto,
Canada, Gift of the Artist, 1944

MARC-AURÈLE SUZOR-COTÉ

65 *Youth and Sunlight*, 1913
Oil on canvas
58 ¼ × 49 ¼ inches (148 × 124.8 cm)
National Gallery of Canada, Ottawa

Artists' Biographies

CAROL LOWREY

FRANCES M. JONES BANNERMAN
b. 1855, Halifax, Nova Scotia
d. 1944, Torquay, England

Painter and illustrator. Educated in Nova Scotia, France, and Italy. Painted Impressionist-inspired genre subjects in Halifax, early-mid-1880s. Exhibited at Paris Salon (1882), Royal Canadian Academy (1881–83; A.R.C.A., 1882), Royal Academy, London (1888–91). Settled in Great Marlowe, England, following her marriage to the British artist Hamlet Bannerman, in 1886. Wrote poetry, including *Milestones* (1899).

VITAL-ACHILLE-RAOUL BARRÉ
b. 1874, Montreal, Quebec
d. 1932, Montreal, Quebec

Landscape and portrait painter, illustrator, pioneer film animator. Travelled to Paris, 1891. Attended Académie Julian, 1896, and École des Beaux-Arts [?]. Influenced by Impressionism and Post-Impressionism. Contributed illustrations to *La Revue Nationale, Le Monde Illustré, Le Soufflet,* and other French periodicals before returning to Montreal in 1898. Worked as a commercial artist and illustrator. Lived in Paris, 1901–02, and in Montreal, 1902–03. Moved to New York in 1903. Painted in Gloucester, Massachusetts and elsewhere in the northeastern U.S. Established an animated film studio in The Bronx, N.Y., in 1914. From around 1919 until 1926, he divided his time between New York City and Glen Cove, Long Island, where he was active as a painter and illustrator. Participated in the production of Felix the Cat films in New York, 1926–27. Returned to Montreal in 1929 due to illness. Resumed painting, exhibiting work at Royal Canadian Academy and Art Association of Montreal.

HENRI BEAU
b. 1863, Montreal, Quebec
d. 1949, Paris, France

Landscape, genre, portrait and history painter, and muralist. Studied under Joseph Chabert in Montreal, circa 1881. Studied under Jean-Léon Gérôme at École des Beaux-Arts, Paris, 1893. Influenced by French Impressionism. Painted landscapes in French countryside. Visited and painted in Brittany, Belgium, Holland, Italy, and Spain. Exhibited at Paris Salons, Royal Canadian Academy, and Art Association of Montreal. Appointed Palmes Académiques, France,

1901. Resided in Montreal, 1900–02, 1904–06. Taught at Sarsfield School, 1904–06. Settled permanently in Paris by 1907. As copyist and assistant archivist for Public Archives of Canada in Paris, 1915–38, he painted views of historic French ports of embarkation, renditions of Canadian military costume, etc. Painted murals for National Assembly, Quebec City, and Royal Alexandra Hotel, Winnipeg.

PELEG FRANKLIN BROWNELL
b. 1857, New Bedford, Massachusetts
d. 1946, Ottawa, Ontario

Portrait, figure, and landscape painter, teacher. Studied under Thomas Dewing and others at Boston Museum School (1877–79), and in Paris, at Académie Julian (1880–83), and privately with Léon Bonnat. Moved to Ottawa, 1886. Taught at Ottawa Art School (1886–1900), Women's Art Association, Ottawa, and Art Association of Ottawa (1900–37). Adhered to an academic realist manner in his figural work. Painted Impressionist-inspired landscapes and street scenes after 1900. Active in the Gatineau Hills and the Gaspé region of Quebec and in Algonquin Park (Ont.). Made painting trips to the West Indies, 1911–12. Exhibited at Royal Canadian Academy, Art Association of Montreal, Ontario Society of Artists, and at Paris Salons. Founding member of the Canadian Art Club, 1907.

WILLIAM BLAIR BRUCE
b. 1859, Hamilton, Ontario
d. 1906, Stockholm, Sweden

Figure, landscape, and marine painter. Studied law and worked as an architectural draftsman before turning to art. Attended Hamilton Mechanics Institute, 1877, and studied privately under Henry Martin. Attended Académie Julian, Paris, 1881. Active in Paris and Barbizon, 1881–85. Lost two hundred paintings in a shipwreck in the St. Lawrence River, November 1885, and subsequently returned to Hamilton. Returned to Paris, January 1887. Active in Giverny, summer 1887 and winter 1888, where he painted his first Impressionist landscapes. Married Caroline Benedicks, a Swedish sculptor, 1888. Divided time between Paris and Grèz-sur-Loing. Made intermittent trips to Hamilton, Stockholm, Italy, and Lapland. Exhibited in Paris Salons and in London, Toronto, Munich, and Stockholm. Settled permanently in Visby, Gotland Island, Sweden, 1899. Retrospective exhibitions held at Galeries Georges Petit, Paris, and at Konstakademien, Stockholm, 1906.

EMILY CARR
b. 1871, Victoria, British Columbia
d. 1945, Victoria, British Columbia

Landscape painter. Studied at California School of Design, San Francisco, 1891–93. Attended Westminster School of Art, London, 1899–1901. Outdoor painting classes with J. Olsson and A. Talmage, St. Ives, Cornwall, 1901–02. Studied with J. Whiteley, Bushy, Eng., 1902, 1904. Taught art in Victoria, 1894–circa 1899, 1905, 1936, and in Vancouver, 1906–10, 1912–13. Studied at Académie Colarossi, Paris, and privately with J. D. Fergusson, 1910. Outdoor classes with P. Gibb in Crécy-en-Brie and St. Efflam, May–Aug. 1911, and with F. Hodgkins in Concarneau, late 1911. Painted views of forests and Indian villages on Vancouver Island, Queen Charlotte Islands, and elsewhere in British Columbia, 1895–1942. Work influenced by Impressionism and Fauvism; however, after meeting the Group of Seven in 1927, her style became increasingly expressionistic. Author of *Klee Wyck* (1941), *The Book of Small* (1942), *Growing Pains* (1946), and other writings.

WILLIAM HENRY CLAPP
b. 1879, Montreal, Quebec
d. 1954, Oakland, California

Landscape painter and museum administrator. Studied at Art Association of Montreal under William Brymner, 1900–03. Travelled to Paris, 1904. Attended Académie Julian, Académie de la Grande Chaumière, and Académie Colarossi, 1904–08. Influenced by Impressionism and Post-Impressionism. Painted landscapes in Chezy-sur-Marne (1906), Spain (1907), and Belgium. Returned to Montreal, 1908. Painted views of rural Quebec. Exhibited at Royal Canadian Academy, Art Association of Montreal, and Canadian Art Club. Exhibited eighty-nine Impressionist paintings at Johnson's Art Galleries, Montreal, 1914. Lived and worked in Cuba, 1915–17. Settled in Oakland, California, 1917. Appointed curator, Oakland Art Gallery, 1918; served as director, 1920–49. Member of Society of Six, an Oakland-based group of painters.

MAURICE GALBRAITH CULLEN
b. 1866, St. John's, Newfoundland
d. 1934, Chambly, Quebec

Landscape painter. Resided in Montreal, 1870–88. Studied sculpture under Louis-Philippe Hébert, 1884–87. Lived in Paris, 1888–95. Studied at École des Beaux-Arts, 1888, 1890–92, at Académie Colarossi, 1889, and at Académie Julian, 1889–90. Painted first Impressionist-inspired canvases, early 1890s. Associated with William Blair Bruce in Paris, 1892, and Grèz-sur-Loing, 1894. Returned to Montreal, 1895, and proceeded to depict native scenery in an Impressionist manner. Active in France, 1897 and 1900–02; Italy, 1890, 1900–02, and 1925; North Africa, circa 1893; Newfoundland, 1907–12. Painted in and around Quebec City, Montreal, the Laurentian Mountains, and Côte de Beaupré. Associated with a coterie of artists that included James Wilson Morrice, William Brymner, and Edmund Morris. Exhibited widely, including Paris Salons, Royal Canadian Academy, and Canadian Art Club. Taught at Art Association of Montreal, 1911–17, 1919–23, including outdoor classes at Beaupré and elsewhere. Official war-artist, Canadian War Records, 1918–20. Resided in Chambly after 1931. Played a key role in the dissemination of Impressionism in Canada.

LIONEL LEMOINE FITZGERALD
b. 1890, Winnipeg, Manitoba
d. 1956, Winnipeg, Manitoba

Painter, printmaker, and teacher. Spent childhood summers on grandparents' farm in Snowflake, Manitoba. Studied under A.S. Keszthelyi in Winnipeg, 1909. Visited Chicago, 1910. Worked as a commercial artist and interior decorator, Winnipeg, 1912–18. Shared studio with Donald Mac-Quarrie, a Scottish-born painter who influenced his early landscapes. Employed by T. Eaton Co., Winnipeg, 1918–21. Painted Prairie scenery in a pointillist manner, 1920–21. Studied at Art Students League, New York, 1921–22, under K.H. Miller and B. Robinson. Influenced by Cézanne and Seurat, early 1920s. Developed a delicate, Precisionist style. Taught at Winnipeg Art School, 1924–49; appointed principal, 1929. Joined Group of Seven, 1932. Founding member, Canadian Group of Painters, 1933. Work became increasingly abstract, late 1940s. Active in Vancouver and Bowen Island, B.C., 1942–44, 1947–49, and Mexico, 1951.

CLARENCE ALPHONSE GAGNON
b. 1881, Montreal, Quebec
d. 1942, Montreal, Quebec

Landscape painter, etcher, and illustrator. Studied at Art Association of Montreal, 1897–1900, under William Brymner, and at Académie Julian, Paris, 1904–05. Early work influenced by M. Cullen, French Impressionists, J.A.M. Whistler, and J.W. Morrice. In 1904, visited Spain and painted Impressionist landscapes and beach scenes in Normandy and Brittany. Visited Venice, 1905. Established an international reputation as an etcher, 1904–09. Returned to Canada, 1909, settling in Baie St. Paul, in Charlevoix County, Quebec. Specialized in landscapes and scenes of *habitant* life. Frequently painted in the company of W.H. Clapp, A.Y. Jackson, and A. Robinson. Lived in Paris, 1917–19, and 1925–36. Made summer painting trips to Norway. Exhibited at Royal Canadian Academy, Ottawa; Canadian Art Club, Toronto; Salmagundi Club, New York, and elsewhere. Had solo exhibition, primarily of Quebec landscapes, at Galerie A.-M. Reitlinger, Paris, 1913. Illustrated L.F. Rouquette's *Le Grand Silence Blanc* (1929) and Louis Hémon's *Maria Chapdelaine* (1933). Returned permanently to Canada, 1936.

JOHN SLOAN GORDON
b. 1868, Brantford, Ontario
d. 1940, Hamilton, Ontario

Painter, illustrator, and teacher. Worked for Howell Litho. Co., Hamilton, and as a commercial artist, circa 1890–94. Resided in Paris, 1895–96. Studied at Académie Julian [?]. Associated with American painters Myron Barlow, Luis F. Mora, and Henry O. Tanner. Co-founded the art magazine *Quartier Latin* (1896–98), which he also edited and illustrated. Assisted the American muralist William de Leftwich Dodge in preparing ceiling decorations for the Library of Congress, 1895. Contributed drawings to periodicals in London and New York. Returned to Canada, late 1896. Settled in Hamilton, 1897. Contributed illustrations to *Canadian Magazine*, *Saturday Night*, and other journals. Helped establish Hamilton Art League, 1898. Taught Hamilton School of Art, 1898–1909. Principal of Art Dept., Hamilton Technical School, 1909–23. Director, Art Dept. of Hamilton Technical Institute, 1923–32. An early exponent of pointillism in Canada, his style was inspired by Le Sidaner, Seurat, Monet, and Japanese prints. Influenced a generation of artists, including A. Robinson, Laura Muntz, and Arthur Crisp. Illustrated numerous books. His wife, Hortense M. Gordon (1887–1961), was also a painter.

LAWREN STEWART HARRIS
b. 1885, Brantford, Ontario
d. 1970, Vancouver, British Columbia

Painter. Attended University of Toronto. Studied art under F. von Wille, A. Schlabitz, and F. Skarbina in Berlin, 1904–07. Influenced by modern German art, notably M. Liebermann, W. Leistikow, and P. Thiem, as well as by Gauguin, van Gogh, Cézanne, and other European Post-Impressionists. Visited Austria, Italy, France, and England before returning to Toronto, 1908. Painted streetscapes, industrial subjects, and wilderness landscapes, combining aspects of Impressionism and Post-Impressionism. Inspired by *Exhibition of Contemporary Scandinavian Art* at Albright Art Gallery, Buffalo, Jan. 1913, he became the guiding force behind the development of a national school of landscape painting. Founding member, Group of Seven, 1920. Landscapes became increasingly abstract, late 1920s. Painted in northern Ontario, Canadian Rockies, the Arctic, and elsewhere in Canada. Founding member, Canadian Group of Painters, 1933. Lived in Hanover, N.H., 1934–38. Moved to Santa Fe, N.M., 1938, where he joined the Transcendental Painting Group and painted pure abstractions. Settled permanently in Vancouver, Dec. 1940.

ALEXANDER YOUNG JACKSON
b. 1882, Montreal, Quebec
d. 1974, Toronto, Canada

Landscape painter. Studied evenings at Monument National, Montreal, 1896–99. Studied with W. Brymner, Montreal. First trip to Europe, 1905. Designer for a lithography firm, Chicago, 1906–1907. Studied evenings at Art Institute of Chicago. Studied at Académie Julian, Paris, 1907. Visited Italy, France, and Holland, 1908–09. Returned to Canada, Dec. 1909. Painted Impressionist landscapes in Sweetsburg, Que., early 1910. Third trip to Europe, 1911–13. Active in St. Malo (with A. Robinson), Paris, Trépied, Brittany, Leeds, Eng., Assisi and Venice. Painted in Émileville, Que., and Georgian Bay (Ont.) region, 1913. Settled in Toronto, 1913. Work became increasingly Post-Impressionistic. Painted in Algonquin Park, 1914. Joined army, 1915. Official artist for Canadian War Records, 1917–19. Returned to Toronto, 1919. Subsequently painted in Algoma and Georgian Bay regions, Charlevoix County (Que.), Alberta, and elsewhere in Canada. Member, Ontario Society of Artists, 1915; Royal Canadian Academy, 1919; Group of Seven, 1920; and Canadian Group of Painters, 1933. Lived in Manotick, Ont., 1955–62; Ottawa, 1962–68; Kleinburg, Ont. 1968–74. Wrote autobiography, *A Painter's Country* (1958).

CHARLES WILLIAM JEFFERYS
b. 1869, Rochester, Kent, England
d. 1951, Toronto, Ontario

Landscape painter, illustrator, muralist, and teacher. His family lived in Philadelphia and Hamilton, Ont. before settling in Toronto, 1881. Studied at Ontario School of Art, Toronto, 1885. Apprenticed with Toronto Lithographing Co., 1885–90. Studied painting with G.A. Reid, 1886–88 (Toronto), 1893, 1896 (Onteora, N.Y.). Worked as an illustrator for Toronto newspapers. Artist-reporter for *New York Herald*, 1892–99. Studied at Art Students League, New York, 1893–94. Returned to Toronto, 1901. Active as an editorial and historical illustrator, cartoonist, and art director. Painted landscapes in Ontario, Quebec, Western Canada, and Maritimes. Exhibited widely, including Royal Canadian Academy and Ontario Society of Artists. Member of Toronto Art Students' League, Graphic Arts Club, Arts and Letters Club, and Canadian Society of Painters in Water Colour, etc. Drawing instructor, University of Toronto School of Architecture, 1912–39. Painted for Canadian War Memorials, 1918. Mural decorations include Château Laurier, Ottawa, and Royal Ontario Museum, Toronto. Author of *The Picture Gallery of Canadian History* (1942–50). Memorial exhibition, Art Gallery of Toronto, 1951.

ERNEST LAWSON
b. 1873, Halifax, Nova Scotia
d. 1939, Miami, Florida

Landscape painter. Resided in Kingston, Ont., 1883–88. Lived in Kansas City, 1888, and Mexico City, 1889. Studied under the Impressionist painter John Henry Twachtman at Art Students League, New York, 1891, and in Cos Cob, Conn. with Twachtman and J. Alden Weir, 1892. Lived in France, 1893–96. Attended Académie Julian, Paris, 1893. Met M. Cullen and J.W. Morrice. Painted at Moret-sur-Loing, where he met Alfred Sisley. Active in Canada, 1896–97, but returned to U.S. after his Impressionist canvases were poorly received in Toronto. Settled in New York City, 1898. Specialized in urban landscapes, notably views of Upper Manhattan. Exhibited with The Eight at Macbeth Galleries, New York, 1908. Participated in *International Exhibition of Modern Art* (Armory Show), New York, 1913. Exhibited widely throughout the U.S. and with Canadian Art Club, 1911–15. Active in Spain (1916), Cornish, N.H. (1919–20), Halifax, N.S. (1924), Colorado Springs (1926), and Kansas City (1928). Lived primarily in Florida after 1936. Late work became increasingly expressionistic.

ARTHUR LISMER
b. 1885, Sheffield, England
d. 1969, Montreal, Quebec

Landscape painter and art educator. Studied at Sheffield School of Art, 1898–1905, while working as an artist-reporter for a local newspaper. Studied at Académie des Beaux-Arts, Antwerp, 1906–07. Travelled to London and Paris. Emigrated to Canada, 1911. Joined Grip Ltd., a Toronto engraving firm, where he met T. Thomson, F. Johnston, and J.E.H. MacDonald. Sketched with Thomson in and around Toronto. Painted Impressionist canvases in Georgian Bay region, 1913, and Algonquin Park, 1914. By 1920 he had evolved a Post-Impressionist style, emphasizing bold color and strong compositional design. Painted landscapes in northern Ontario, Nova Scotia, Quebec, Newfoundland, the Rocky Mountains, and British Columbia. Taught at Ontario College of Art, Toronto, 1915–16; vice-principal, 1920–27. Principal, Victoria School of Art and Design, Halifax, 1916–19. Founding member, Group of Seven, 1920. Member, Canadian Group of Painters, 1933, and Royal Canadian Academy (R.C.A., 1946). Supervisor of Education, Art Gallery of Toronto, 1929–36, where he established the children's program. Visiting Professor, Columbia University, New York, 1938–39. Head of Education, The Montreal Museum of Fine Arts, 1940–67. Lectured throughout Canada and abroad.

JAMES EDWARD HARVEY (J.E.H.) MACDONALD
b. 1873, Durham, England
d. 1932, Toronto, Ontario

Landscape painter, teacher. Moved to Hamilton, Ont., 1887. Evening classes at Hamilton Art School, 1887–90.

Moved to Toronto, 1890. Apprenticed at Toronto Lithographing Co. Studied part-time under W. Cruikshank and G.A. Reid at Ontario School of Art and Design, 1893. Joined Grip Ltd. as a graphic designer, 1895. Lived in London, Eng., 1903–07. Head designer at Grip, 1907–11. Began painting full-time, 1911. Painted Impressionist-inspired landscapes in and around Toronto and in Georgian Bay and Muskoka districts. Moved to Thornhill, Ont., 1913. Saw, and was influenced by, exhibition of contemporary of Scandinavian art at Albright Art Gallery, Buffalo, Jan. 1913. Made first sketching trip to Algoma (Ont.) district, 1918. Original member, Group of Seven, 1920. Taught at Ontario College of Art, Toronto, 1921–32. Painted in northern Ontario, Quebec, Atlantic Canada (1922), Canadian Rockies (1924–30), and the West Indies (1931–32). Founding member, Canadian Group of Painters, 1933.

HENRIETTA MABEL MAY
b. 1884, Montreal, Quebec
d. 1971, Vancouver, British Columbia

Landscape and figure painter. Studied at Art Association of Montreal under W. Brymner, 1909–1912. Lived in Paris, 1912–13, where she was influenced by Renoir and other French Impressionists. Travelled and painted in northern France, Belgium, Holland (Aug.–Sept. 1912); visited London, Edinburgh, and Glasgow (late 1912). Returned to Montreal, 1913. Specialized in Impressionist street scenes and outdoor figure subjects. Painted for the Canadian War Memorials, 1918. Influenced by the Group of Seven, especially A.Y. Jackson, during the 1920s. Subsequently turned exclusively to landscapes painted in a stylized, Post-Impressionist manner. Depicted scenery in the lower St. Lawrence region and in the Eastern Townships of Quebec, Maine, New Hampshire, and Vermont. Supervised children's art classes at the National Gallery of Canada, Ottawa, 1938–47. Retired to Vancouver, 1950. Member of Royal Canadian Academy (A.R.C.A., 1915), Canadian Group of Painters (founding member, 1933), Federation of Canadian Artists, B.C. Society of Artists.

HELEN GALLOWAY MCNICOLL
b. 1879, Toronto, Ontario
d. 1915, Swanage, Dorset, England

Figure and landscape painter. Became deaf at age two from an attack of scarlet fever. Studied under W. Brymner at Art Association of Montreal, 1899–1902, and at Slade School of Art, London under F. Brown, 1902–04. Outdoor painting classes with A.Talmage in St. Ives, Cornwall, circa 1905, where she met the English Impressionist, Dorothea Sharp. Lived primarily in England. Painted Impressionist figure studies, landscapes, and beach scenes in London and Yorkshire, France, Italy, Quebec, and elsewhere. Exhibited at Royal Society of British Artists, 1913–15; Royal Canadian Academy, 1906–14; Art Asso-

ciation of Montreal; and Ontario Society of Artists, 1910–15. Died prematurely due to complications from diabetes. Memorial exhibition held at the Art Association of Montreal, 1925.

DAVID B. MILNE
b. 1882, near Borgoyne, Ontario
d. 1953, Bancroft, Ontario

Landscape, figure and still life painter, watercolorist, and etcher. Taught school near Paisley, Ont. before moving to New York in 1903. Studied at Art Students League (1903). Employed as a window dresser, showcard painter, and illustrator. Visited local galleries where he saw paintings by Monet and American Impressionists. Saw work by Matisse, Cézanne and early American modernists at Alfred Stieglitz's 291. Turned from illustration to painting in 1910. Experimented with Impressionism and Post-Impressionism. Produced "billboard series," 1911–12. Exhibited five paintings at *International Exhibition of Modern Art* (Armory Show), 1913. After around 1916, worked in a lyrical, calligraphic style. Resided in Boston Corners, N.Y., 1916–17, 1919–29. Official war artist for the Canadian Army, 1918–19. Returned permanently to Canada, 1929. Painted in Temagami, Ont., 1929. Lived in Weston, Ont., 1929–30; Palgrave, Ont., 1930–33; Six Mile Lake, Ont.,1933–39, Toronto, 1940; Uxbridge, Ont., 1940–52; Bancroft, Ont., 1952–53.

JAMES WILSON MORRICE
b. 1865, Montreal, Quebec
d. 1924, Tunis, Tunisia

Landscape and figure painter. Attended University of Toronto, 1882–86, and was a law student at Osgoode Hall, Toronto, 1886–89. Decided to pursue an artistic career. Studied at Académie Julian, Paris, 1889–? and privately with Henri Harpignies. Lived in London, early 1891–early 1892. After April 1892, he lived primarily in Paris. Associated with an international coterie of artists and literati including A. Bennett, C. Bell, C. Conder, R. Henri, H. Matisse, S. Maugham, M. Prendergast, W. Sickert, P. Verlaine, among many others. Made occasional trips back to Canada until 1914. Friendly with M. Cullen and W. Brymner. Depicted scenery in and around Montreal, Quebec City, and along the north shore of the St. Lawrence. Painted in Paris, Brittany, Normandy, Holland, Belgium, England, Venice, Spain, North Africa, West Indies, etc. Work influenced by Harpignies, J.A.M. Whistler, Impressionism, and the Nabis. After 1909, his style was influenced by Matisse and Fauvism. Exhibited widely, including Paris Salons, Munich *Secession*, Art Association of Montreal, Canadian Art Club, Royal Canadian Academy, and Pennsylvania Academy of the Fine Arts. Painted in France for the Canadian War Memorials, 1918.

GEORGE AGNEW REID
b. 1860, Wingham, Ontario
d. 1947, Toronto, Ontario

Portrait, genre, history, and landscape painter, muralist, architect, and teacher. Studied at Central Ontario School of Art under Robert Harris and others, 1879–80, 1882. Active as a portrait painter in Wingham, 1880–82. Studied at Pennsylvania Academy of the Fine Arts, Philadelphia, under Thomas Eakins, 1882–84. Visited Europe, 1885. Studied at Académies Julian and Colarossi, Paris, 1888–89. Summered in Onteora, N.Y. 1891–1917. Visited Paris, 1896; England, Scotland, and The Netherlands, 1910; U.S. and Europe, 1923–24. Taught at Ontario College of Art, 1890–1928 (Principal, 1912–29). Painted for Canadian War Memorials, 1918. Mural work included decorations for Toronto City Hall, 1897–99. Exhibited widely throughout Canada, U.S. and Europe, including Paris Salons, Royal Canadian Academy (R.C.A. 1890), and Royal Academy, London. Member of Society of Mural Decorators, Toronto Guild of Civic Art, Canadian Society of Painters in Water Colour, etc. Memorial exhibition held at Art Gallery of Toronto, 1948.

ALBERT HENRY ROBINSON
b. 1881, Hamilton, Ontario
d. 1956, Montreal, Quebec

Landscape painter. Studied under J. S. Gordon at Hamilton Art School, 1901–03. Attended Académie Julian and École des Beaux-Arts, Paris, 1903–06. Spent summers of 1904 and 1905, travelling and painting in Normandy with T.W. Marshall. Returned to Hamilton, 1905. Taught life classes at Hamilton Art School. Settled in Montreal, 1908. Associated with William Brymner and Maurice Cullen. Painted Impressionist-inspired views of Montreal and the Quebec countryside. Travelled to France with A.Y. Jackson, 1911. Active in Brittany, Italy, and possibly England. Returned to Canada, 1914. Worked as munitions inspector for Dominion Copper Products, Longue Pointe, Que., 1914–18. Returned to Montreal. Painted and sketched in Baie-St.-Paul, St. Tite-des-Caps, the Laurentians, and elsewhere in rural Quebec, often accompanied by A.Y. Jackson, C. Gagnon, and Edwin Holgate. Work included in first Group of Seven exhibition, 1920. Stopped painting in 1940s after contracting arthritis.

MARC-AURÈLE SUZOR-COTÉ
b. 1869, Arthabaska, Quebec
d. 1937, Daytona Beach, Florida

Landscape painter, illustrator, sculptor. Studied drawing at the school of Abbé Joseph Chabert in Montreal, circa 1887. Attended École des Beaux-Arts, Paris, 1891–94, and Académies Julian and Colarossi, 1897. Travelled throughout England and Europe, 1895. Lived primarily in Paris, 1897–1907. Painted first Impressionist landscapes in 1906.

Settled in Montreal, 1907. Established a studio in Arthabaska, circa 1909. Specialized in winter subjects, especially views of snow-bordered rivers in and around Arthabaska. Also painted and sculpted the Quebec *habitant*. Illustrated Louis Hémon's *Maria Chapdeleine* (1916). Exhibited at Paris Salons, Royal Canadian Academy, Canadian Art Club, and elsewhere. Painting activity ceased following an attack of hemiplegia in 1927. Lived in Florida after 1928.

TOM THOMSON
b. 1877, Claremont, Ontario
d. 1917, Canoe Lake, Ontario

Landscape painter. Grew up on a farm near Owen Sound, Ont. Employed as a machinist's apprentice, 1898. Worked for photo-engraving firms in Seattle, Wash., 1901–05. Sketched in crayon and watercolor. Moved to Toronto, 1905, continuing his work as a photo-engraver. Joined Grip Ltd., a commercial art firm, 1908, where he met future Group of Seven members J.E.H. MacDonald, F. Varley, A. Lismer, and F. Carmichael. First sketching trip to Algonquin Park (Ont.), 1912. Employed by Rous and Mann, Toronto, 1912–14. Met A.Y. Jackson, 1914, who enhanced his knowledge of contemporary European art. Left Grip to paint full-time, 1914. From 1914 until 1917, spent most of the year in Algonquin Park, returning to Toronto in winters. Painted wilderness landscapes, capturing the essence of the Ontario northland by means of a bold palette and rich, decorative patterning. Drowned mysteriously in Canoe Lake, (Ont.), 1917.

ERNEST PERCYVAL TUDOR-HART
b. 1873, Montreal, Quebec
d. 1954, Cataraqui, Quebec

Portrait and landscape painter, sculptor, restorer, and teacher. Studied in Paris at Académie Julian, early 1890s [?], and at École des Beaux-Arts under Jean-Léon Gérôme, 1894. Studied sculpture under Auguste Thomas. Influenced by Impressionism. Painted landscapes in Brittany, New Hampshire, Quebec, Italy, and elsewhere in Europe and Great Britain. Operated his own art school in Paris, 1903–13, and in London, 1913–16. Worked on camouflage with the Architects' Central London Regiment during World War I. Exhibited at Paris Salons; Royal Academy, London; Art Association of Montreal; and elsewhere. Lived in London, 1913–35. In England, he was active as a restorer of paintings and as a consultant on the preservation of Old Masters. Also involved with the Art Workers' Guild and helped promote the art of tempera painting. Settled in Cataraqui, near Quebec City, in 1935. At the time of his death, he was designing a Gobelin tapestry (Royal Ontario Museum, Toronto), which was subsequently completed by his wife, Catherine.

Selected Bibliography

CAROL LOWREY

Books, Theses, and Exhibition Catalogues

Baker, Victoria A. *Images de Charlevoix, 1784–1950 = Scenes of Charlevoix, 1784–1950*. Montreal: The Montreal Museum of Fine Arts, 1981.

Barbeau, Marius. *Painters of Quebec*. Toronto: Ryerson Press, 1946.

Buchanan, Donald. *The Growth of Canadian Painting*. Toronto: Collins, 1950.

Canadian Impressionists, 1895–1967. London, Ont.: London Public Library and Art Museum, 1965.

Cavell, Edward, and Dennis Reid. *When Winter was King: The Image of Winter in 19th Century Canad*a. Banff, Alberta: Whyte Museum of the Canadian Rockies, 1988.

Chauvin, Jean. *Ateliers: études sur vingt-deux peintres et sculpteurs canadiens*. Montréal: Louis Carrier, Éditions du Mercure, 1928.

Colgate, William. *Canadian Art: Its Origins and Development*. Toronto: Ryerson Press, 1943.

Crooker, Mervyn. "The Influence of French Impressionism on Canadian Painting." M.A. thesis, University of British Columbia, 1965.

Donegan, Rosemary. *Industrial Images = Images industrielles*. Hamilton, Ont.: Art Gallery of Hamilton, 1987.

Duval, Paul. *Canadian Impressionism*. Toronto: McClelland & Stewart, 1990.

Dyonnet, Edmond. *Mémoires d'un artiste canadien*. Ottawa: Éditions de l'Université d'Ottawa, 1968.

Farr, Dorothy. *Urban Images: Canadian Painting = L'image de la ville en peinture canadienne*. Kingston, Ont.: Agnes Etherington Art Centre, Queen's University, 1990.

_____, and Natalie Luckyj. *From Women's Eyes: Women Painters in Canada*. Kingston, Ont.: Agnes Etherington Art Centre, Queen's University, 1975.

Harper, J. Russell. *Painting in Canada: A History*. Reprint of 2nd ed. Toronto: University of Toronto Press, 1988.

Hill, Charles C. *The Group of Seven: Art for a Nation*. Toronto: McClelland & Stewart, 1995.

James Morrice, Emily Carr and David Milne. Halifax, N.S.: Dalhousie Art Gallery, 1984.

Laing, G. Blair. *Memoirs of an Art Dealer*. 2 vols. Toronto: McClelland & Stewart, 1979–81.

Lamb, Robert J. *The Canadian Art Club, 1907–1915*. Edmonton: Edmonton Art Gallery, 1988.

MacTavish, Newton. *Ars Longa*. Toronto: Ontario Publishing Co., 1938.

_____. *The Fine Arts in Canada*. Reprint. Toronto: Coles, 1973.

McTavish, David. *Canadian Artists in Venice, 1830–1930*. Kingston, Ont.: Agnes Etherington Art Centre, Queen's University, 1984.

McInnes, Graham. *Canadian Art*. Toronto: MacMillan, 1950.

Mellen, Peter. *The Group of Seven*. Toronto: McClelland & Stewart, 1970.

Murray, Joan. *Impressionism in Canada, 1895–1935*. Toronto: Art Gallery of Ontario, 1973.

Nasgaard, Roald. *The Mystic North: Symbolist Landscape Painting in Northern Europe and North America, 1890–1940*. Toronto: Art Gallery of Ontario, 1984.

Ostiguy, Jean-René. *Les esthétiques modernes au Québec de 1916 à 1946 = Modernism in Quebec Art, 1916–1946*. Ottawa: National Gallery of Canada, 1982.

Page, Anne Mandely. *Canada's First Professional Women Painters, 1890–1914: Their Reception in Canadian Writing on the Visual Arts*. M.A. thesis, Concordia University, 1991. Canadian Theses on Microfiche, no. 68775. Ottawa: National Library of Canada, 1992.

Porter, John R., and Didier Prioul. *Québec plein la vue*. Québec: Musée du Québec, 1994.

Rees, Ronald. *Land of Earth and Sky: Landscape Painting of Western Canada*. Saskatoon: Western Producer Prairie Books, 1984.

Reid, Dennis. *A Concise History of Canadian Painting*. 2nd ed. Toronto: Oxford University Press, 1988.

_____. *The Group of Seven*. Ottawa: National Gallery of Canada, 1970.

Robert, Guy. *La peinture au Québec depuis ses origines*. Sainte-Adèle, Qué.: Iconia, 1978.

Robson, Albert. *Canadian Landscape Painters*. Toronto: Ryerson Press, 1932.

Tippett, Maria. *By a Lady: Celebrating Three Centuries of Art by Canadian Women*. Toronto: Viking/Penguin, 1992.

Tooby, Michael, et al. *The True North: Canadian Landscape Painting, 1896–1939*. London: Lund Humphries, 1991.

Walther, Ingo F., ed. *Impressionist Art, 1860–1920: Volume II: Impressionism in Europe and North America*. Cologne: Benedikt Taschen Verlag, 1993.

Watson, William R. *Retrospective: Recollections of a Montreal Art Dealer*. Toronto: University of Toronto Press, 1974.

Wistow, David. *Canadians in Paris, 1867–1914*. Toronto: Art Gallery of Ontario, 1979.

Articles and Essays

Allaire, Sylvain. "Les Canadiens au salon officiel de Paris entre 1870 et 1910: Section Peinture et Dessin." *Journal of Canadian Art History = Annales d'Histoire de l'Art canadien*. 7 (1977–1978): 141–54.

"An Artistic Trend." *The Herald* (Montreal), 1 December 1896, p. 6.

"Art at Home." *Arcadia* 1 (15 November 1892): 281.

Buchanan, Donald W. "The Gentle and the Austere: A Comparison in Landscape Painting," *University of Toronto Quarterly* 11 (October 1941): 72–77.

"Canadian Art in Paris." *Saturday Night*, No. 7 (3 January 1925): 3.

"Canadian Artists in Paris." *Saturday Night*, No. 9 (14 December 1907): 5.

"Canadian Artists in Paris." *Dominion Illustrated*, 11 January 1890, p. 22.

Fairburn, M[argaret] L[aing]. "A Decade of Canadian Art." *Canadian Magazine* 17 (June 1901: 159–63.

_____. "A Milestone in Canadian Art." *Canadian Courier* 1 (13 April 1907): 12.

Harte, W. Blackburn. "Canadian Art and Artists." *New England Magazine* 4 (April 1891): 153–73.

"The Impressionists." *Arcadia* 1 (15 December 1892): 325.

Jenkins, M. "Impressionist Art Exhibition." *Canadian Courier* 5 (20 February 1909): 11.

Kerr, Estelle M. "The Artist." *Saturday Night* 26 (7 June 1913): 29.

Lacroix, Laurier. "Essai de définition de rapport entre la peinture française et la peinture canadienne au XIXe siècle." *Relations France-Canada au XIXe siècle.; Cahier, no. 3*. Paris: Centre Cultural Canadienne, 1975, pp. 39–43.

_____. "Le lieu de la peinture de paysage au Canada" = "Landscape Painting in Canada." In *Les Maîtres canadiens de la collection Power Corporation du Canada, 1850–1950 = Canadian Masters from the Collection of Power Corporation of Canada, 1850–1950*, pp. xxi–xxvii. Québec: Musée du Séminaire de Québec, 1989.

_____. "Ombres Portées: notes sur le paysage canadien avant le Groupe des sept." *Journal of Canadian Art History = Annales de l'art canadien* 13, no. 1 (1991): 6–19.

_____. "Painting." In *The Arts in Canadian Society During the Age of Laurier*. Edited by Robert J. Lamb. Edmonton: University of Alberta and Edmonton Art Gallery, 1988.

Lowrey, Carol. "Arcadia and Canadian Art." *Vanguard* 15 (April–May 1986): 19–22.

MacTavish, Newton. "Some Canadian Painters of the Snow." *International Studio* 75 (January 1919): 78–82.

_____. "A Renaissance of Art in Canada." *Art and Progress* 2 (September 1911): [319]–25.

McInness, G. Campbell. "Art and Philistia: Some Sidelights on Aesthetic Taste in Montreal and Toronto, 1880–1910." *University of Toronto Quarterly* 6 (1936–1937): 516–24.

Murray, Joan. "Victorian Canada: Part 2—The Development." *Canadian Collector* 5 (February 1970): 16–20.

Osborne, Brian S. "The Iconography of Nationhood in Canadian Art." In *The Iconography of Landscape*, pp. 162–78. Edited by Denis Cosgrove and Stephen Daniels. Cambridge Studies in Historical Geography; 9. Cambridge: Cambridge University Press, 1988.

Ostiguy, Jean-René. "The Paris Influence on Quebec Painters." *Canadian Collector* 13 (January/February 1978): 50–54.

Parker, Gilbert. "Canadian Art Students in Paris." *Week* 9 (1 January 1892): 70–71.

"Post-Impressionism Creates Much Discussion Locally." *Montreal Daily Star*, 7 April 1913, p. 10.

"Post Impressionists Shock Local Art Lovers at the Spring Art Exhibition." *Montreal Daily Witness*, 26 March 1913, p. 5.

Reid, Dennis. "Impressionism in Canada." In *World Impressionism*, edited by Norma Broude, pp. [90]–[113], 409. New York: Harry N. Abrams, 1990.

"Re. Impressionism. What It Is and in What It Differs From Other Schools, By Mr. W. Brymner, R.C.A." *The Gazette* (Montreal), 12 March 1896, p. 2.

Seranus. "New Tendency in Canadian Art." *Canadian Courier* 7 (19 March 1910): 11.

Sherwood, W.A. "The Influences of the French School Upon Recent Art." *Canadian Magazine* 1 (October 1893): 638–41.

Simmins, Geoffrey. "Reinterpreting the Canadian Art Club: A Documentary Approach." Term Paper, Graduate Department of Art History, University of Toronto, 1983. Photocopy in the E.P. Taylor Reference Library, Art Gallery of Ontario, Toronto.

Stacey, Robert. "A Contact in Context: The Influence of Scandinavian Landscape Painting on Canadian Artists Before and After 1913." *Northward Journal* 18/19 (1980): 36–56.

"Studio Notes. Impressionism." *Arion* 1 (September 1881): [89]–90.

Zilczer, Judith. "The Dissemination of Post-Impressionism in North America: 1905–1918." In Peter Morrin, Judith Zilczer and William C. Agee, *The Advent of Modernism: Post-Impressionism and North American Art, 1900–1918*, pp. 23–42. Atlanta: High Museum of Art, 1986.

Artists' Bibliographies

FRANCES M. JONES BANNERMAN

Blakely, Phyllis R. "Three Nova Scotia Women Artists: Maria Morris Miller, Frances Jones Bannerman and Annie Louisa Pratt." Archives, Art Gallery of Nova Scotia, Halifax.

Harper, J. Russell. *Early Painters and Engravers in Canada*. Toronto: University of Toronto Press, 1970, p. 16.

Kelly, Gemey. "Frances Jones Bannerman." In *Backgrounds: Ten Nova Scotian Women Artists*, pp. 7, 9, 11. Halifax: Dalhousie Art Gallery, 1984.

Morgan, Henry J. *The Canadian Men and Women of the Time: A Hand-book of Canadian Biography of Living Characters*. Toronto: William Briggs, 1912, p. 57.

Piers, Harry. "Artists in Nova Scotia." Nova Scotia Historical Society, *Collections* 18 (1914): 156.

Stacey, Robert. "Eighty: 1887–1967." In Robert Stacey and Liz Wylie, *Eight/Twenty: 100 Years of The Nova Scotia College of Art and Design*, pp. 31–32, 108–109. Halifax: Art Gallery of Nova Scotia, 1988.

VITAL-ACHILLE-RAOUL BARRÉ

"City-Born Artist was Film Pioneer." *The Gazette* (Montreal), 9 July 1982, p.3.

Martin, André. *Barré l'introuvable = In Search of Raoul Barré*. [Montréal?]: Cinémathèque Québécoise, 1976.

HENRI BEAU

Allaire, Sylvain. "Un hommage à Henri Beau." *Le Collectionneur* 5 (avril 1987): 30–31.

Buron, Henri. "L'oeuvre d'Henri Beau." *La Revue Moderne* (Montréal) (mai 1932): 5, 49.

Dumas, Paul. "Redécouverte d'Henri Beau (1863–1949) à la Galerie Bernard Desroches." *L'information médicale et paramédicale* (Montréal), 18 mars 1975, pp. 40–41.

L'Allier, Pierre. *Henri Beau, 1863–1949*. Québec: Musée du Québec, 1987.

PELEG FRANKLIN BROWNELL

Brown, F. Maud. *Breaking Barriers: Eric Brown and the National Gallery*. [Ottawa]: The Society for Art Publications, 1964.

Burant, Jim. *History of Art and Artists of Ottawa and Surroundings, 1790–1970: Part II, 1880–1945*. Ottawa: Ottawa Art Gallery, 1994.

Cohen, Joan. "Franklin Brownell: His Brushes Captured Early Ottawa." *Ottawa Citizen*, 11 February 1967, p. 35.

Franklin Brownell Leaves Old Art Post." *Montreal Gazette*, 19 June 1937, p. 13.

"Franklin Brownell, Noted Artist, Dies in Ottawa." *Ottawa Journal*, 14 March 1946, p. 19.

Lismer, Arthur. *The Beach, St. Kitts by Franklin Brownell, R.C.A.* National Gallery of Canada, Outline for Picture Study; ser. 1, no. 7. Ottawa: National Gallery of Canada, [1930s?].

Retrospective Exhibition of the Work of Franklin Brownell, R.C.A. Ottawa: National Gallery of Canada, 1922.

Topp, Elizabeth Cadiz. *Canadian Artists in the Caribbean.* Kleinburg, Ont.: McMichael Canadian Art Collection, 1988.

WILLIAM BLAIR BRUCE

Bonds, Gunvor. "William Blair Bruce, Caroline Benedicks och Brucebo." M.A. thesis, Stockholms Universitet Konstvetenskapliga Institutionen, 1977.

Bruce, William Blair. Papers. Art Gallery of Hamilton, Hamilton, Ont.

Exposition rétrospective de l'oeuvre de W. Blair Bruce. Paris: Galeries Georges Petit, 1907.

Gerdts, William H. *Monet's Giverny: An Impressionist Colony.* New York: Abbeville Press, 1993.

Minnesutställning W. Blair Bruce. Stockholm: Kunst-akademien, 1907.

Murray, Joan, ed. *Letters Home, 1859–1906: The Letters of William Blair Bruce.* Moonbeam, Ont.: Penumbra Press, 1982.

_____. "The Man Who Painted Ghosts." *MD* (December 1985): 30–32.

_____. *Preparatory Sketches for a Salon Painting: Bathers at Capri by William Blair Bruce.* Oshawa, Ont.: Robert McLaughlin Gallery, 1993.

_____. *William Blair Bruce.* Oshawa, Ont.: Robert McLaughlin Gallery, 1975.

_____. "William Blair Bruce: Poet of Paint." *Northward Journal*, No. 35 (1985): [34]–39.

"Short Sketch of W. Blair Bruce, Artist, Paris." Typescript, [circa 1901]. W.B. Bruce Artist File, E.P. Taylor Reference Library, Art Gallery of Ontario, Toronto.

Svensk konst i Grez = Art Suédois à Grez. Stockholm [?]: Kungl Akademien för de fria konsterna; Paris: Centre Culturel Suédois, 1991.

Wistow, David. "William Blair Bruce." *Dictionary of Canadian Biography,* vol. 13. Toronto: University of Toronto Press, 1994, pp. 117–118.

EMILY CARR

Blanchard, Paula. *The Life of Emily Carr.* Vancouver: Douglas & McIntyre, 1987.

Carr, Emily. *Growing Pains: The Autobiography of Emily Carr.* Reprint. Toronto: Clarke, Irwin & Co., 1971.

_____. *Emily Carr Omnibus.* Introduction by Doris Shadbolt. Vancouver: Douglas & McIntyre, 1993.

Gowers, Ruth. *Emily Carr.* Leamington Spa, Eng.: Berg, 1989.

Hembroff-Schleicher, Edythe. *Emily Carr: The Untold Story.* Saanichton, B.C.: Hancock House, 1978.

Monaghan, Anne. *Emily Carr: The Different Victorian.* Ottawa: Canadian Library Association, 1981.

Moray, Gerta. "Northwest Coast Native Culture and The Early Indian Paintings of Emily Carr, 1899–1913." Ph.D. dissertation, University of Toronto, 1993.

Shadbolt, Doris. *The Art of Emily Carr.* Toronto: Douglas & McIntyre, 1979.

_____. *Emily Carr.* Vancouver: Douglas & McIntyre, 1990.

Thom, Ian M. *Emily Carr in France.* Vancouver: Vancouver Art Gallery, 1991.

Tippett, Maria. *Emily Carr: A Biography.* Toronto: Oxford University Press, 1979.

WILLIAM HENRY CLAPP

Boas, Nancy. *The Society of Six: California Colorists.* San Francisco: Bedford Arts Publishers, 1988.

Clapp, William H. File. Archives of California Art, Oakland Museum.

Jeppson, Lawrence. "William Henry Clapp: The Gentle Impressionist." Typescript, 1975. Private Collection.

Mills, Paul. *William Henry Clapp, R.C.A., 1879–1954.* Carmel, Calif.: Laky Gallery, 1966.

Prakash, A. "William Henry Clapp." *Magazin'Art*, No. 2 (décembre 1994): 84–89.

MAURICE GALBRAITH CULLEN

Antoniou, Sylvia. *Maurice Cullen, 1866–1934.* Kingston, Ont.: Agnes Etherington Art Centre, Queen's University, 1982.

Beaudry, Louise. *Couleur et lumière: Les paysages de Cullen et de Suzor-Coté.* Laval, Qué.: Fondation de la Maison des Arts de Laval, 1991.

Constantinidi, Mela. *The Laurentians: Painters in a Landscape.* Toronto: Art Gallery of Ontario, 1977.

Gour, Romain. *Maurice Cullen: un maître de l'art du Canada.* Montréal: Les Éditions Éoliennes, 1952.

Jouvancourt, Hugues de. *Maurice Cullen.* Montréal: Éditions La Frégate, 1978.

Mellen, Peter. "Around a Retrospective: Maurice Cullen and the Group of Seven.: *Vie des Arts,* No. 61 (hiver 1970–1971): 27–29, 79–80.

Pilot, Robert. *Maurice Cullen, 1866–1934.* Hamilton, Ont.: Art Gallery of Hamilton, 1956.

LIONEL LeMOINE FITZGERALD

Bovey, Patricia E., and Ann Davis. *Lionel LeMoine FitzGerald (1890–1956): The Development of an Artist.* Winnipeg: Winnipeg Art Gallery, 1978.

Callahan, Maggie. *Lionel LeMoine FitzGerald. His Drawings and Watercolours.* Edmonton: Edmonton Art Gallery, 1982.

Eckhardt, Ferdinand. *L.L. FitzGerald, 1890–1956: A Memorial Exhibition.* Winnipeg: Winnipeg Art Gallery, 1958.

_____ . "The Technique of L.L. FitzGerald." *Canadian Art* 15 (April 1958): 114–19, 149, 163–64.

McDougall, Anne. "La facture magistrale de FitzGerald / Lionel LeMoine FitzGerald: Master of the Brushstroke." *Vie des arts,* no. 24 (hiver 1979–80): 56–58, 92–93.

Sens, Karen Linda. *A Discussion of the Stylistic Development in the Dated Oil Paintings of Lionel LeMoine FitzGerald, 1890–1956.* M.A. thesis, University of British Columbia, 1978. Canadian Theses on Microfiche, no. 40779. Ottawa: National Library of Canada, 1980.

Wylie, Elizabeth. "The Development of Spirituality in the Work of Lionel LeMoine FitzGerald." M.A. thesis, Concordia University, Montreal, 1981.

CLARENCE ALPHONSE GAGNON

Boissay, René. *Clarence Gagnon.* English translation by Raymond Chamberlain. Ottawa: Marcel Broquet, 1988.

Exposition Clarence A. Gagnon. Paris: Galerie A.-M. Reitlinger, 1913.

Gagnon, Clarence. Papers. Archives. McCord Museum of Canadian History, Montreal.

Gagnon, François-Marc, and Andrée Gendreau. *Clarence Gagnon, 1891–1942.* Baie-Saint-Paul, Qué.: Centre d'Exposition de Baie-Saint-Paul, 1992.

Gauvreau, Jean-Marie. "Clarence Gagnon à la Baie Saint-Paul." *Mémoires de la Société Royale du Canada* 38 sect. 1, sér. 3 (May 1944): 113–20.

Gustavson, Susan. "The Picture Frames of Clarence Gagnon: A Neglected History." *Journal of Canadian Art History* 12 (Fall 1989): 80–91.

Jouvancourt, Hugues de. *Clarence Gagnon.* Montreal: Éditions de la Frégate, 1970.

Pilot, Robert. "Notes on Clarence Gagnon, R.C.A." Typescript, 1937–1940. Library, National Gallery of Canada, Ottawa.

Robson, Albert H. *Clarence A. Gagnon.* Canadian Artists Series. Toronto: Ryerson Press, 1938.

JOHN SLOAN GORDON

Exhibition of Paintings by John S. Gordon, A.R.C.A. [(Hamilton, Ont.: Art Gallery of Hamilton?)], 1957.

Gordon, Hortense to Charles Comfort, 28 May 1949. Copy in the J.S. Gordon file, Library, National Gallery of Canada, Ottawa.

Gordon, John Sloan. File. Library, Art Gallery of Hamilton, Hamilton, Ontario.

_____. "My First Library." Typescript, n.d. Private collection.

Inglis, Grace. "Hortense and J.S. Gordon: They Deserve More Notice Than They've Got." *Hamilton* [Ont.] *Spectator*, 15 September 1984, p. S3.

"John Sloan Gordon, A.R.C.A." *Saturday Night*, No. 6 (25 December 1926): 5.

"Late John Sloan Gordon Versatile in Art." *Montreal Gazette*, 19 October 1940, p. 14.

Macuaig, Stuart. *Climbing the Cold White Peaks: A Survey of Artists In and From Hamilton, 1910–1950.* Hamilton, Ont.: Hamilton Artists' Inc., 1986.

Memorial Exhibition of Works by John S. Gordon, A.R.C.A. Hamilton, Ont.: Art Gallery of Hamilton, 1949.

LAWREN STEWART HARRIS

Adamson, Jeremy. *Lawren S. Harris: Urban Scenes and Wilderness Landscapes, 1906–1930.* Toronto: Art Gallery of Ontario, 1978.

Harris, Bess, and R.G.P. Colgrove, eds. *Lawren Harris.* Introduction by Northrop Frye. Toronto: Macmillan, 1969.

Jackson, A.Y., and Sydney Key. *Lawren Harris: Paintings, 1910-1948.* Toronto: Art Gallery of Toronto, 1948.

Larisey, Peter. *Light for a Cold Land: Lawren Harris's Work and Life —An Interpretation.* Toronto: Dundurn Press, 1993.

_____. "Nationalist Aspects of Lawren S. Harris's Aesthetics." *National Gallery of Canada Bulletin* 23 (1974): 3–9.

McNairn, Ian, et al. *Lawren Harris Retrospective Exhibition, 1963.* Ottawa: National Gallery of Canada, 1963.

Wong, Maureen Lansing. "A Study of the Painting of Lawren Harris." M.A. thesis, Bowling Green State University, 1974.

ALEXANDER YOUNG JACKSON

A.Y. Jackson: Paintings, 1902–1953. Catalogue by S.J. Key; introduction by Arthur Lismer. Toronto: Art Gallery of Toronto, 1953.

Firestone, O.J. *The Other A.Y. Jackson: A Memoir.* Toronto: McClelland & Stewart, 1979.

Groves, Naomi Jackson. *A.Y.'s Canada.* Toronto: Clarke, Irwin & Co., 1968.

Jackson, A.Y. *A Painter's Country: The Autobiography of A.Y. Jackson.* Memorial ed. Toronto: Clarke, Irwin & Co., 1976.

Robson, Albert H. *A.Y. Jackson.* Canadian Artists Series. Toronto: Ryerson Press, 1938.

CHARLES WILLIAM JEFFERYS

Colgate, William. *C.W. Jefferys.* Toronto: Ryerson Press, 1945.

Jefferys, C.W. Archive. E.P. Taylor Reference Library, Art Gallery of Ontario, Toronto.

_____. Papers. Imperial Oil Collection. National Archives of Canada, Ottawa.

Osborne, Brain S. "The Kindling Touch of Imagination: C.W. Jefferys and Canadian Identity." In *A Few Acres of Snow: Literary and Artistic Images of Canada*, pp. 28–47. Edited by P. Simpson-Horsley and G. Norcliffe. Toronto: Dundurn Press, 1992.

Pierce, Lorne. "C.W. Jefferys, O.S.A., P.C.A., LL.D." *Ontario History* 41 (1949): 213–16.

Rees, Ronald. "A Native Vision: C.W. Jefferys and Prairie Landscape." In *Land of Earth and Sky: Landscape Paintings of Western Canada*, pp. 36–41. Saskatoon: Western Producer Prairie Books, 1984.

Stacey, Robert. *Charles William Jefferys, 1869–1951.* Kingston, Ont.: Agnes Etherington Art Centre, Queen's University, 1976.

_____. *C.W. Jefferys.* Canadian Artists Series; 10. Ottawa: National Gallery of Canada, 1985.

_____. "C.W. Jefferys Section." *Northward Journal*, No. 20 (1981): 6–50.

_____. *Western Sunlight: C.W. Jefferys on the Canadian Prairies, 1901–1924.* Saskatoon: Mendel Art Gallery, 1985.

ERNEST LAWSON

Anderson, Dennis R. *Ernest Lawson Retrospective.* New York: ACA Galleries, 1976.

Berry-Hill, Henry, and Sidney Berry-Hill. *Ernest Lawson: American Impressionist, 1873–1939.* Leigh-on-Sea, Eng.: F. Lewis, 1968.

Du Bois, Guy Pène. *Ernest Lawson.* New York: Whitney Museum of American Art, 1932.

Ely, Catherine Beach. "The Modern Tendency in Lawson, Lever and Glackens." *Art in America* 10 (December 1921): 31–37.

Karpiscak, Adeline Lee. *Ernest Lawson, 1873–1939.* Tucson: University of Arizona, Museum of Art, 1979.

O'Brien, Mern. *Ernest Lawson (1873–1939): From Nova Scotia Collections.* Halifax: Dalhousie Art Gallery, Dalhousie University, 1983.

O'Neal, Barbara. *Ernest Lawson, 1873–1939.* Ottawa: National Gallery of Canada, 1967.

Phillips, Duncan. "Ernest Lawson." *American Magazine of Art* 8 (May 1917): 257–63.

Price, F. Newlin. *Ernest Lawson, Canadian-American.* New York: Feragil Galleries, 1930.

_____. "Lawson, of the 'Crushed Jewels'." *International Studio* 78 (February 1924): 367–70.

Sherman, Frederic Fairchild. "The Landscape of Ernest Lawson." *Art in America* 8 (January 1919): 32–39.

ARTHUR LISMER

Darroch, Lois. *Bright Land: A Warm Look at Arthur Lismer.* Toronto: Merritt Publishing, 1981.

Harris, Lawren. *Arthur Lismer: Paintings, 1913–1949.* Toronto: Art Gallery of Toronto, 1950.

Kelly, Gemey. *Arthur Lismer: Nova Scotia, 1916–1919.* Halifax: Dalhousie Art Gallery, Dalhousie University, 1982.

McLeish, John A.B. *September Gale: A Study of Arthur Lismer and the Group of Seven.* 2nd ed. Toronto: J.M. Dent & Sons, 1973.

Tolmatch, Elaine. "L'esthétique du paysage chez Arthur Lismer." M.A. thesis. Université de Montréal, 1978.

JAMES EDWARD HERVEY (J.E.H.) MACDONALD

Duval, Paul. *The Tangled Garden: The Art of J.E.H. MacDonald.* Scarborough, Ont.: Prentice-Hall, 1978.

Hill, Charles C. *Exploring the Collections: Bouquets from a Tangled Garden.* Ottawa: National Gallery of Canada, 1975.

Hunter, E.R. *J.E.H. MacDonald: A Biography and Catalogue of His Work.* Toronto: Ryerson Press, 1940.

J.E.H. MacDonald: Memorial Exhibition. Montreal: Dominion Gallery, 1957.

Mastin, Catherine. *J.E.H. MacDonald: Logs on the Gatineau.* Windsor, Ont.: Art Gallery of Windsor, 1991.

Pierce, Lorne. *A Postscript on J.E.H. MacDonald, 1873–1932.* Toronto: Ryerson Press, 1940.

Robertson, Nancy E. *J.E.H. MacDonald, R.C.A., 1873–1932.* Toronto: Art Gallery of Toronto, 1965.

Robson, Albert H. *J.E.H. MacDonald, R.C.A.* Canadian Artists Series. Toronto: Ryerson Press, 1937.

HELEN GALLOWAY MCNICOLL

"Death Cuts Short Promising Career." *The Gazette* (Montreal), 28 June 1915, p. 5.

Gualtieri, Julia. *The Woman as Artist and Subject in Canadian Painting (1890–1930): Florence Carlyle, Laura Muntz Lyall, Helen McNicoll.* M.A. thesis, Queen's University, Kingston, Ont., 1989. Ann Arbor, Mich.: University Microfilms International, 1989; Canadian Theses on Microfiche, no. 60737. Ottawa: National Library of Canada, 1991.

"Honor Montreal Artist. Miss Helen McNicoll Elected a R.B.A." *The Gazette* (Montreal), 2 April 1913, p. 2.

Memorial Exhibitions [sic] *of Paintings by the late Helen G. McNicoll, R.B.A., A.R.C.A.* Montreal: Art Association of Montreal, 1925.

"Memorial Show of Work by Canadian." *The Gazette* (Montreal), 10 November 1925, p. 25.

"Miss McNicoll Now a Member of Royal Art Society." *Montreal Daily Star*, 2 April 1913, p. 2.

Murray, Joan, intro. *Helen McNicoll, 1879–1915: Oil Paintings from The Estate.* Toronto: Morris Gallery, 1974.

_____. *Helen McNicoll: Oil Paintings from The Estate: Part Two.* Toronto: Morris Gallery, 1976.

DAVID B. MILNE

Carney, Lora. *David Milne: New York City Paintings, 1910–1916.* Toronto: Mira Godard Gallery, 1984.

Jarvis, Alan. *David Milne.* Toronto: McClelland & Stewart, 1962.

O'Brian, John. *David Milne and the Modern Tradition of Painting.* Toronto: Coach House Press, 1983.

_____. *David Milne: The New York Years, 1903–1916.* Edmonton: Edmonton Art Gallery, 1981.

_____. "Reflections on David Milne." *Canadian Forum* 61 (June–July 1981): 35–36.

Silcox, David. *David Milne, 1882–1953.* Kingston, Ont.: Agnes Etherington Art Centre, Queen's University, 1967.

Thom, Ian M., ed. *David Milne.* Vancouver: Douglas & McIntyre, 1991.

Tovell, Rosemarie L. *David Milne: Painting Place.* Masterpieces in the National Gallery of Canada. Ottawa: National Gallery of Canada, 1976.

Zemans, Joyce. "David Milne, 1911–1915." *Artscanada*, No. 176/177 (February–March 1973): 72–73.

JAMES WILSON MORRICE

Buchanan, Donald W. "A Canadian in St. Malo." *Queen's Quarterly* 43 (Autumn 1936): 298–300.

_____. "James Wilson Morrice." *University of Toronto Quarterly* 2 (January 1936): 216–27.

_____. *James Wilson Morrice.* Toronto: Ryerson Press, 1947.

_____. *James Wilson Morrice: A Biography.* Toronto: Ryerson Press, 1936.

Charles Conder, Robert Henri, James Morrice, Maurice Prendergast: The Formative Years, Paris, 1890s. New York: Davis and Long, 1975.

Cloutier, Nicole, et al. *James Wilson Morrice, 1865–1924.* Montreal: The Montreal Museum of Fine Arts, 1985.

Dorais, Lucie. "James Wilson Morrice: Les années de formation." M.A. thesis, Université de Montréal, 1980.

_____. *J.W. Morrice.* Canadian Artists Series; 8. Ottawa: National Gallery of Canada, 1985.

Hill, Charles C. *Morrice: A Gift to the Nation: The G. Blair Laing Collection.* Ottawa: National Gallery of Canada, 1992.

Ingram, W.H. "Canadian Artists Abroad." *Canadian Magazine* 28 (January 1907): 218–22.

Johnston, William R. *James Wilson Morrice, 1865–1924.* Montreal: The Montreal Museum of Fine Arts, 1965.

Laing, G. Blair. *Morrice: A Great Canadian Artist Rediscovered.* Toronto: McClelland & Stewart, 1984.

Langdale, Cecily. *Charles Conder, Robert Henri, James Morrice, Maurice Prendergast: The Formative Years, Paris, 1890s.* New York: Davis & Long, 1975.

Lyman, John. *Morrice.* Montréal: L'Arbre, 1945.

McCrea, Rosalie Smith. "James Wilson Morrice and the Canadian Press, 1888–1916: His Role in Canadian Art." M.A. thesis, Carleton University, Ottawa, 1980.

O'Brian, John. "James Wilson Morrice: His Relationship with the Avant-Garde in France." In *O Kanada,* pp. 57–62. Ottawa: Canada Council, 1985; Berlin: Akademie der Künste, 1982, pp. 62–69.

_____. "Morrice—O'Conor, Gauguin, Bonnard et Vuillard." *Revue de l'université de Moncton* 15 (avril–décembre 1982): 9–34.

Pepper, Kathleen Daly. *James Wilson Morrice.* Toronto: Clarke, Irwin & Co., 1966.

Reid, Dennis. *James Wilson Morrice, 1865–1924.* Bath, Eng.: Holburne of Menstrie Museum, 1968.

Vauxcelles, Louis. "The Art of J.W. Morrice." *Canadian Magazine* 34 (December 1909): 169–76.

GEORGE AGNEW REID

Boyanoski, Christine. *Sympathetic Realism: George A. Reid and the Academic Tradition*. Toronto: Art Gallery of Ontario, 1986.

Dickman, Chris. *G.A. Reid: Towards a Union of the Arts*. Durham, Ont.: Durham Art Gallery, 1985.

Fairburn, Margaret L. "The Art of George A. Reid." *Canadian Magazine* 22 (November 1903): 2–9.

Miner, Muriel Miller. *George Reid: A Biography*. Edited by Ian R. Coutts. Toronto: Summerhill Press Ltd., 1987. Rev. ed. of *G.A. Reid: Canadian Artist* (1946).

Moyer, Stanley G. "Interpreting the Pioneers: A Study of the Dean of Canadian Artists, George Agnew Reid, R.C.A., O.S.A., Who Has Been So Large a Factor in the Development of Art in Canada." *Canadian Magazine* 76 (August 1931): 17–18, 36–37.

Peppall, Rosalind. "Architect and Muralist: The Painter George Reid in Onteora, New York." *Canadian Collector* 19 (July–August 1984): 44–47.

Reid, George A. "The Evolution of Two of My Pictures." *Massey's Magazine* 1 (January 1896): 10–15.

_____ . Scrapbooks, circa 1880s–circa 1947. 2 vols. E.P. Taylor Reference Library, Art Gallery of Ontario, Toronto.

Staley, John E. "Reid—Painter of Canadian Character." *Maclean's* 25 (March 1913): 123–30.

Walker, Doreen E. " 'L'Art pour la Vie' ": l'esthétique de George Agnew Reid." *Revue de l'Université de Moncton* 15 (avril–décembre 1982): 49–67.

ALBERT HENRY ROBINSON

Lee, Thomas R. *Albert H. Robinson*. Québec: Baie d'Urfée, 1955.

_____ . "Albert H. Robinson." *Educational Record* 71 (July–September 1955): 145–51.

_____ . *Albert H. Robinson: The Painter's Painter*. Montreal: Privately printed, 1956. Portions reprinted in *Albert H. Robinson (1881–1956): Retrospective Exhibition*. Montreal: La galerie Walter Klinkhoff, 1994.

MacDonald, T.R. *Albert H. Robinson: Retrospective Exhibition*. Foreword by Robert H. Pilot. Hamilton, Ont.: Art Gallery of Hamilton, 1955.

Murray, Joan. "Albert H. Robinson: Rescued from Christmas Card Land." *Canadian Collector* 18 (May 1983): 31–33.

Watson, Jennifer. *Albert H. Robinson: The Mature Years*. Kitchener, Ont.: Kitchener-Waterloo Art Gallery, 1982.

MARC-AURÈLE SUZOR-COTÉ

Beaudry, Louise. *Couleur et lumière: Les paysages de Cullen et de Suzor-Coté*. Laval, Qué.: Fondation de la maison des arts de Laval, 1991.

Brunette, Michel. "Paysage et paysan dans l'oeuvre de Suzor-Coté (Suzor-Coté et Edmond de Nevers)." M.A. thesis, Université de Montréal, 1974.

Burgogne, St. George. "A Painter of Winter Landscape." *Canadian Courier* 7 (19 February 1910): 14.

Falardeau, Émile. *Marc-Aurèle-alias-Suzor-Coté, peintre et sculpteur, 1869–1937*. Artistes et artisans du Canada; 6. Montréal: Galerie des anciens, 1969.

Gour, Romain. *Suzor-Coté: artiste multiforme*. Montréal: Éditions Éoliennes, 1950.

Jouvancourt, Hugues de. *Suzor-Coté*. Montréal: Stanké, 1978.

Lacroix, Laurier. *Marc-Aurèle de Foy Suzor-Coté: Retour à Arthabaska = Return to Arthabaska*. Arthabaska, Qué.: Musée Laurier, 1987.

Ostiguy, Jean-René. *Marc-Aurèle de Foy Suzor-Coté: Paysage d'hiver = Winter Landscape*. Masterpieces in the National Gallery of Canada; 12. Ottawa: National Gallery of Canada, 1978.

Sibley, C. Lintern. "A. Suzor-Coté, Painter." In *The Year Book of Canadian Art, 1913*, pp. 149–57. Toronto: J.M. Dent and Sons, 1913.

TOM THOMSON

Davies, Blodwen. *Paddle and Palette: The Story of Tom Thomson*. Toronto: Ryerson Press, 1930.

Little, William. *Tom Thomson Mystery*. Toronto: McGraw-Hill, 1970.

MacCallum, J.M. "Tom Thomson: Painter of the North." *Canadian Magazine* 50 (May 1918): 375–85.

Murray, Joan. *The Art of Tom Thomson*. Toronto: Art Gallery of Ontario, 1971.

_____ . *The Best of Tom Thomson*. Edmonton: Hurtig, 1986.

_____ . *Tom Thomson: The Last Spring*. Toronto: Dundurn Press, 1994.

Thomson, Tom. Collection. National Archives of Canada, Ottawa (MG 30, D284).

Town, Harold and David P. Silcox. *Tom Thomson: The Silence and The Storm*. 2nd ed. Toronto: McClelland and Stewart, 1982.

Wistow, David. *Tom Thomson and The Group of Seven*. Toronto: Art Gallery of Ontario, 1982.

ERNEST PERCYVAL TUDOR-HART

Catalogue: Exposition Rétrospective de P. Tudor-Hart. Québec: Musée de la Province de Québec, 1943.

"E.P. Tudor-Hart, Noted Artist, Dies." *Quebec Chronicle Telegraph*, 9 June 1954, p. 3.

Garlick, K.J. *Percyval Tudor-Hart, 1873–1954*. Oxford: Ashmolean Museum, 1981.

MacGregor, Alasdair Alpin. *Percyval Tudor-Hart, 1873–1954: Portrait of an Artist*. London: P.R. Macmillan, 1961.

Tudor-Hart, Percyval. "The Analogy of Sound And Colour." *Cambridge Magazine*, 2 March 1918, p. 480.

_____ . "A New View of Colour." *Cambridge Magazine*, 23 February 1918, pp. 452–56.